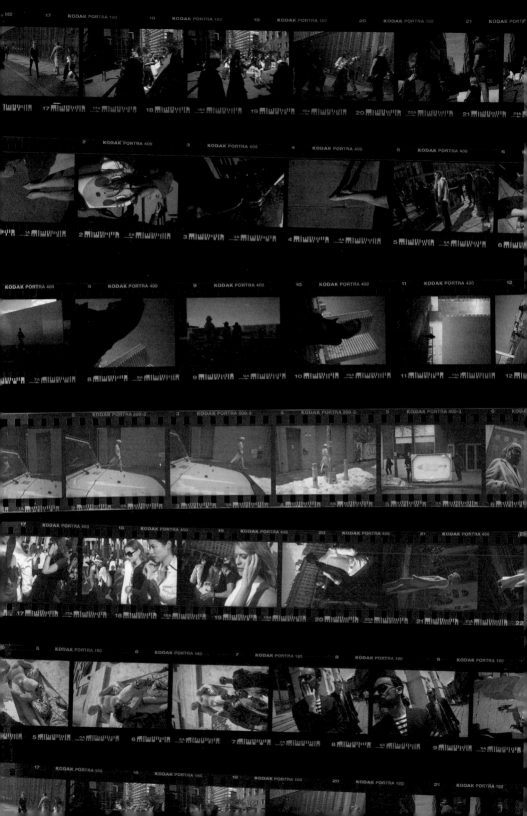

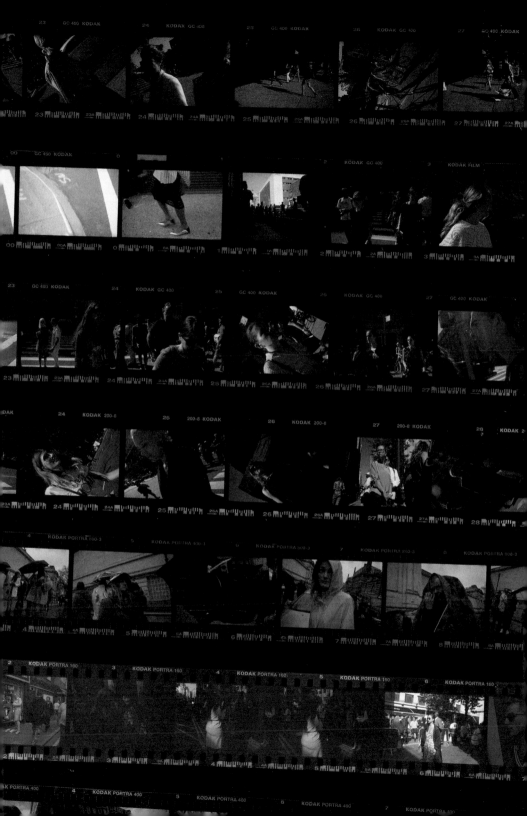

2018년 6월 18일 초판 발행

사 진 남현범
발행인 전용훈
디자인 박은비

주소 서울시 마포구 동교로 194 혜원빌딩 1층
전화 02-325-1984
팩스 0303-3445-1984
홈페이지 www.re1984.com
이메일 master@re1984.com
ISBN 979-11-85042-35-0 03600

LOOK GOOD BOOK

1984

세상에는 수많은 사진작가가 있다. 하지만 남현범의 작업은
특별하다. 왜냐하면 그의 이미지들은 완전히 그만의 것이기
때문이다. 아무도 그의 사진을 흉내 낼 수 없다. 남현범은
매우 자유롭고 그의 메시지는 강력하다. 그는 오로지 자신
이 찍고 싶은 것만을 찍는다. 실제로, 이런 방식으로 작업하
는 사진작가를 찾기란 매우 어려운 일이다.

—레이나 나카가와 (아트앤커머스 에이전트)

There are so many photographers in the world, but
Nam's works stand out because his images are so Nam.
No one can copy his works. Nam is so free and his
voice is strong. He only shoots what he wants to shoot.
Actually, it is hard to find photographers who are in this
way.

—Reina Nakagawa (Art + Commerce Agent)

기록 사진도 패션 사진도 거리의 사진도 남현범의 사진에 다 들어있다. 그의 사진들은 너무 복합적이기 때문에 하나의 장르로 규정할 수 없다. 각각의 이미지는 사진 너머의 삶을 시사하고 있다. 그것은 단순히 귀걸이나 드레스 또는 플랫 슈즈를 찍은 사진이 아니라 누군가의 머리카락 아래에서 튀어나온 귀걸이, 누군가가 걸어갈 때 드러나는 드레스의 디테일한 부분, 늦은 오후 플랫 슈즈를 신고 걸어가는 사람이 만들어 내는 그림자에 관한 것이다. 그것은 남현범이 사람과 패션을 어떻게 바라보고 경험하고 있는지에 대한 것이고 그의 사진이 시즌을 거듭하며 지속하고 있는 이유이다. 남현범의 매력적인 앵글과 따뜻하고 특별한 질감의 사진들은 (모두 35mm 필름 카메라로 찍은) 거리의 패션을 기록하는데 신선하고도 미묘한 접근을 제시한다.

−스테파니 닐 (아트앤커머스 에이전트)

There is documentary photography, there is fashion photography, there is street photography − and there are Nam's photographs. You can't pin them into one type of genre because they're too complex; each image intimates a life beyond the picture. It's not just a photo of an earring or a dress or platform shoe, but the way the earring sticks out from under someone's hair, the way the details in the dress in the dress blur as someone walks, the shadows cast by the platform heels as someone walks in the late afternoon. This is how Nam sees and experiences people and fashion, and so his photos endure, season after season. Nam's striking angles and warm, textured photographs − all taken on 35mm − provide a fresh and nuanced approach to documenting fashion on the street.

−Stephanie Neel (Art + Commerce Agent)

#metallica
#laura_cassidy
#gilda_ambrosio
#models_after_show
#long_hair
#georgia_tai
#favorite_bag
#editor
#street_style
#yellow_glove
#vintages
#busy_moment
#pink_fur
#chanel_invitation
#fashion_editor
#look_good
#palm_tree_shirts
#winter_face
#yellow_car

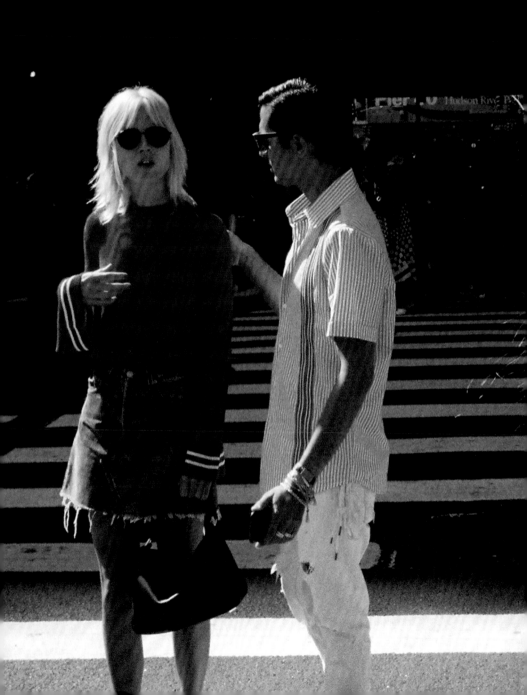

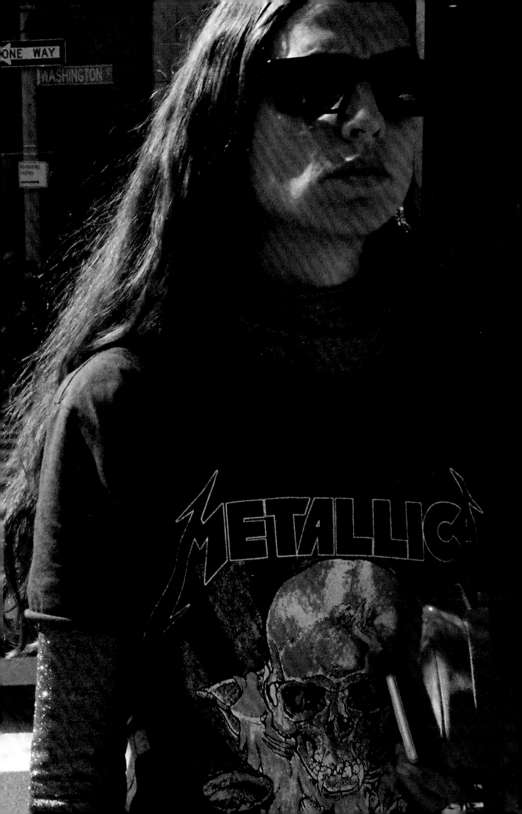

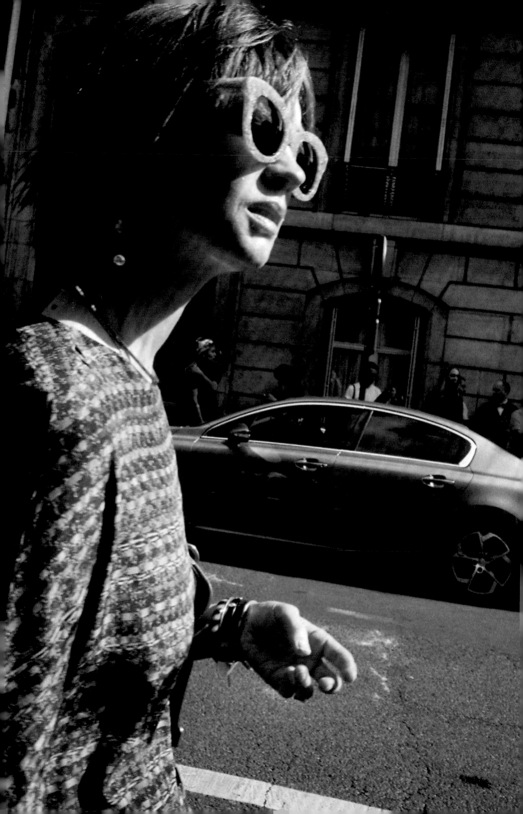

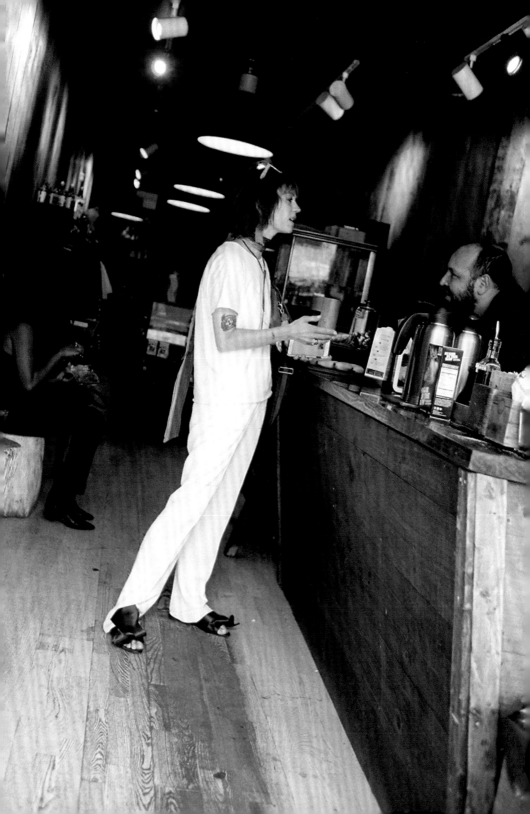

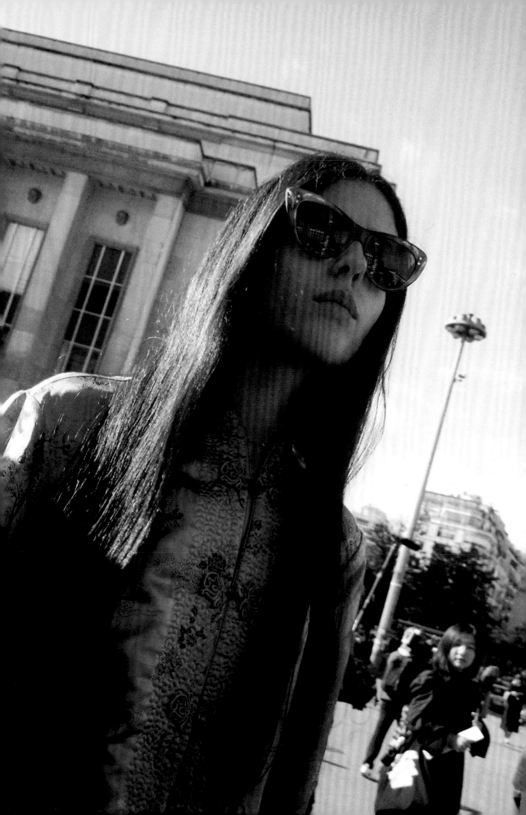

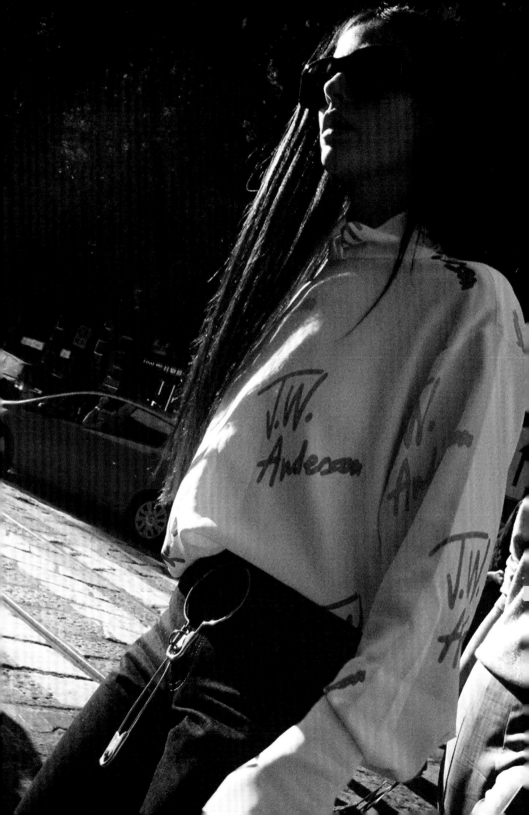

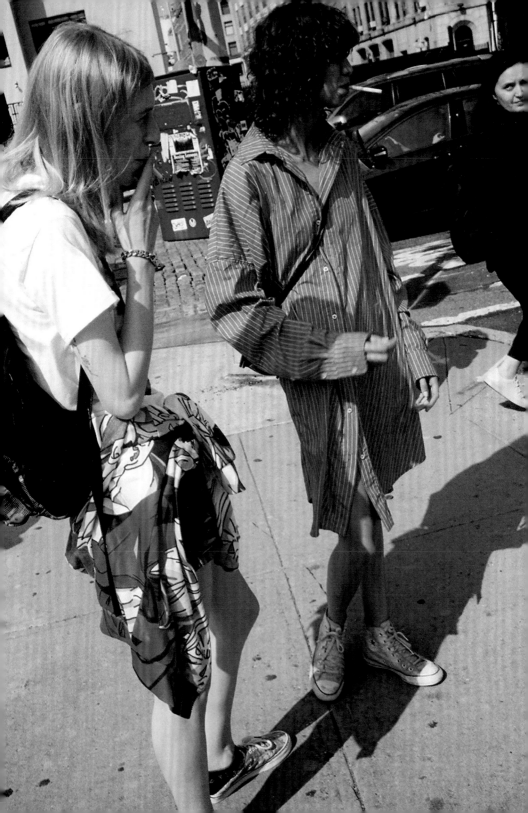

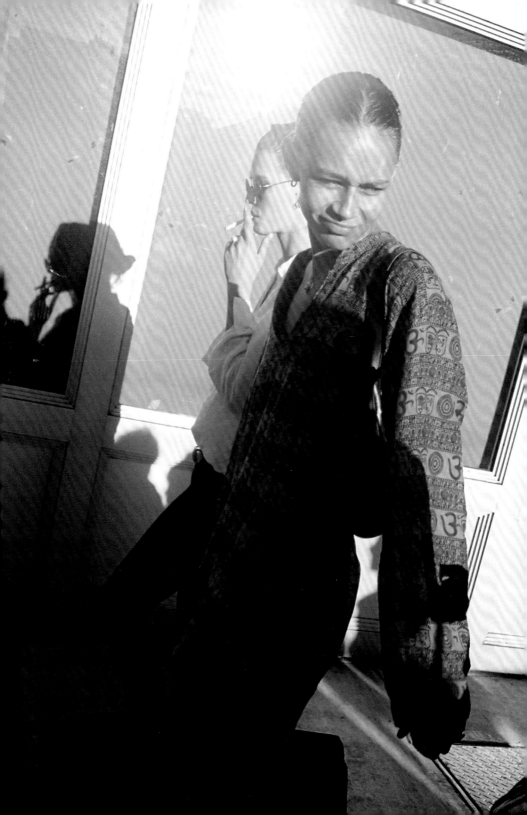

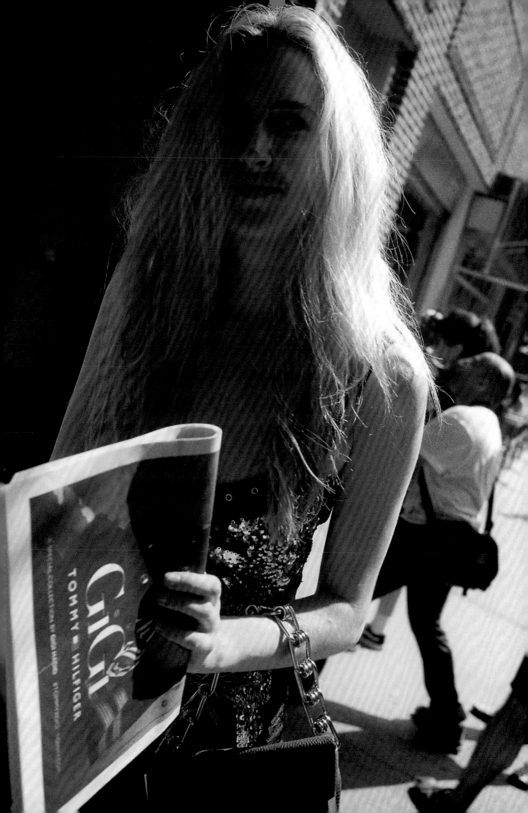

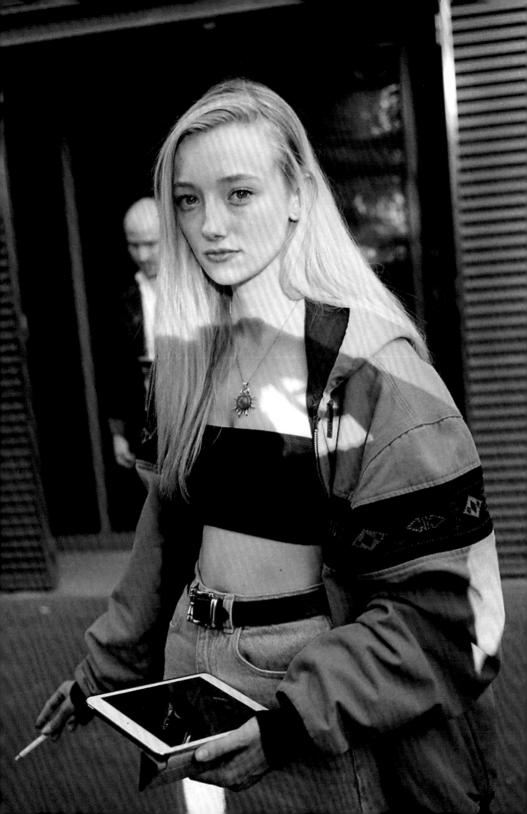

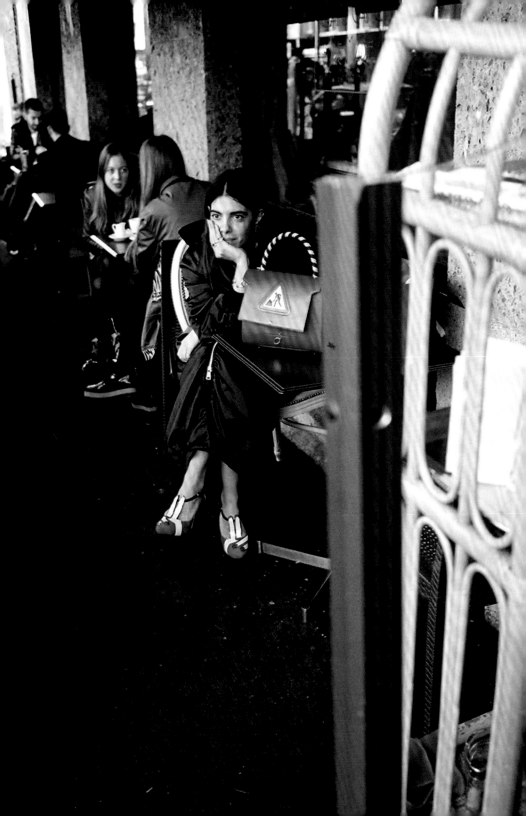

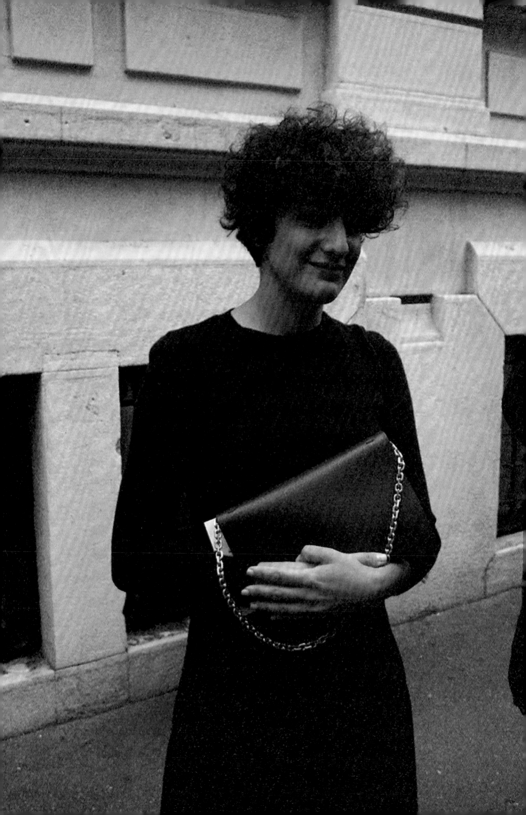

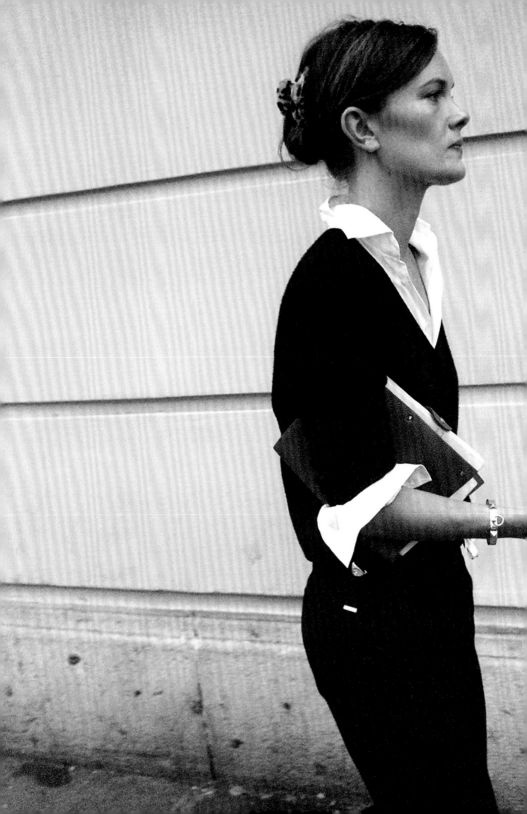

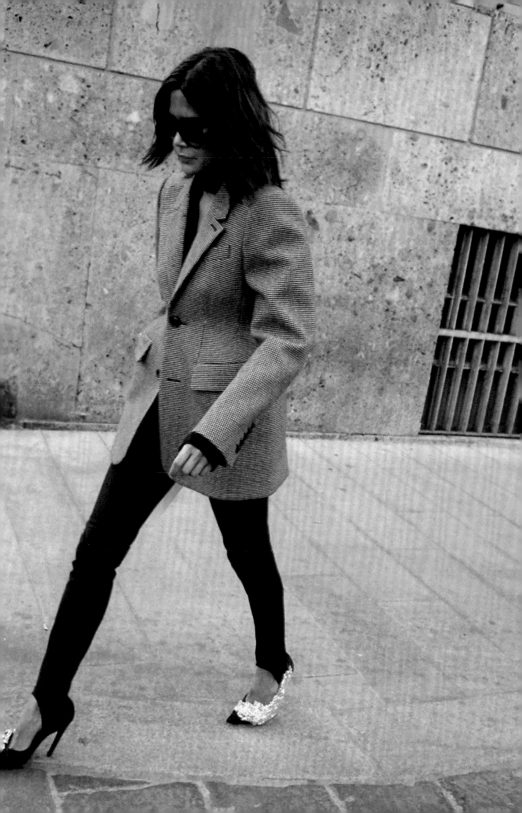

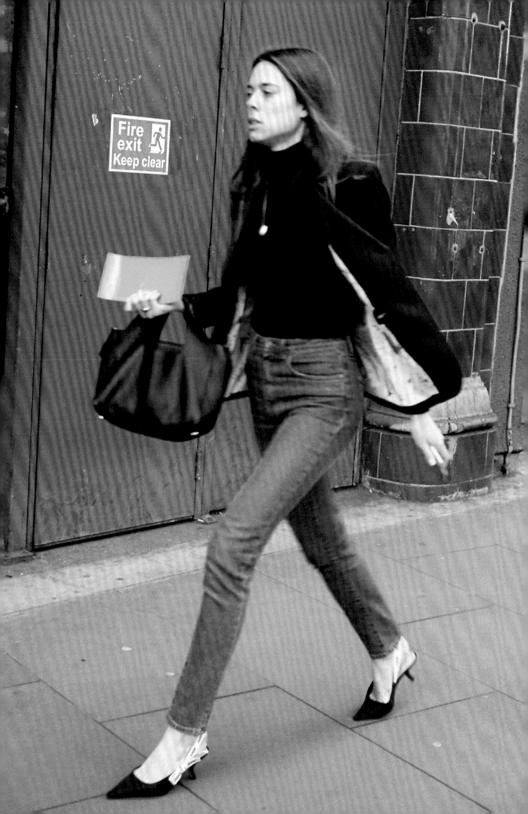

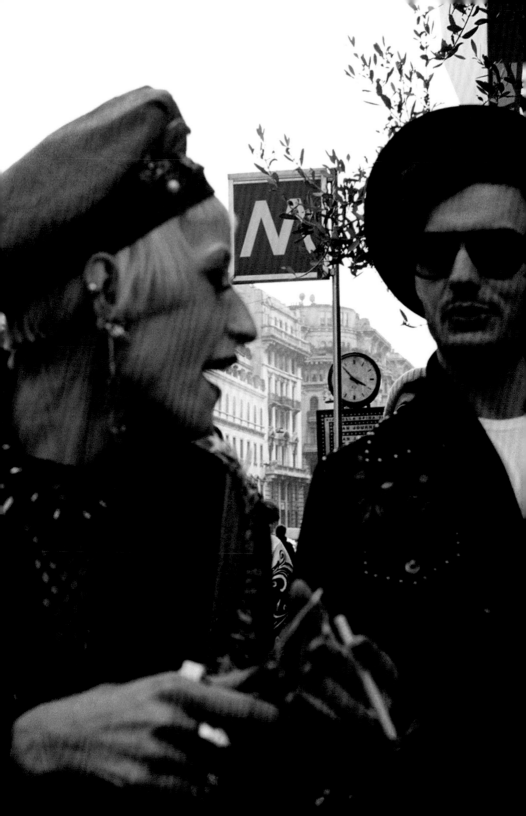

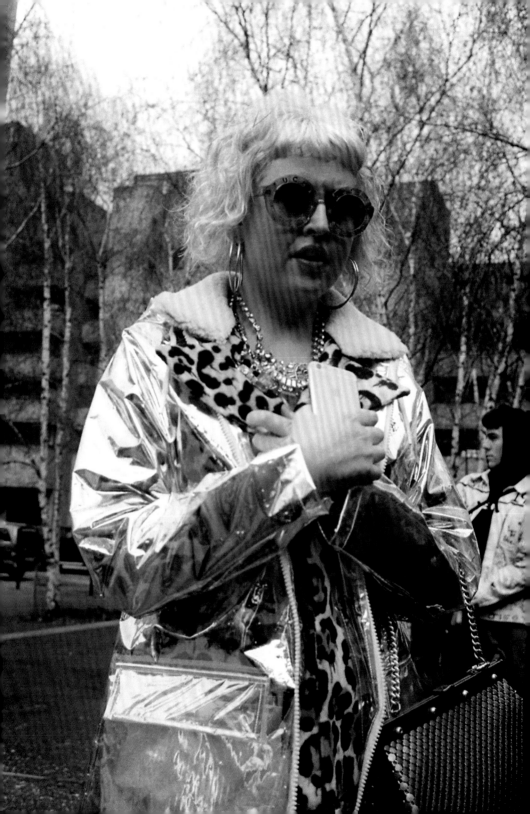

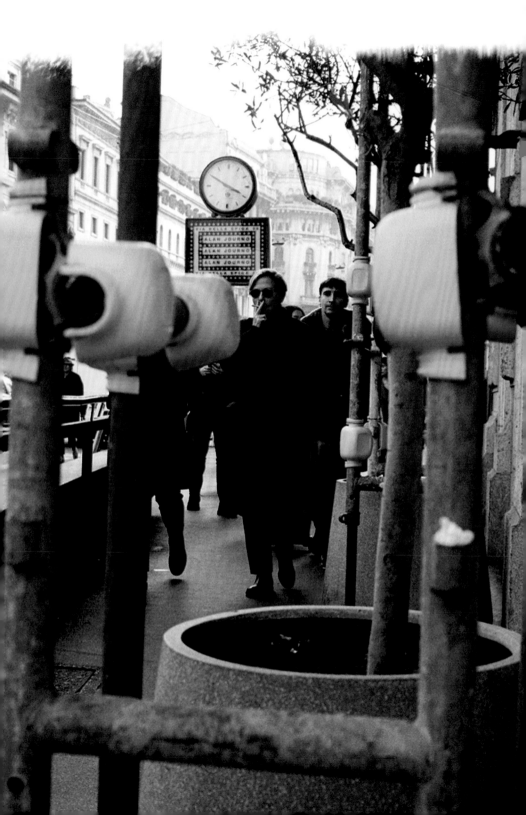

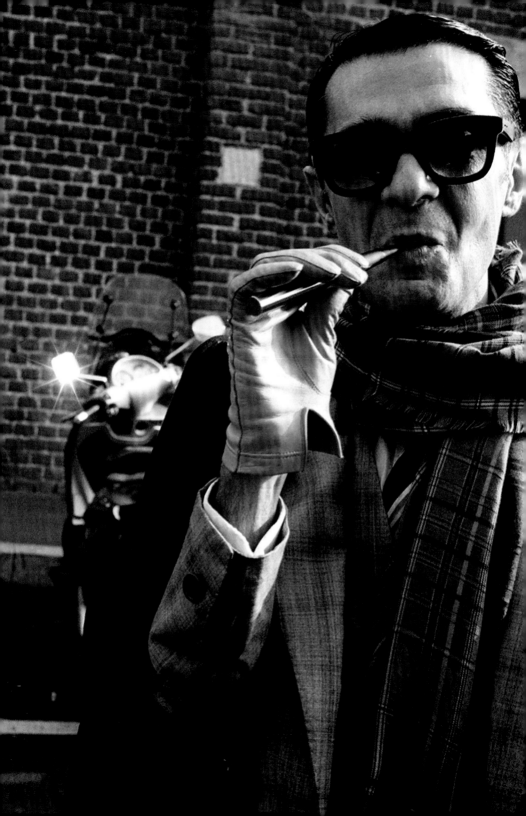

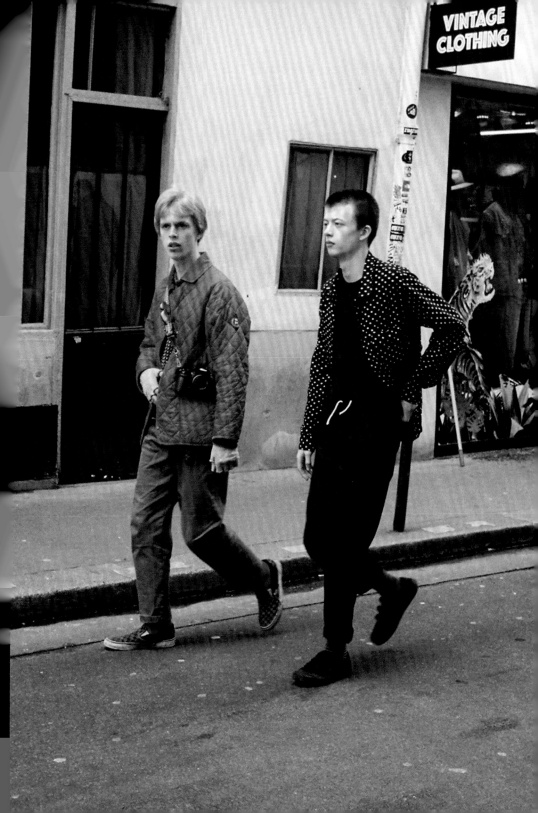

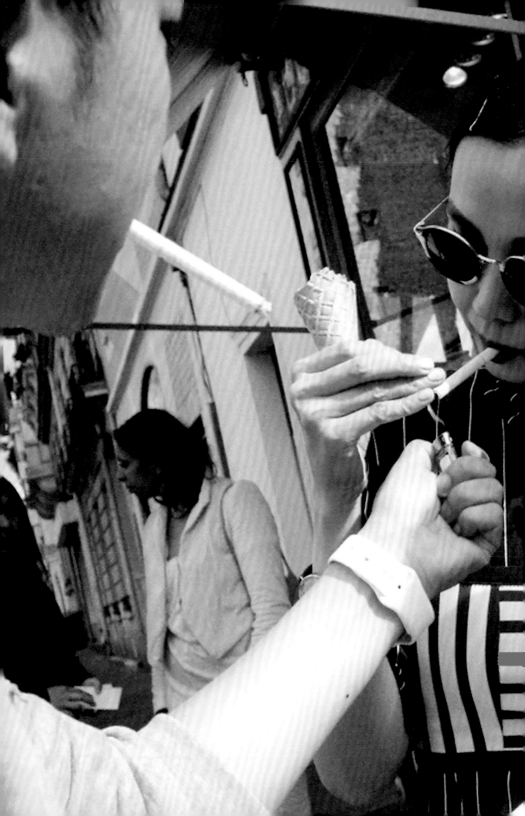

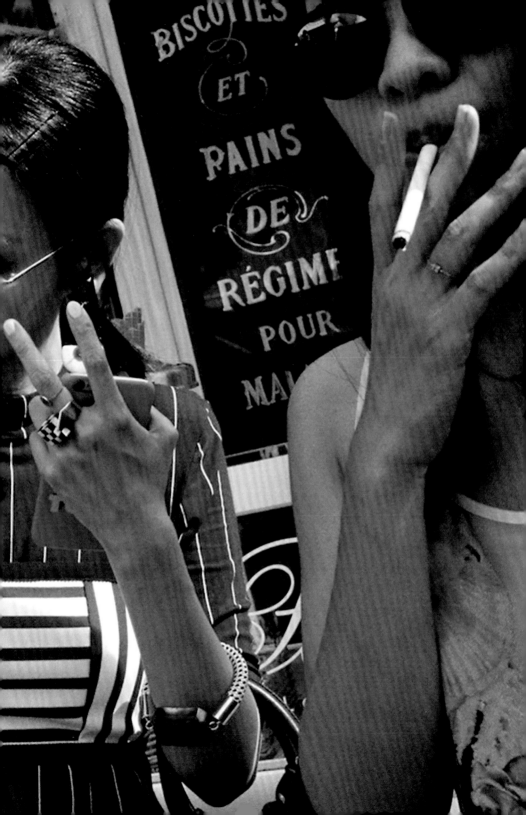

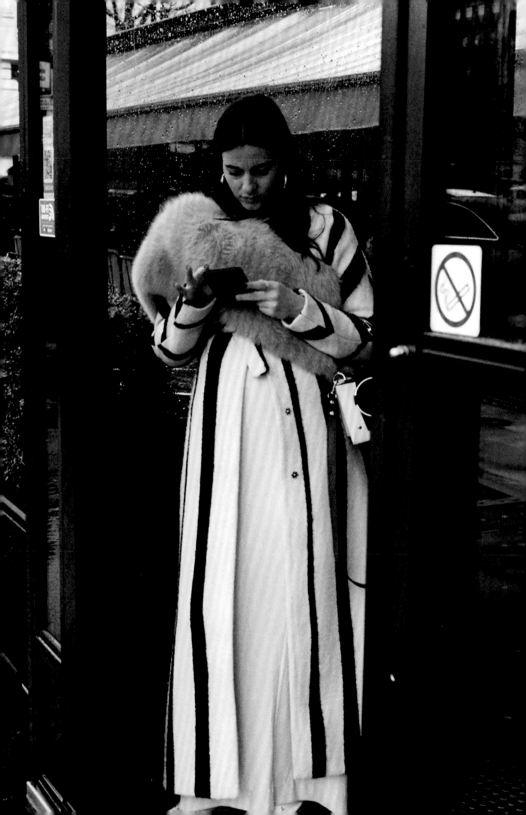

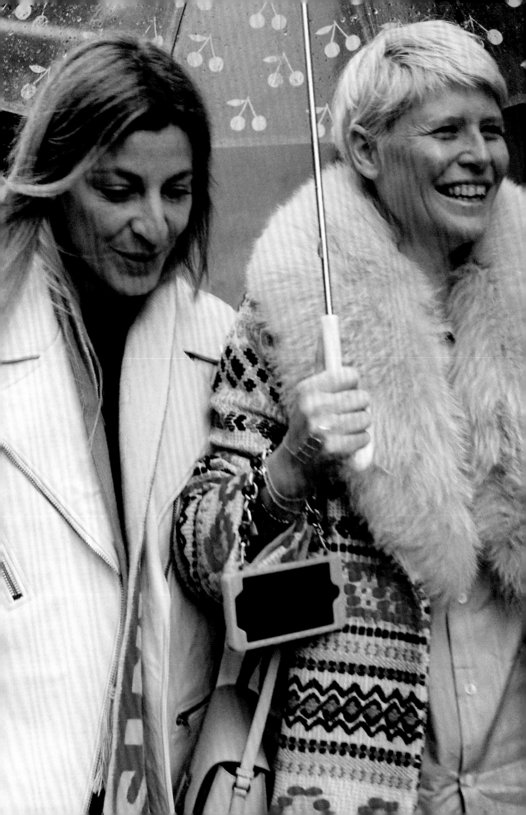

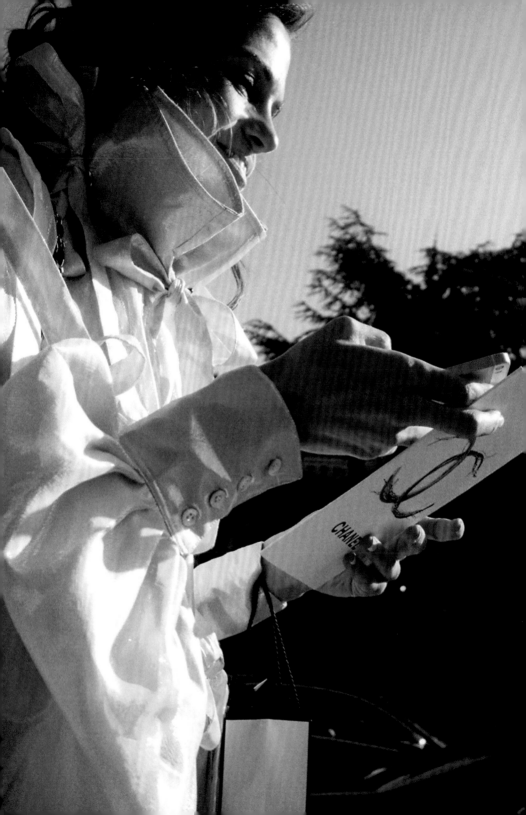

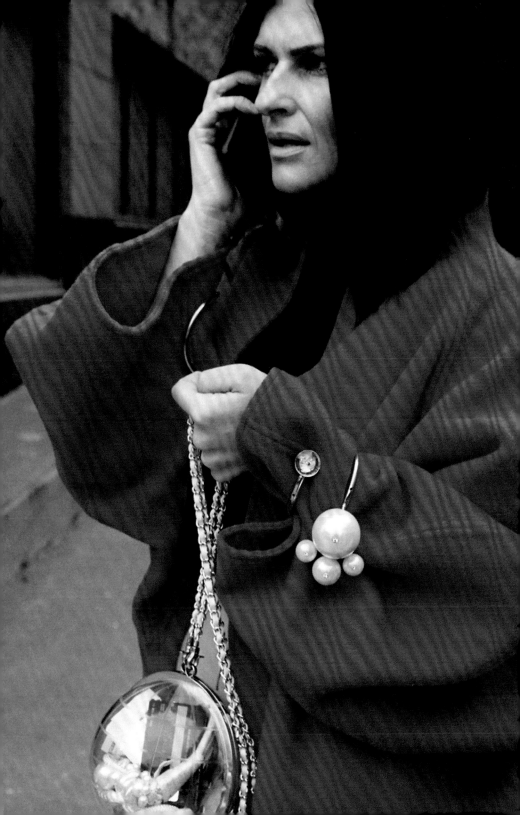

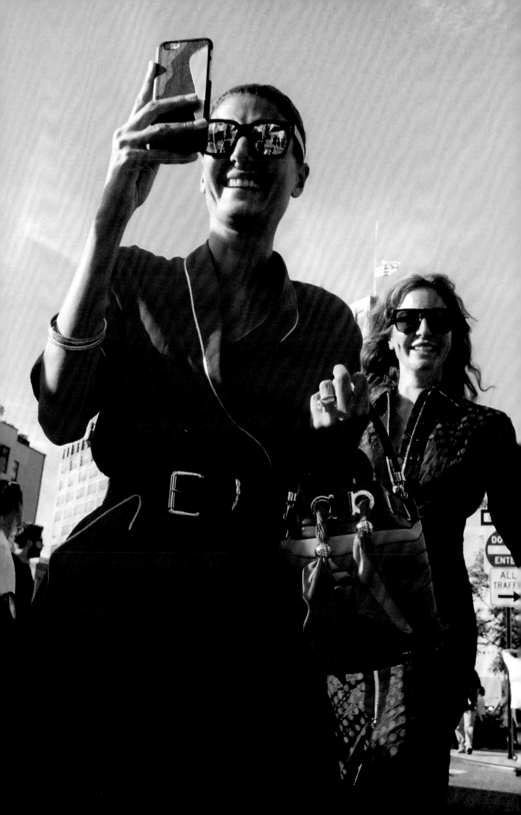

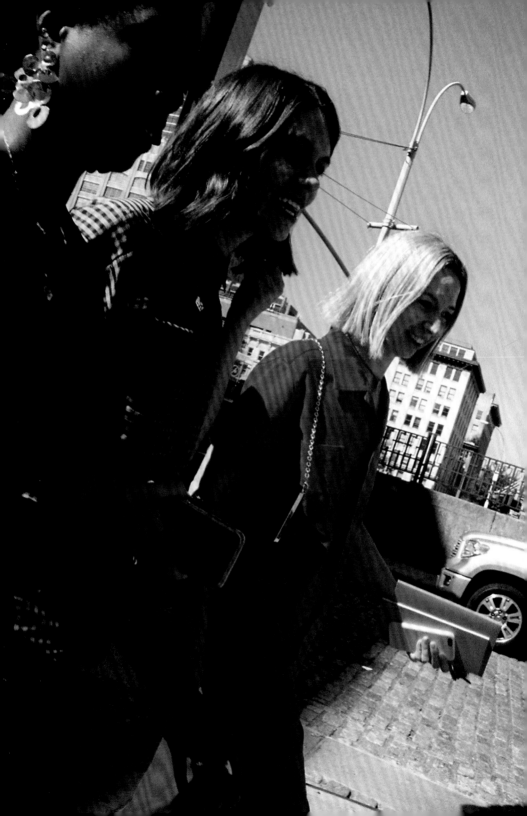

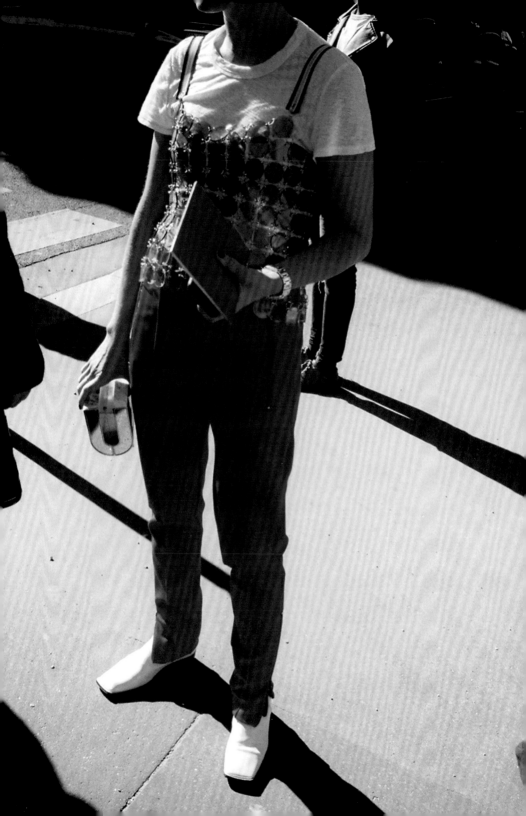

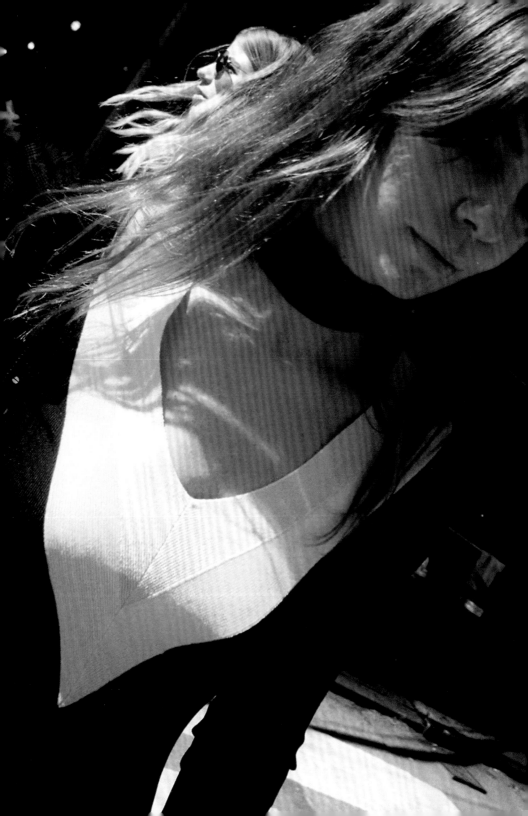

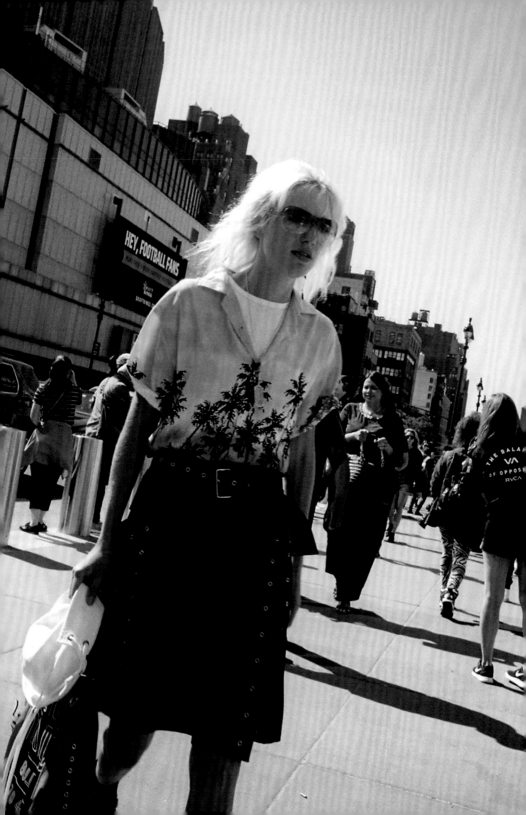

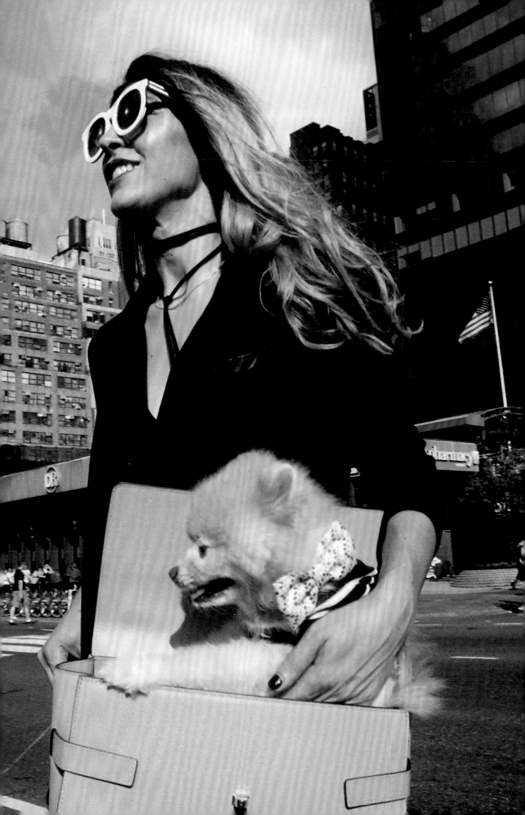

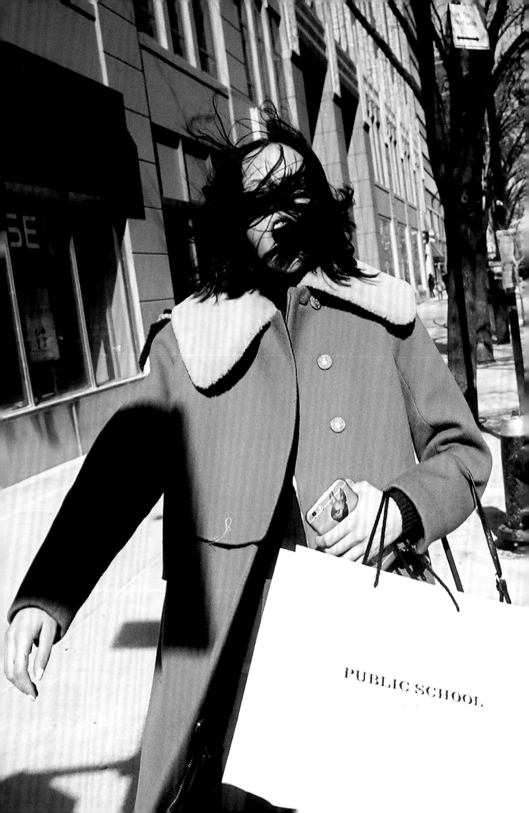

PUBLIC SCHOOL

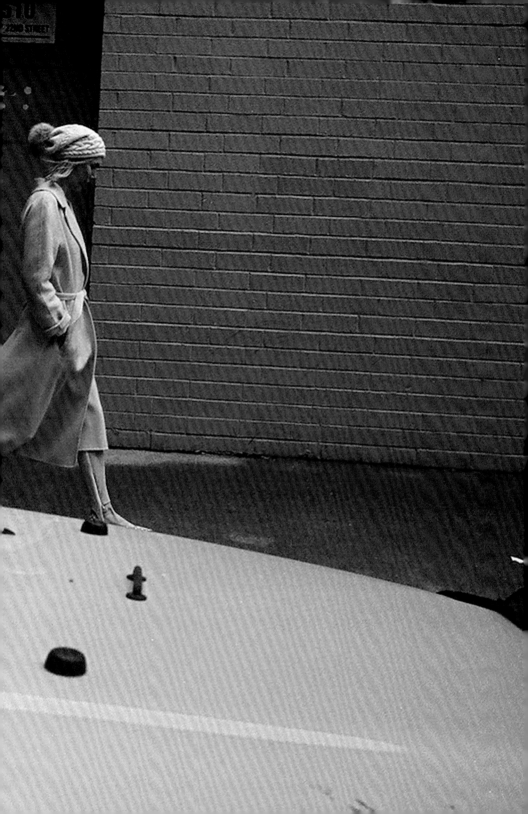

#pose
#jeans
#easy_look
#comfort
#after_rain
#mood
#pink
#vintage
#woman_at_park
#london_street
#comfort_pants
#heavy_rain
#yellow_cigarette
#eiffel_tower
#tucked_in_hair
#tie
#oversized_shirts
#clean
#woman_and_poster
#pajama
#paris_cafe

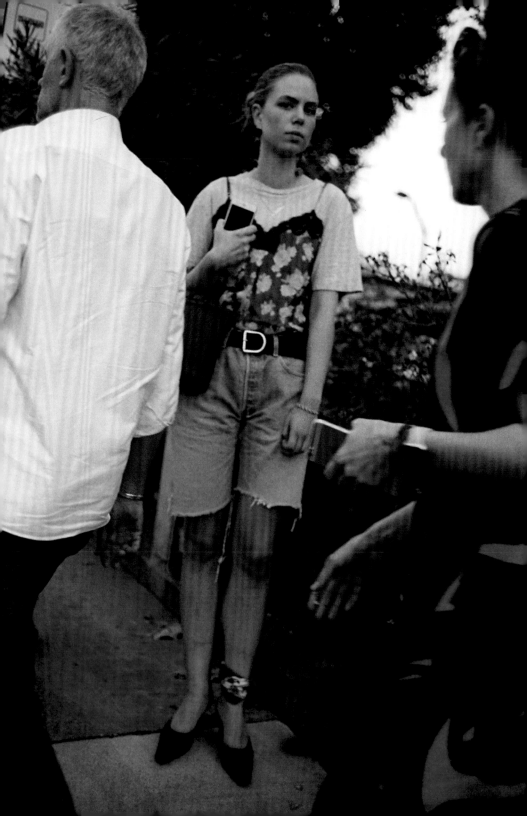

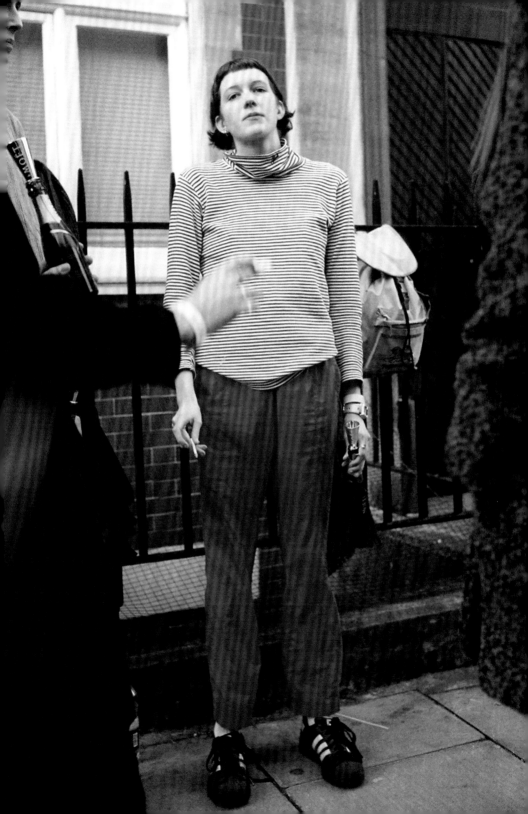

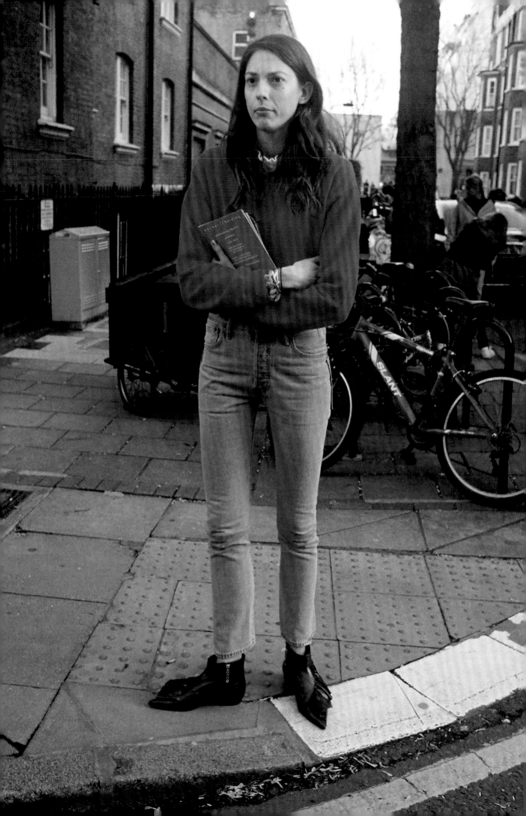

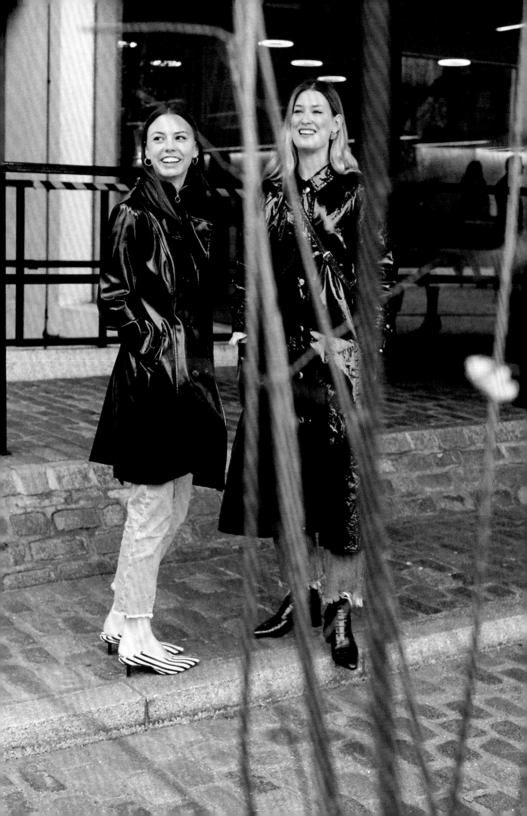

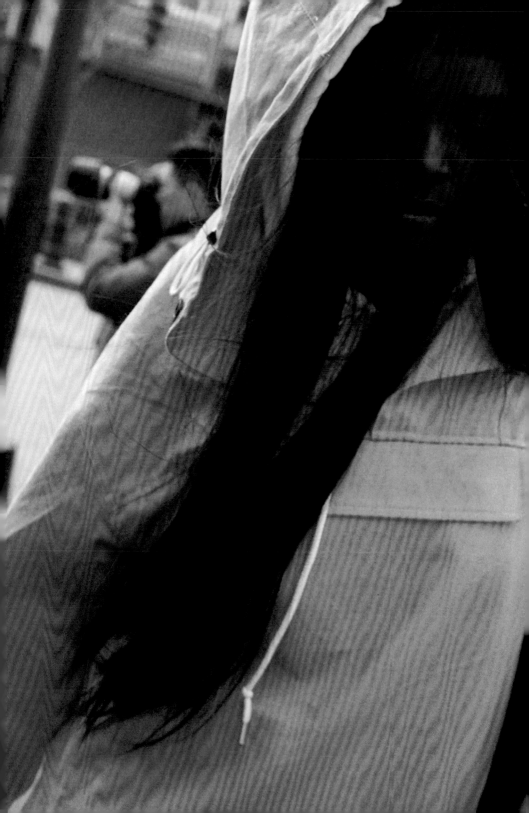

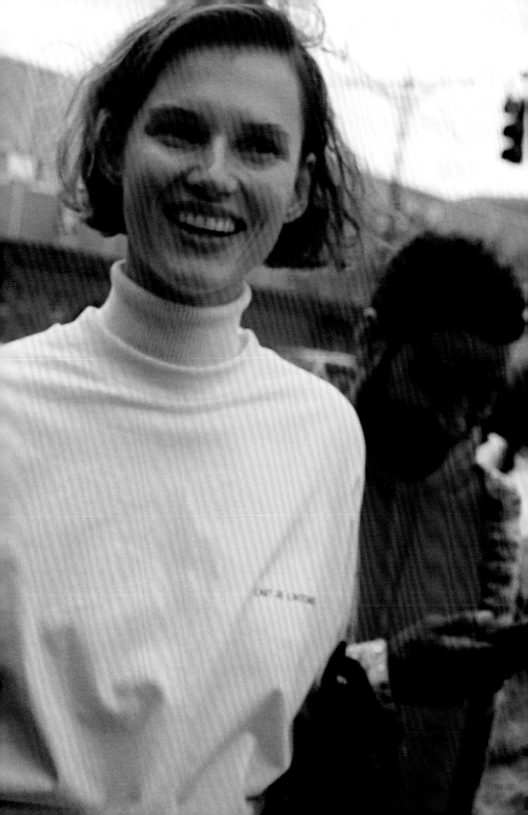

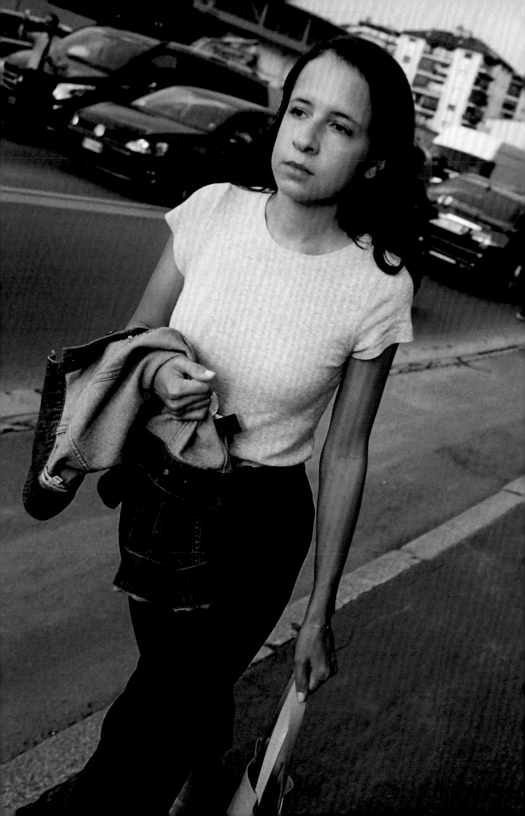

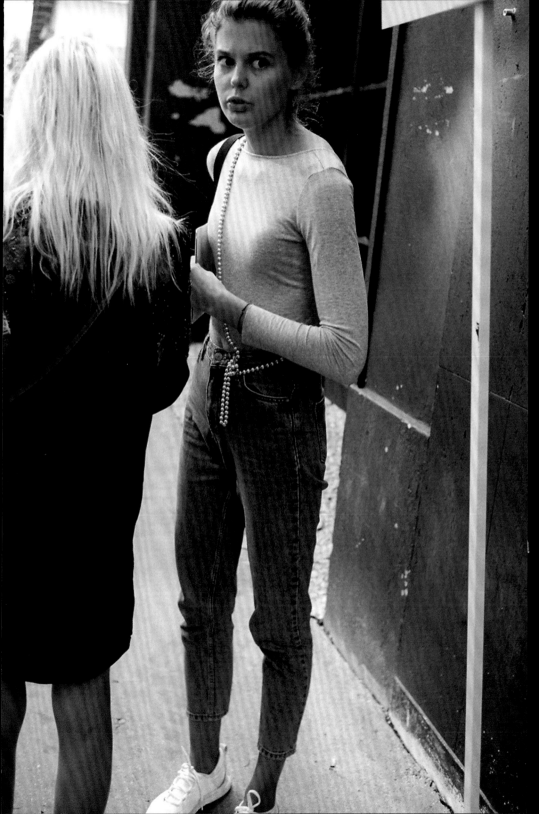

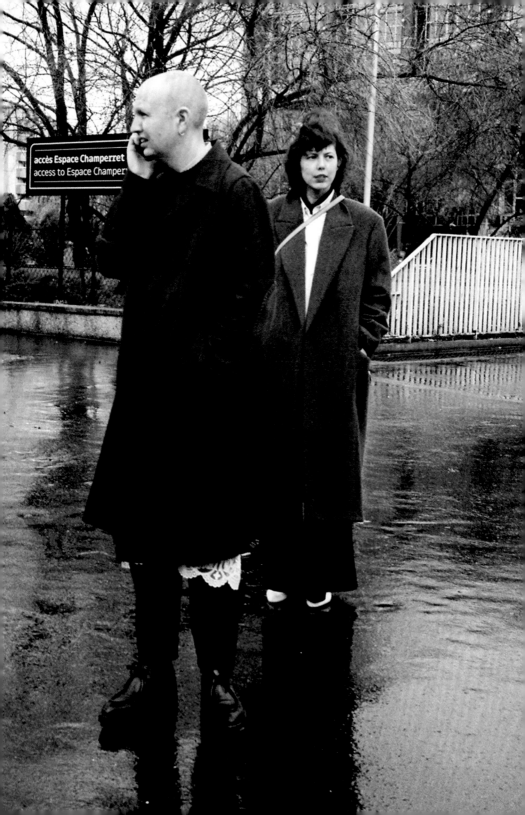

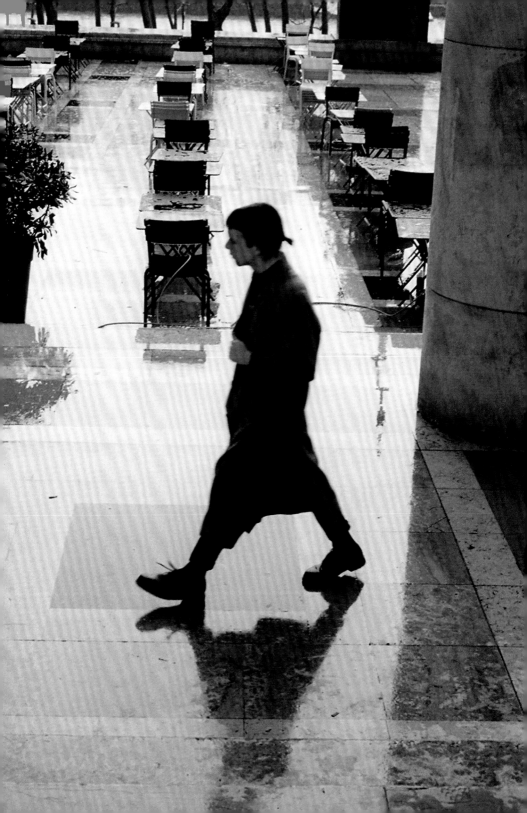

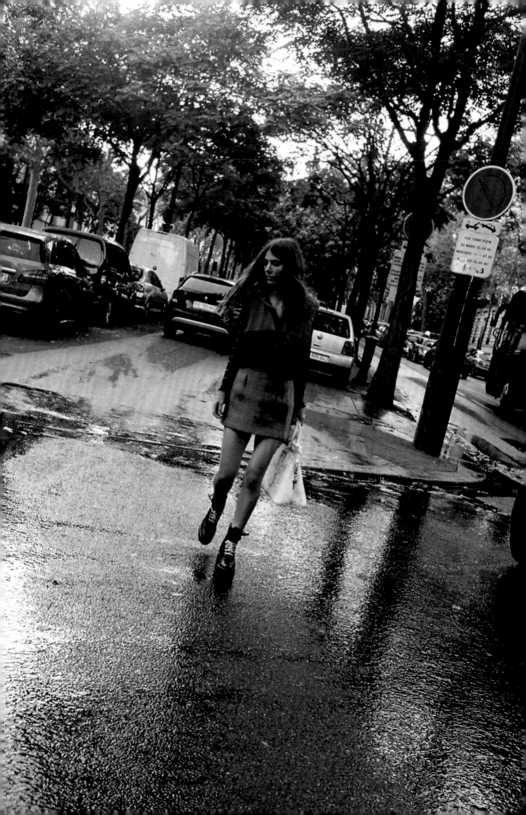

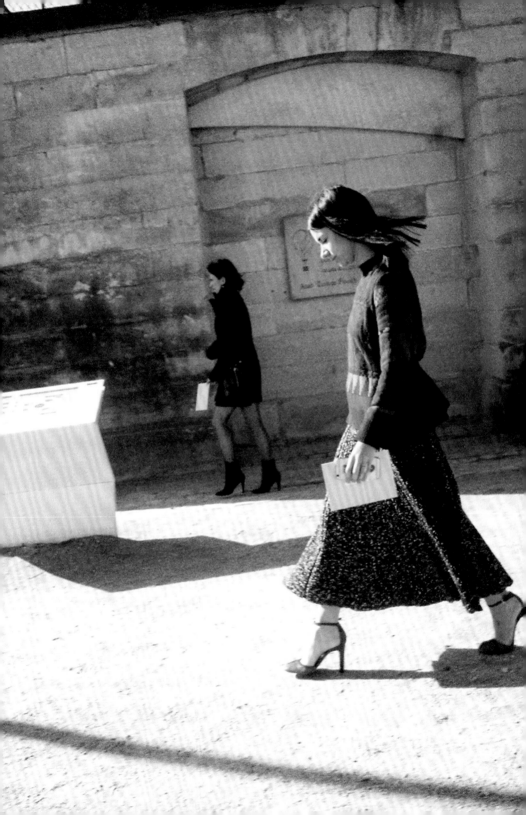

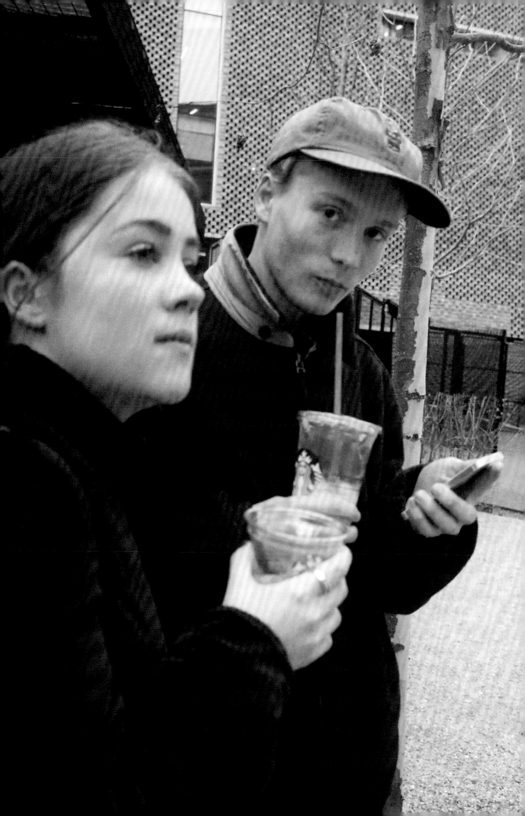

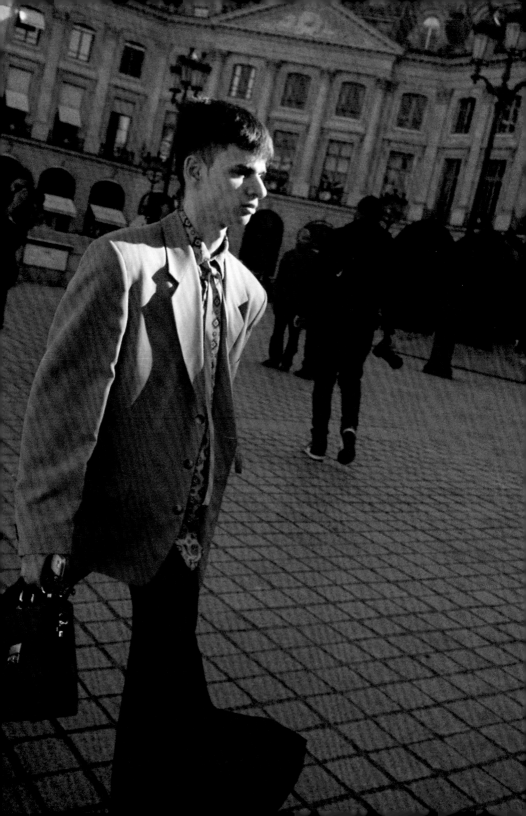

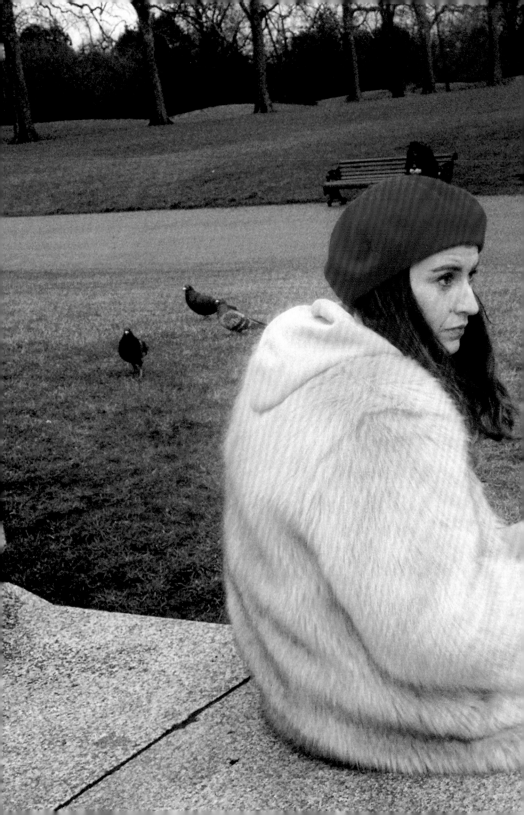

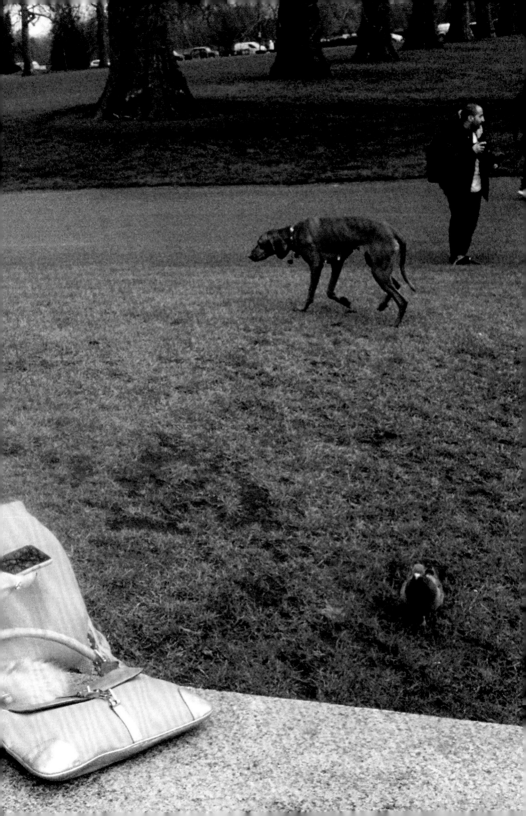

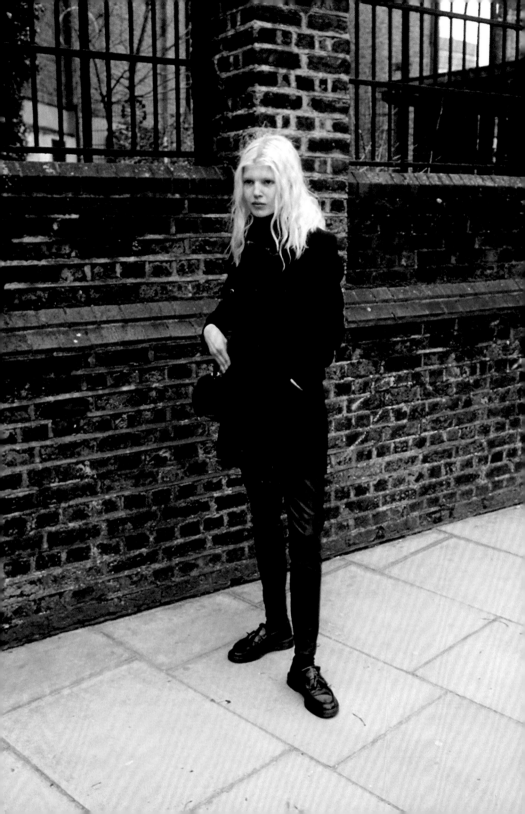

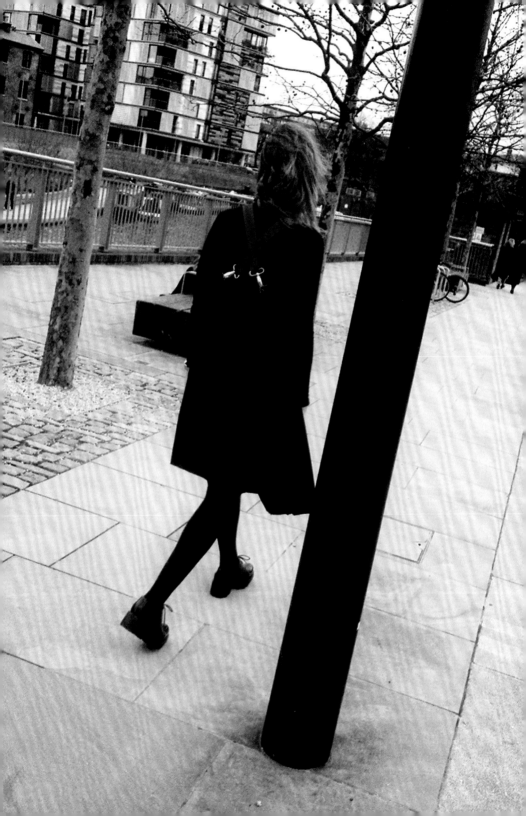

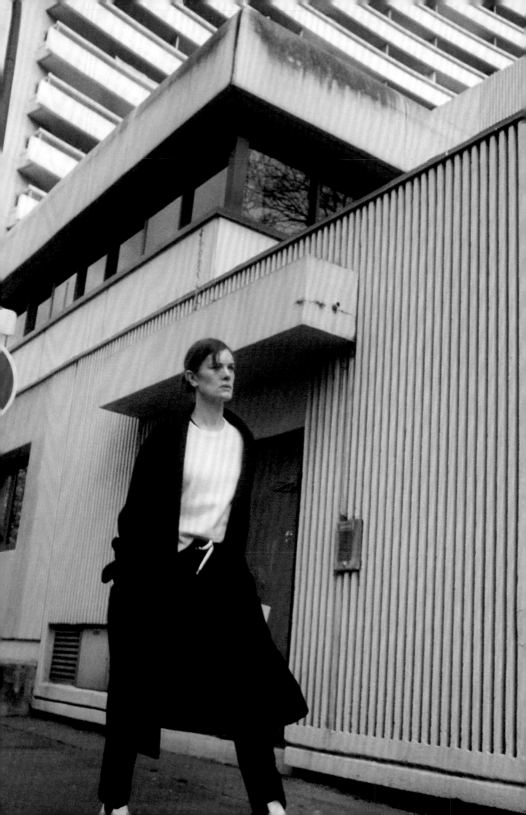

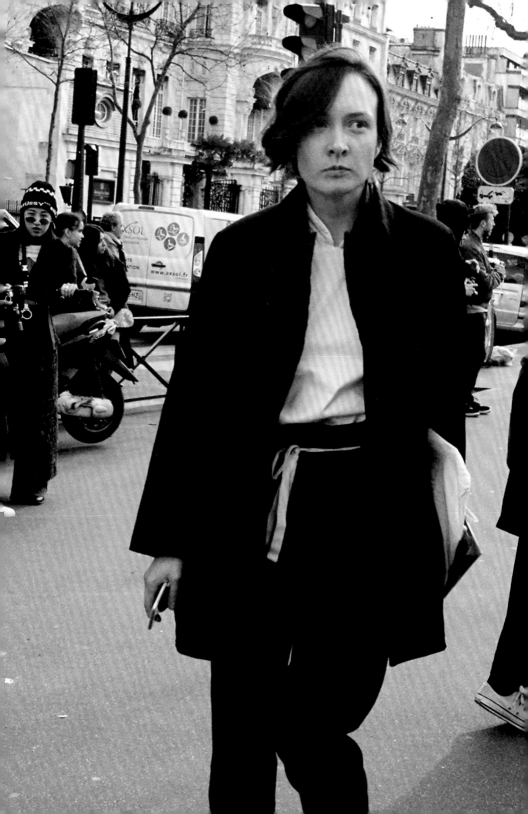

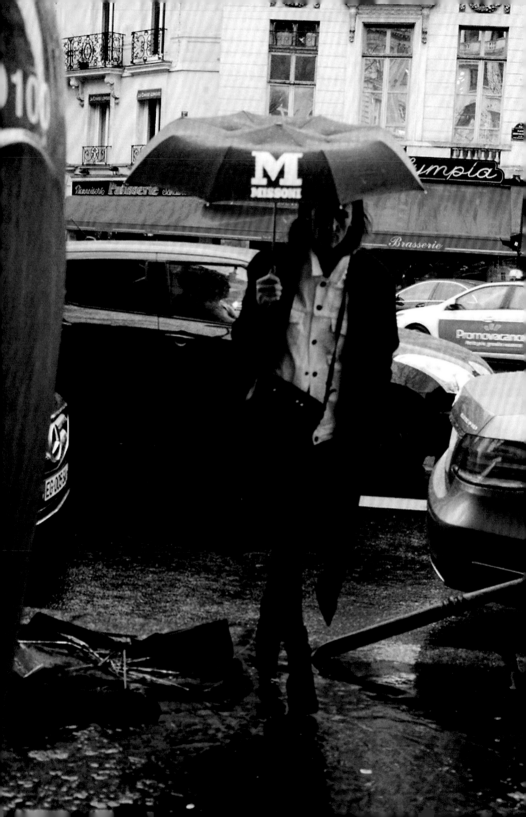

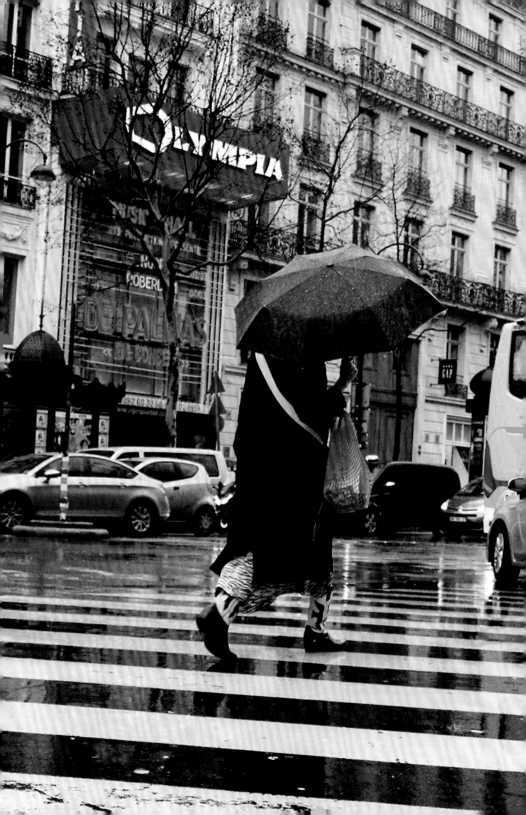

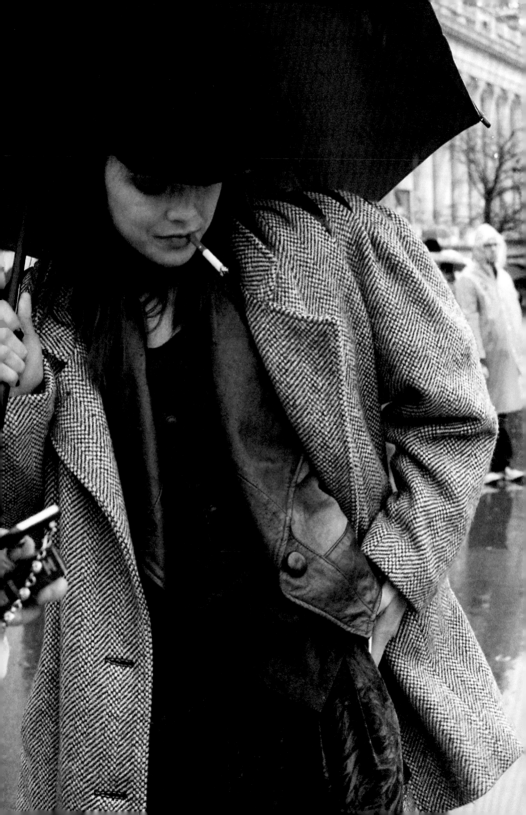

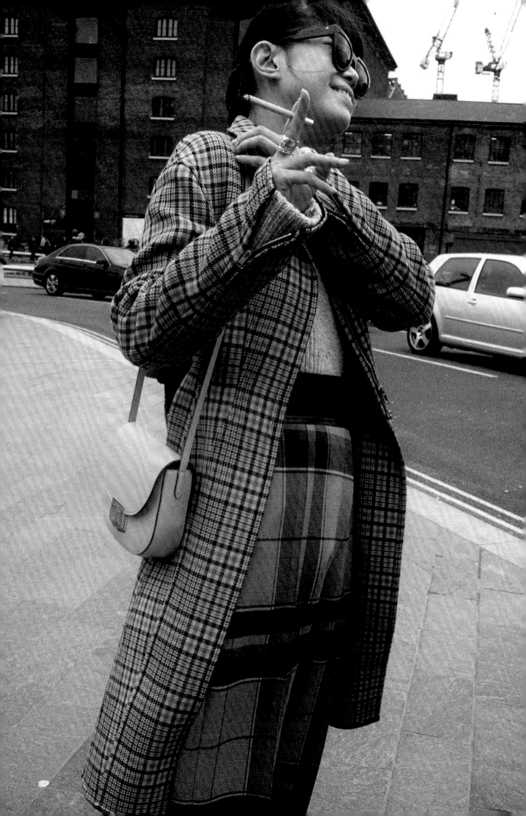

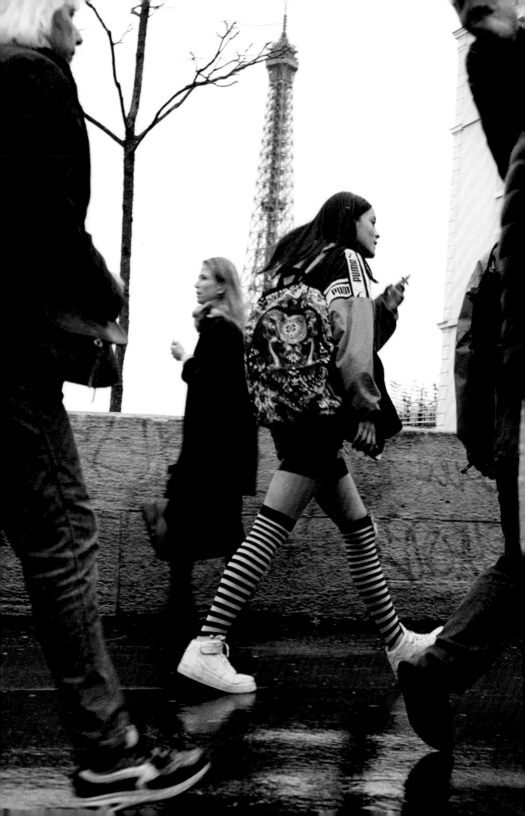

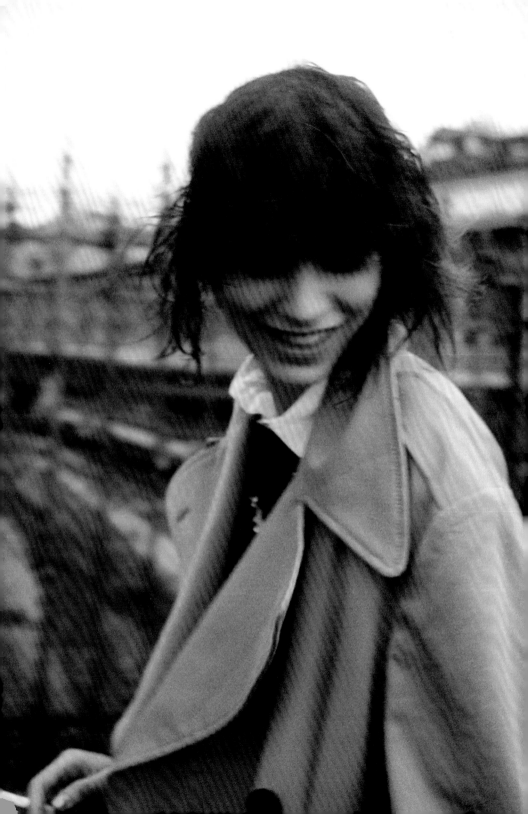

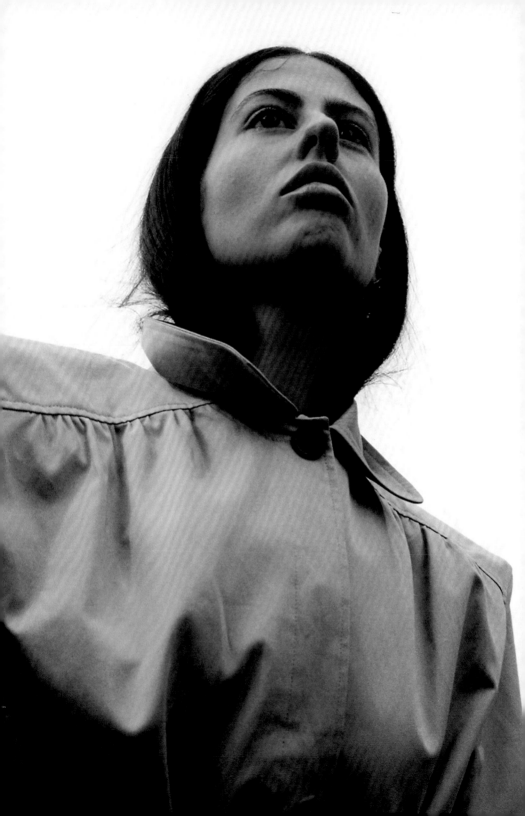

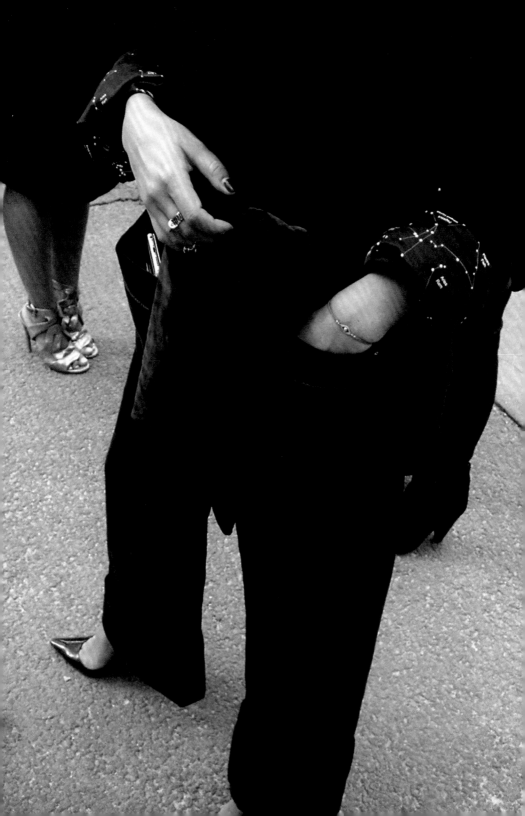

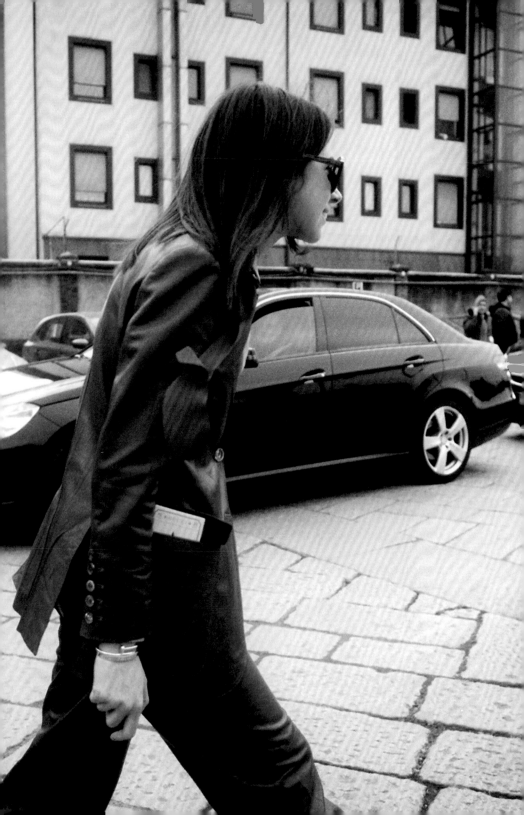

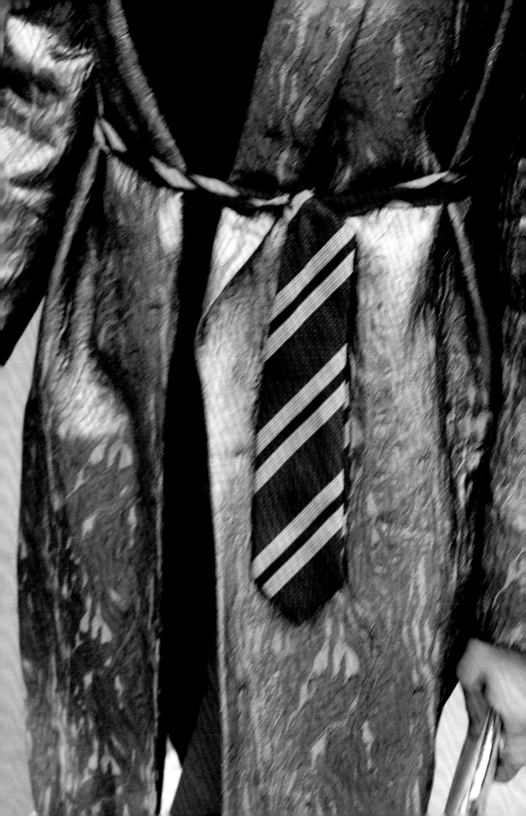

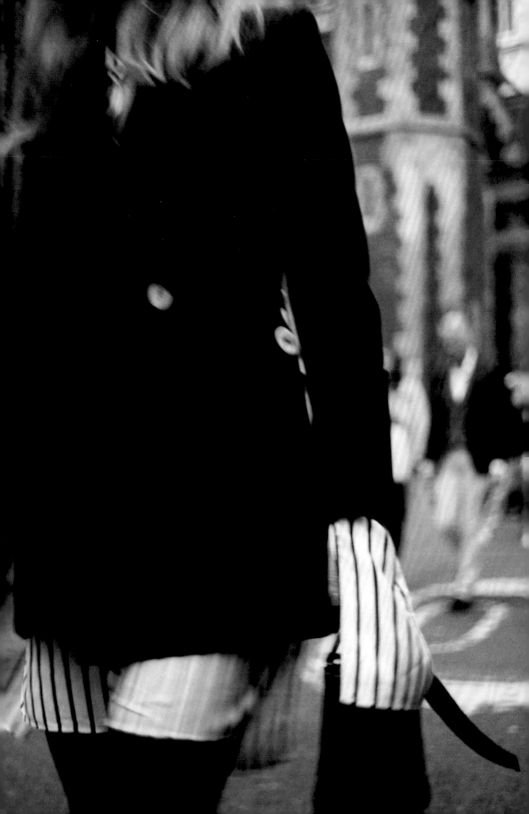

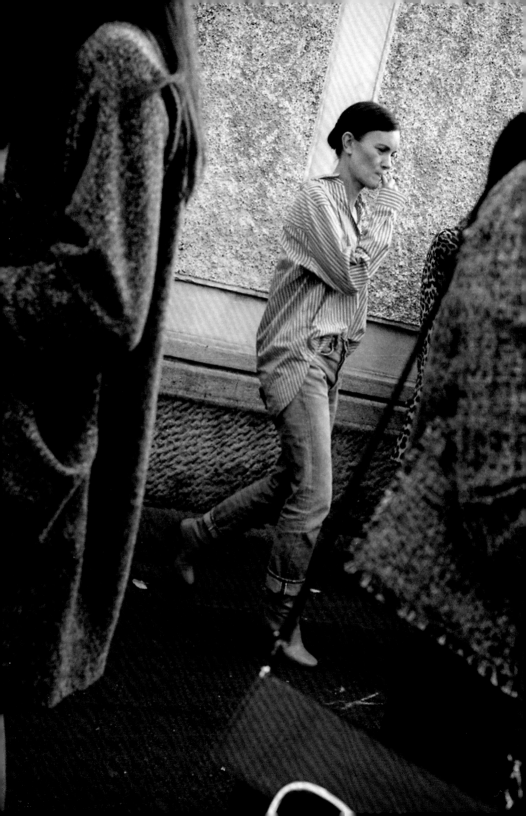

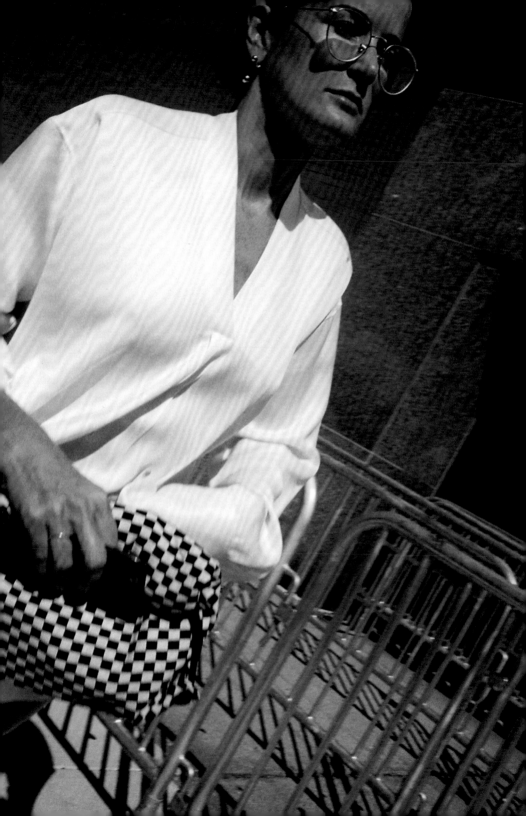

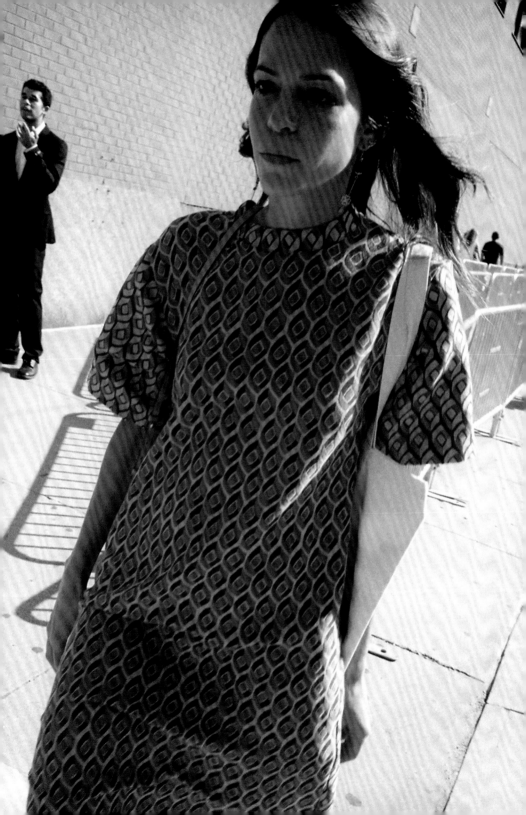

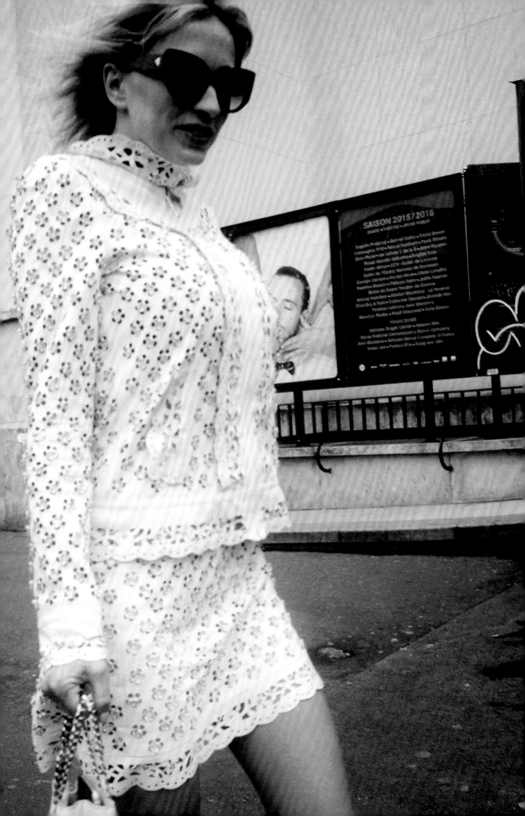

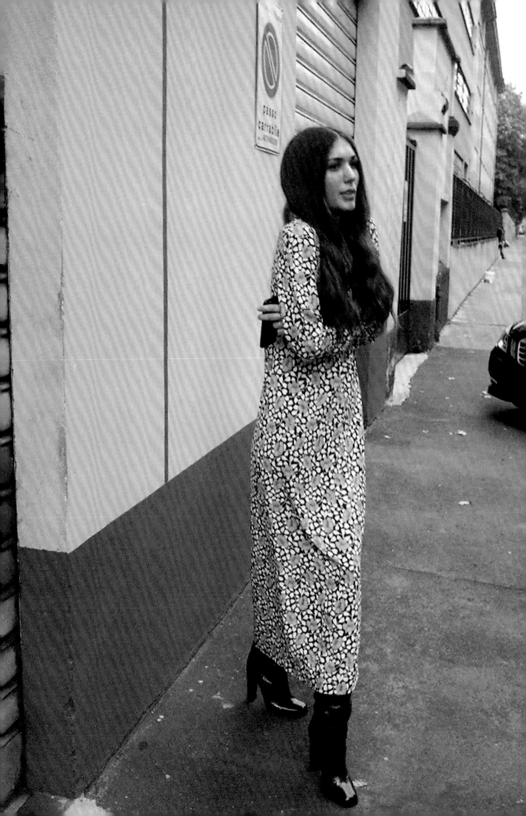

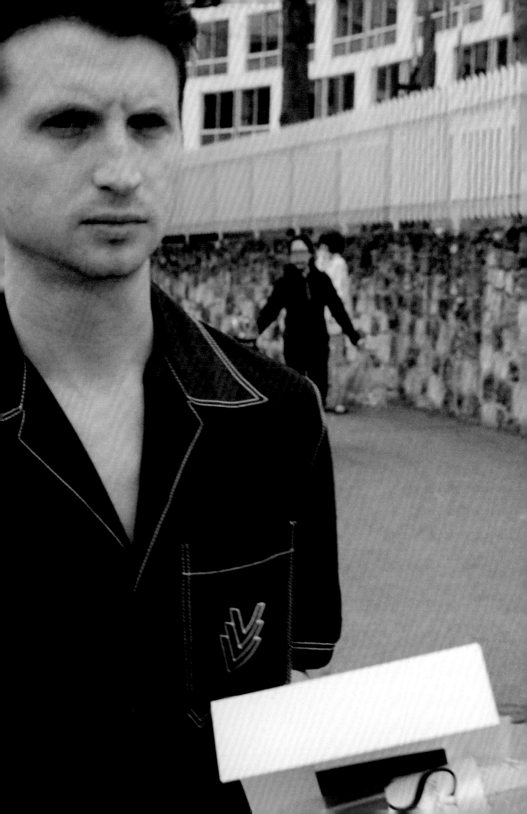

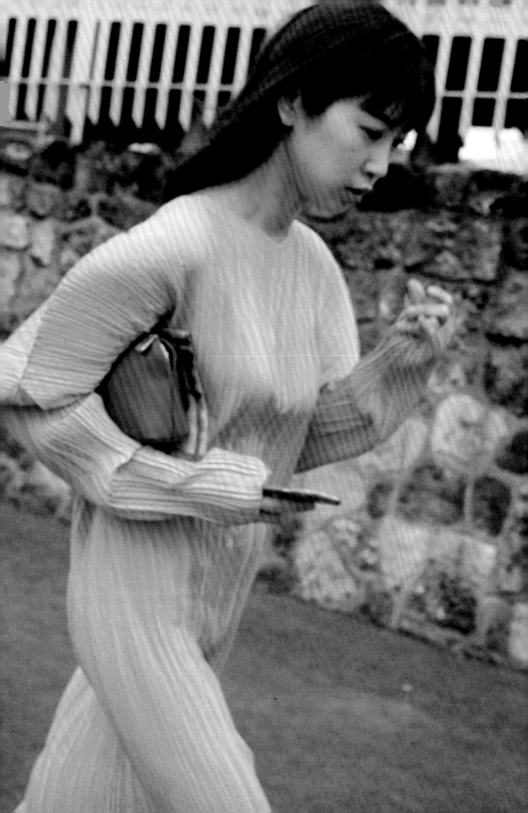

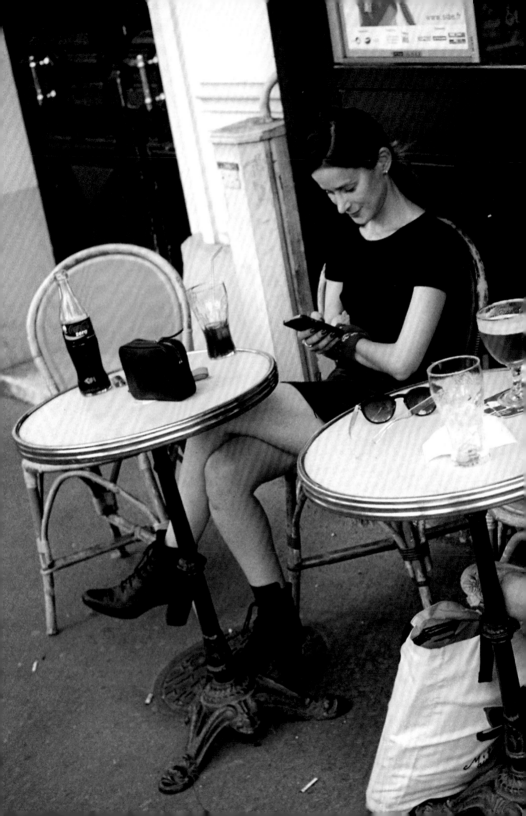

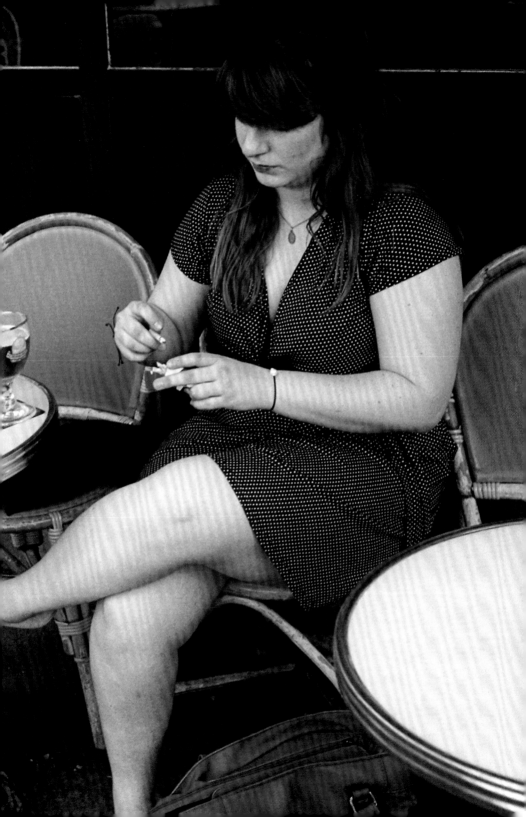

#simple
#silk_leopard
#portrait_card
#summer_detail
#shoulder_off
#red_nails
#2LATEs
#gucci_street
#blue hair
#A$AP_rocky
#small_detail
#interesting_sock
#red_net_stocking
#autumm
#waiting_uber
#gesture
#accs_trend
#legs
#in_the_bus
#wondering_eyes
#curly_hair

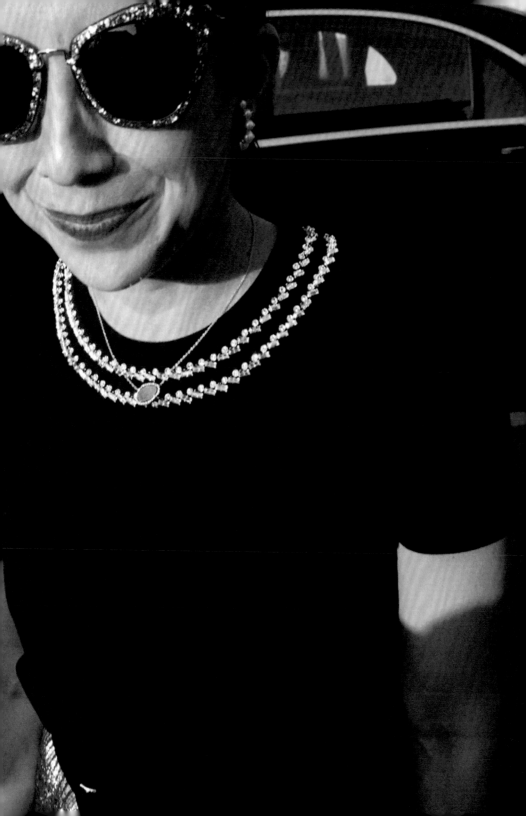

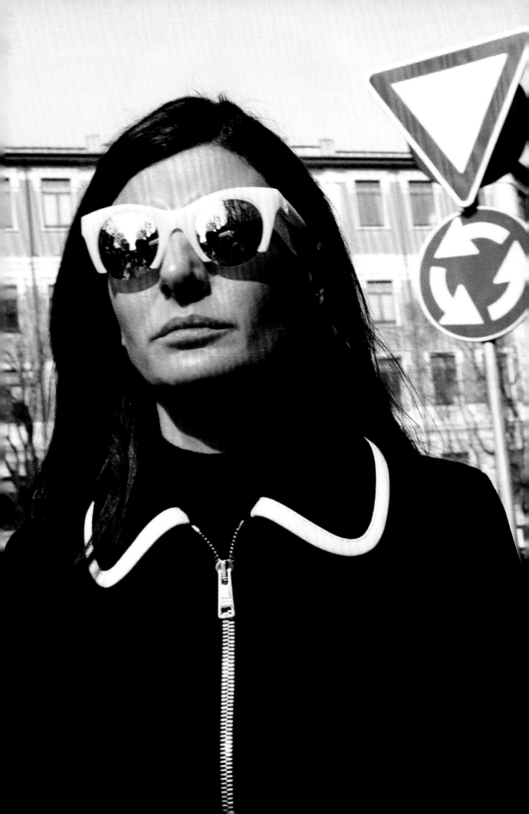

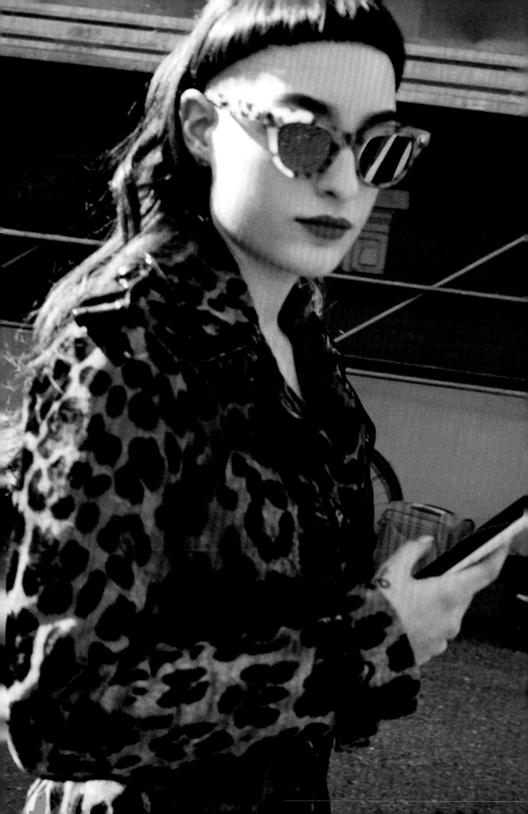

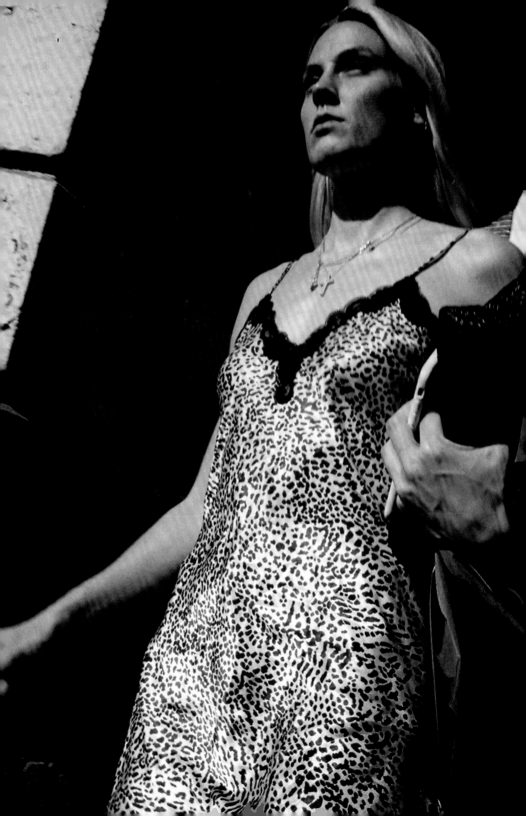

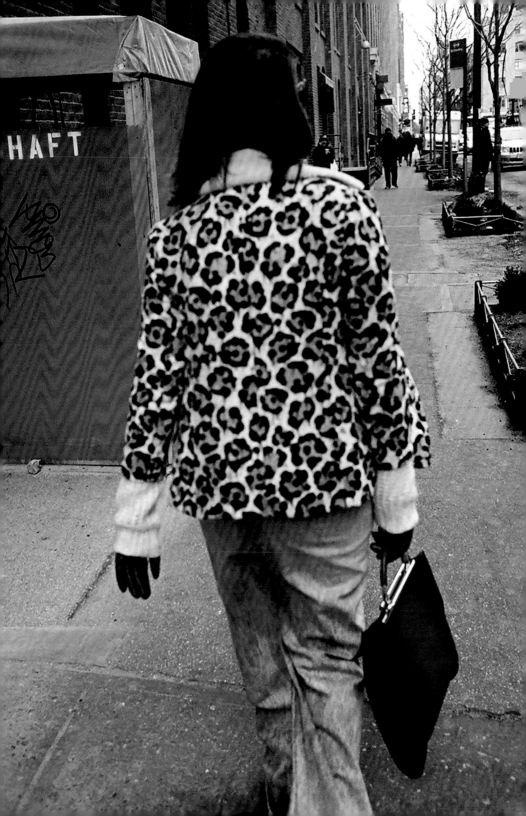

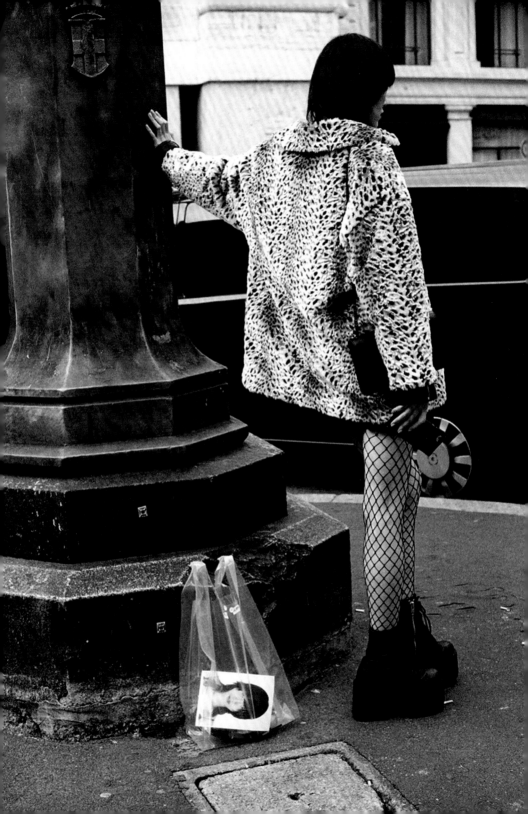

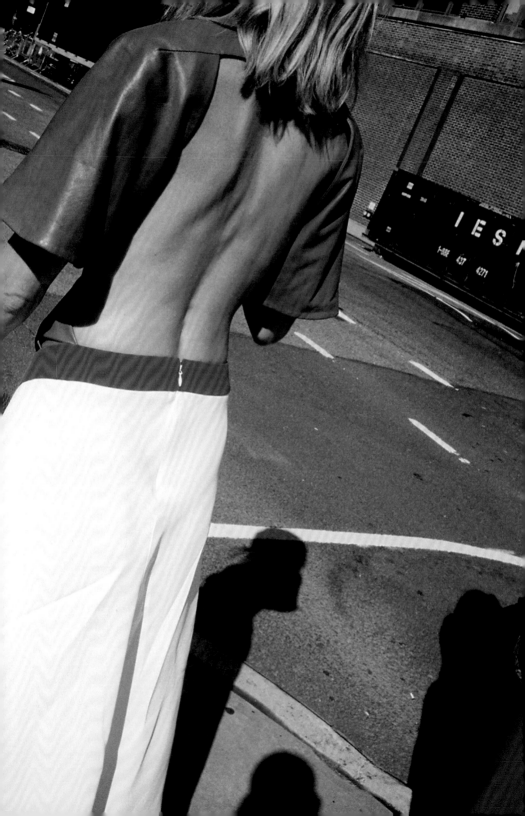

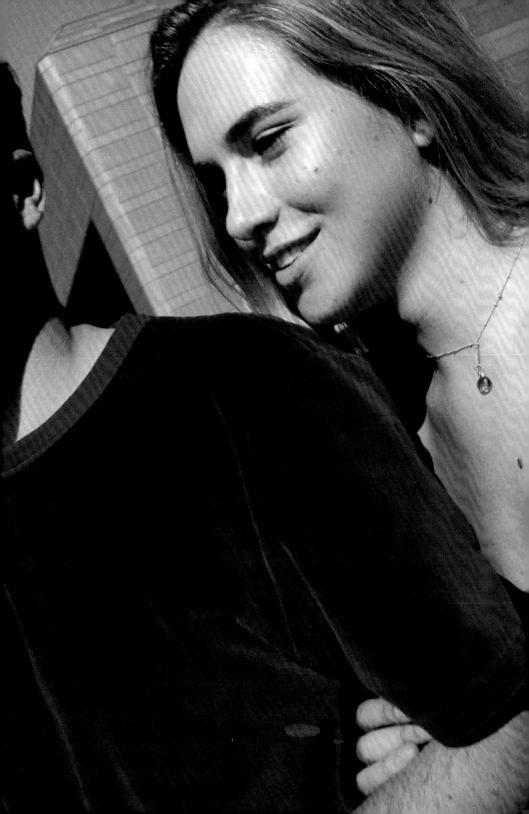

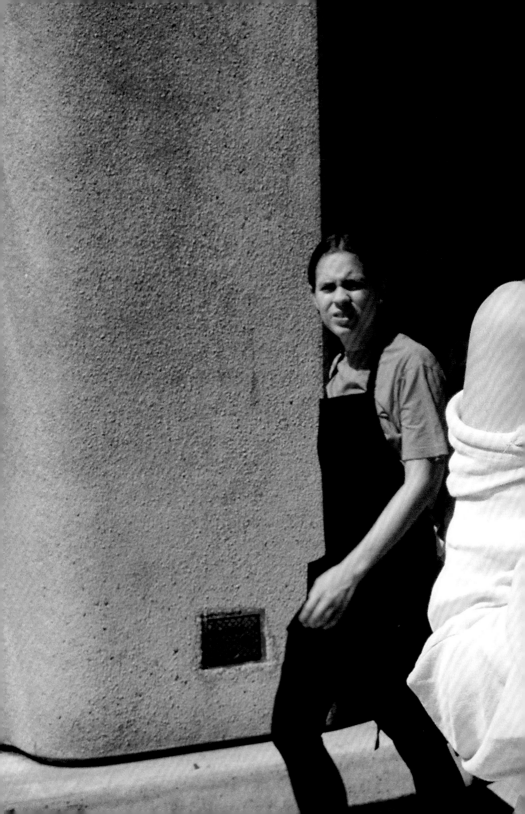

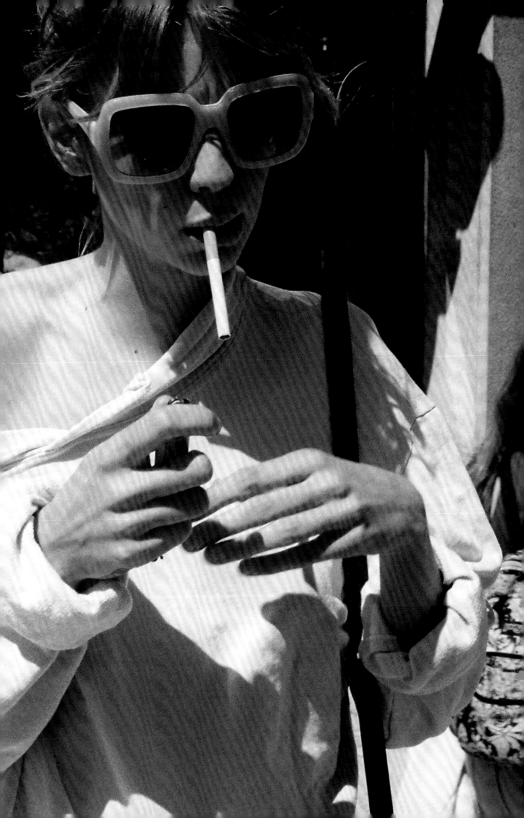

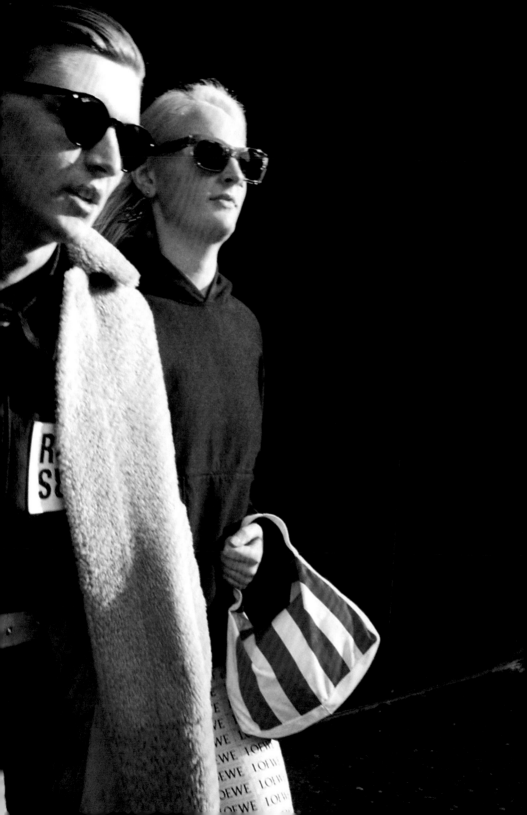

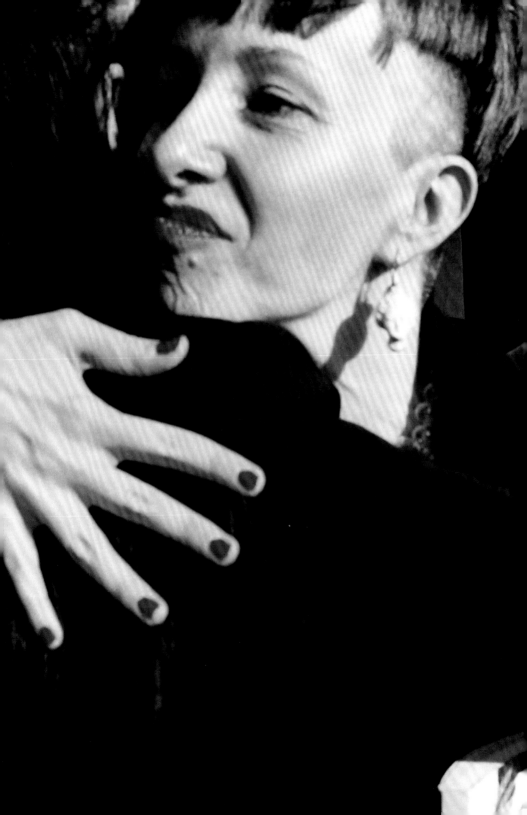

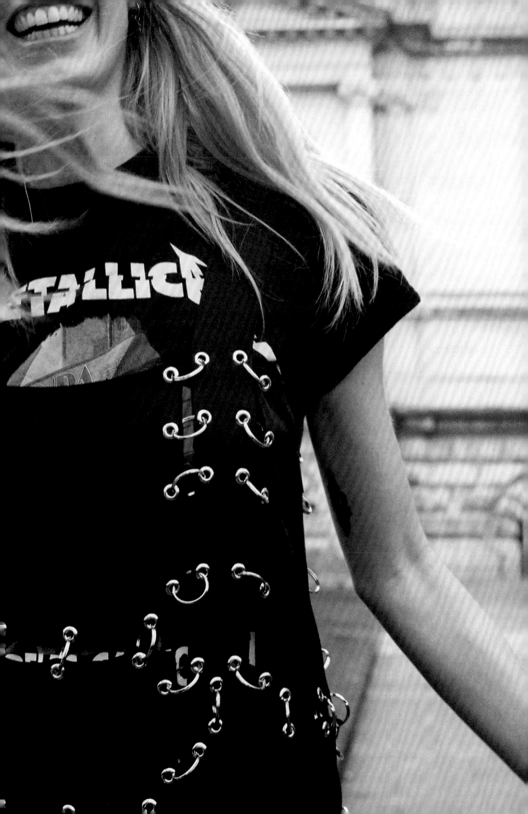

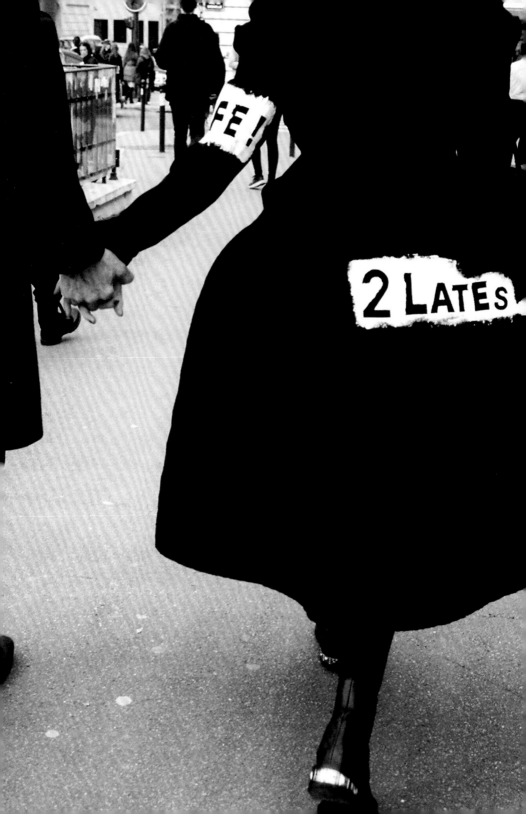

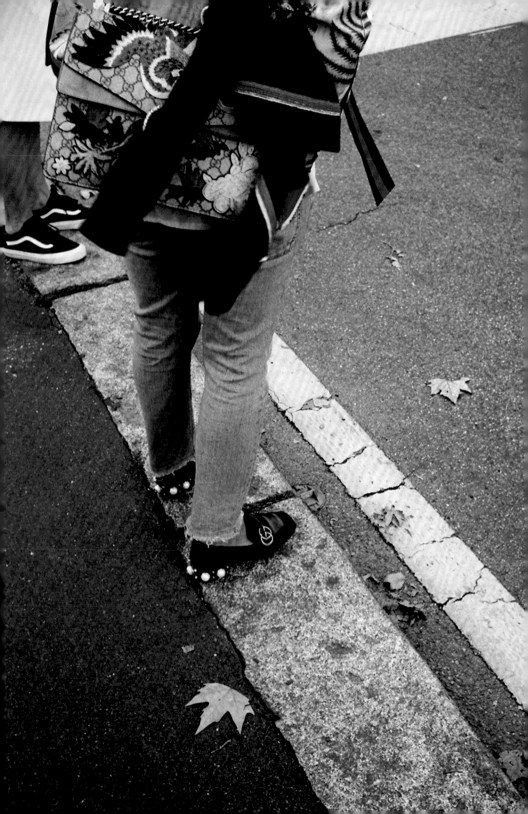

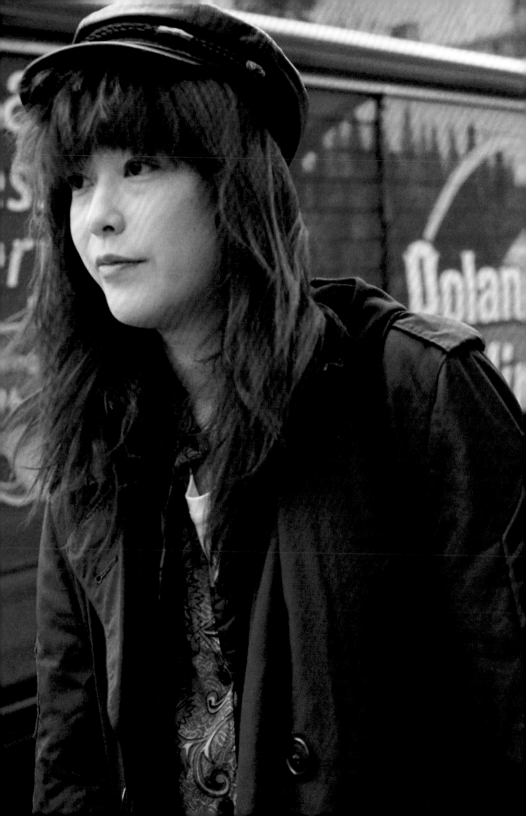

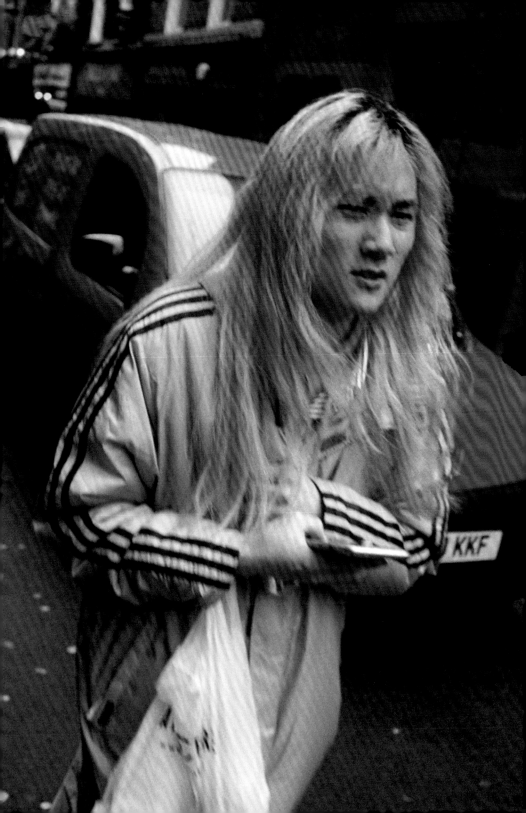

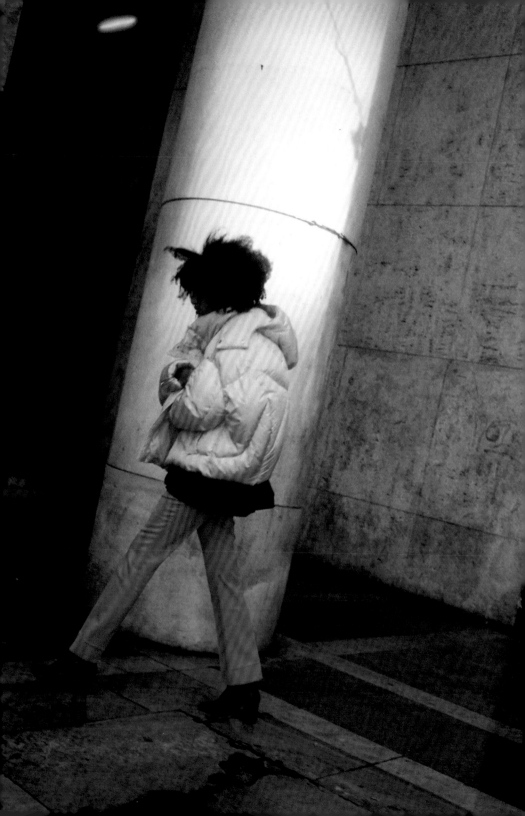

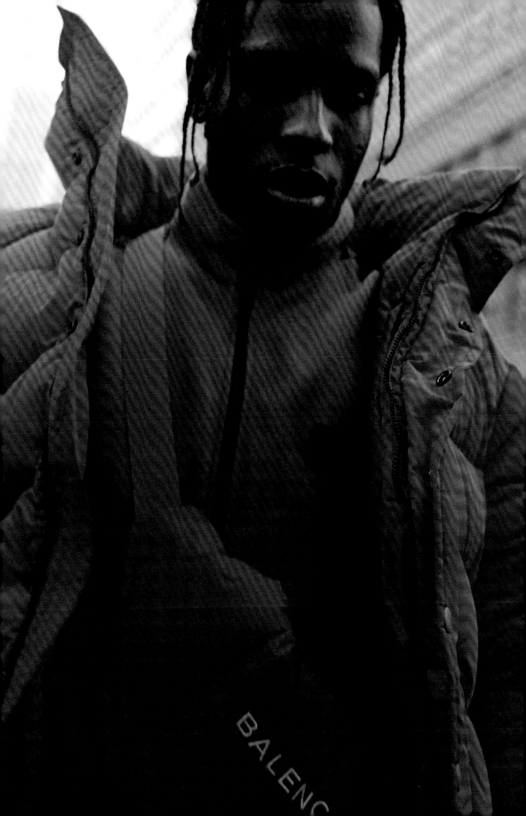

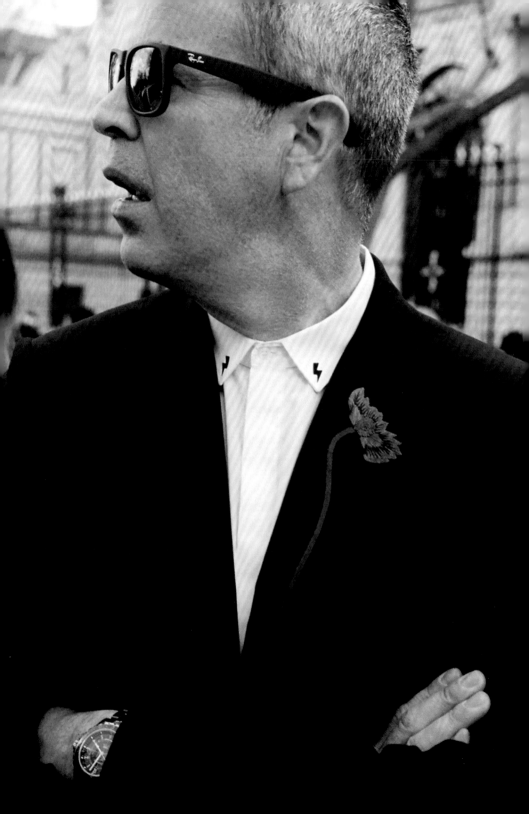

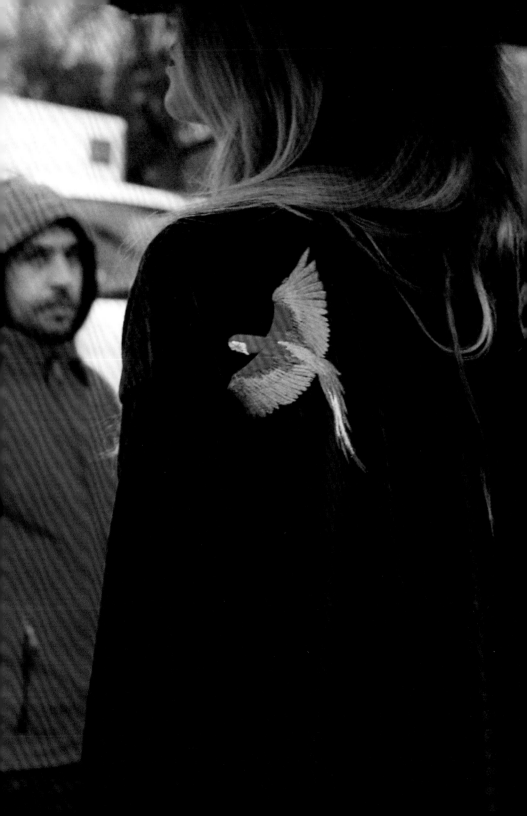

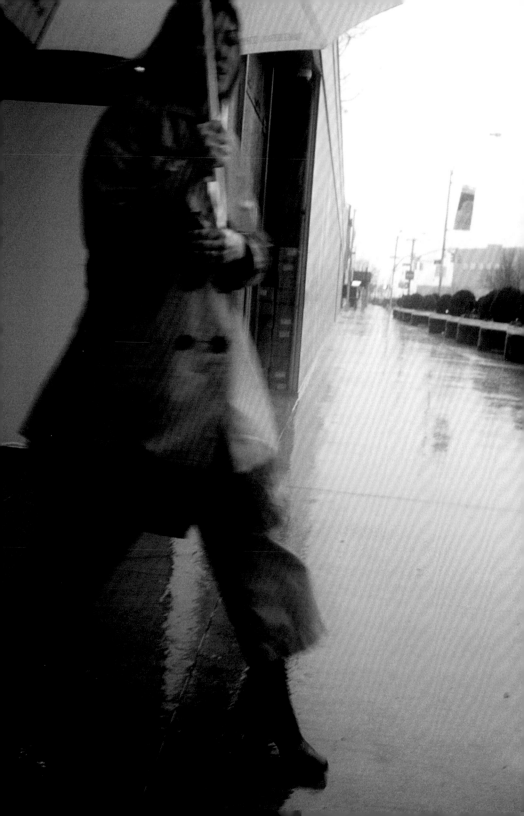

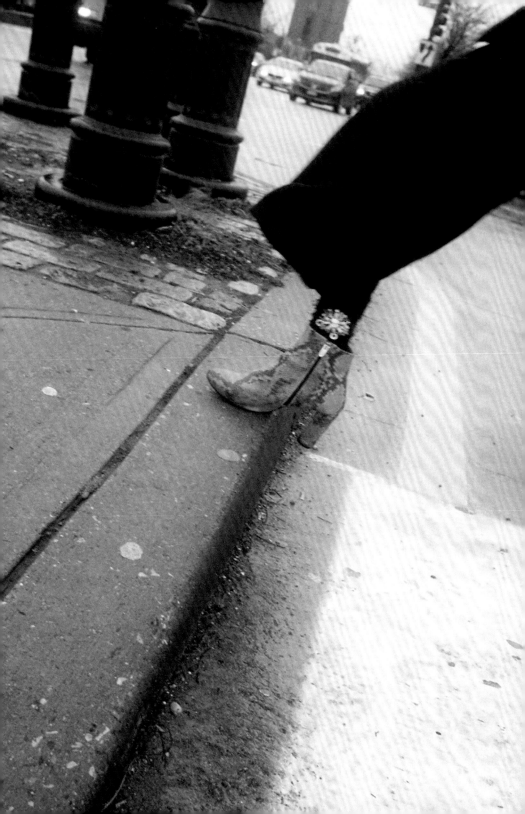

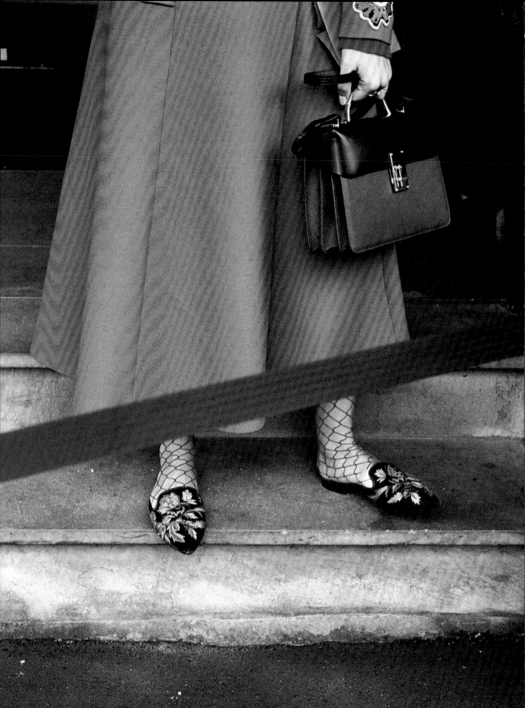

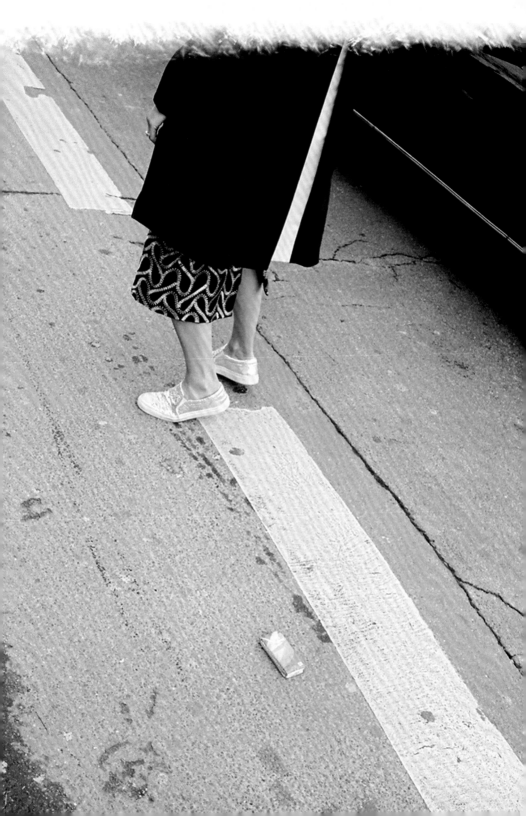

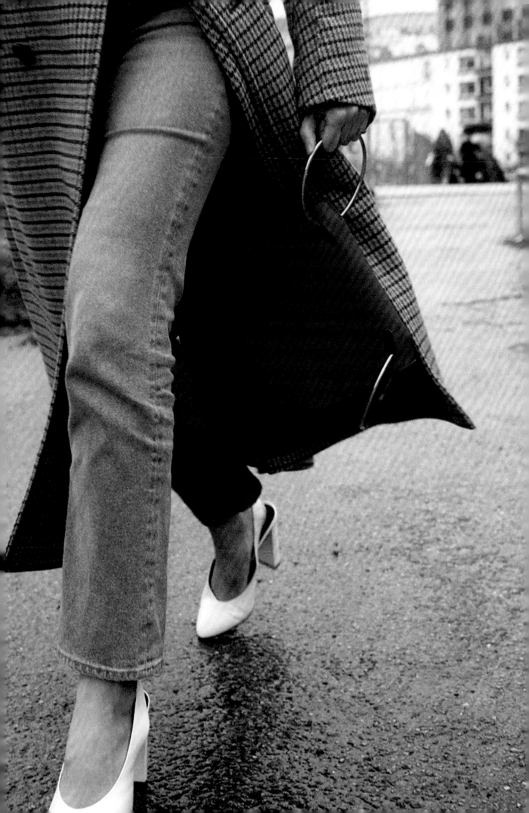

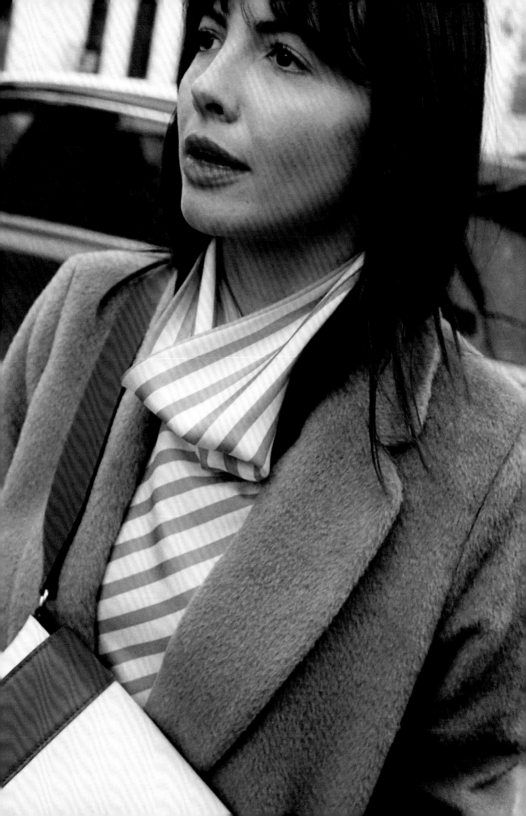

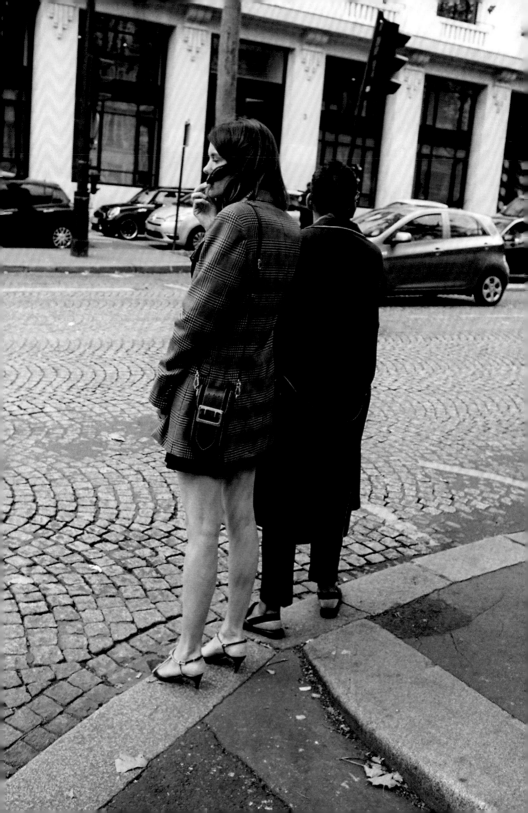

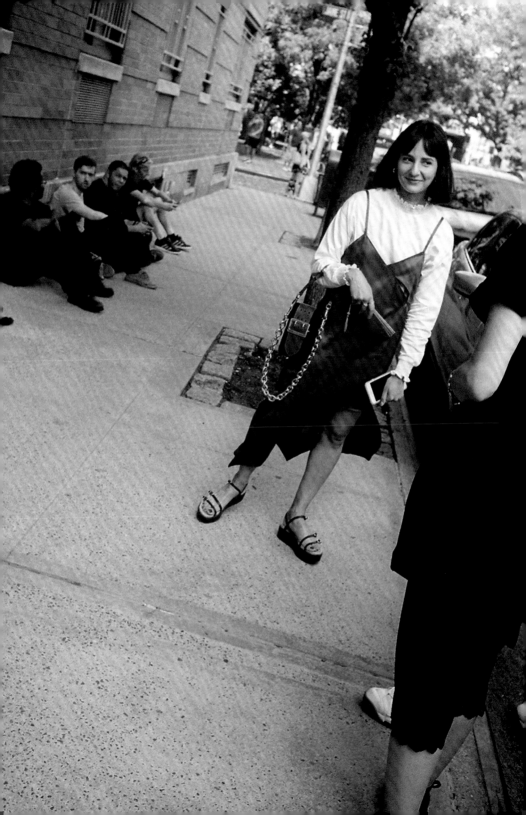

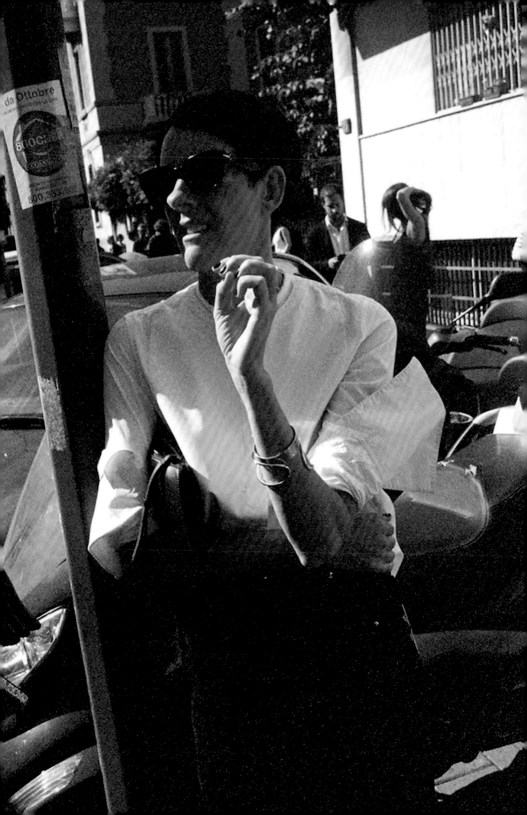

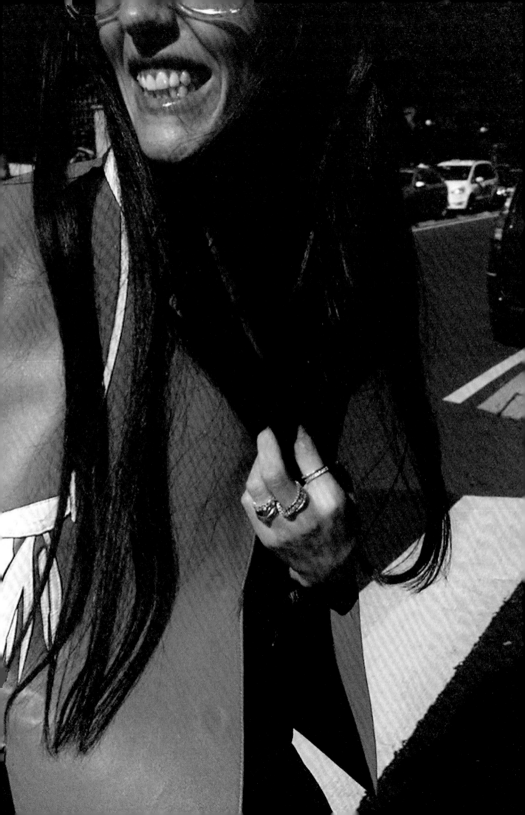

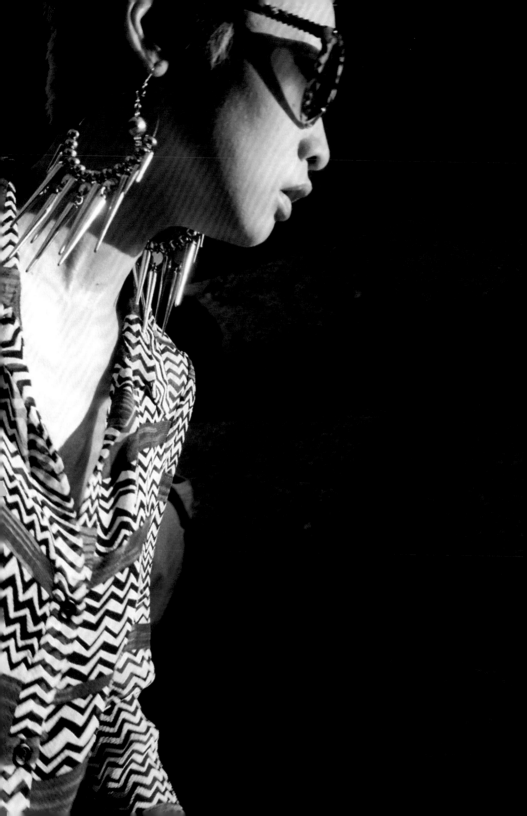

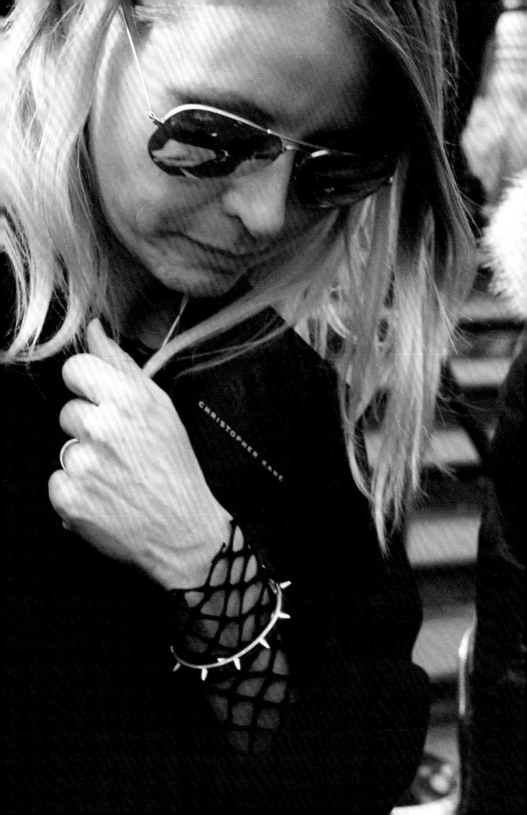

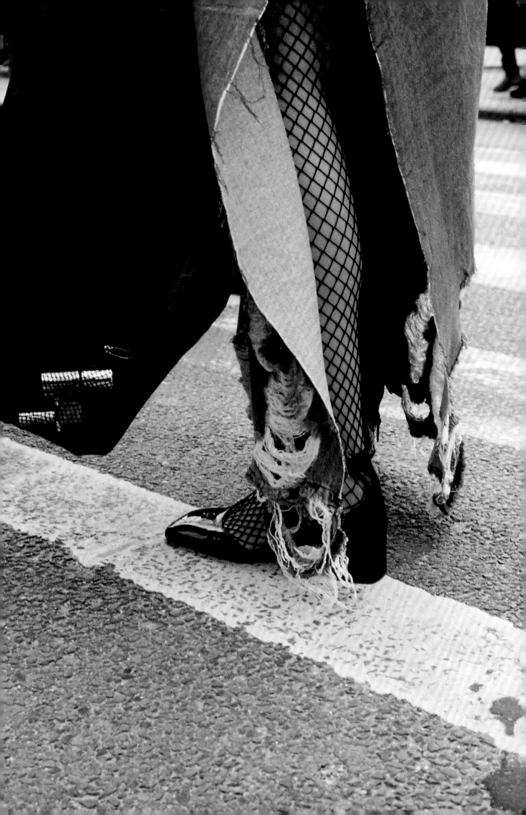

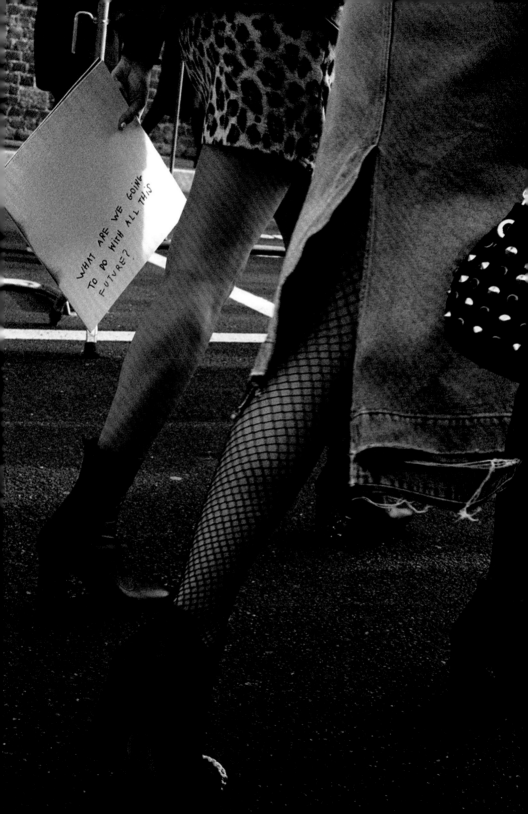

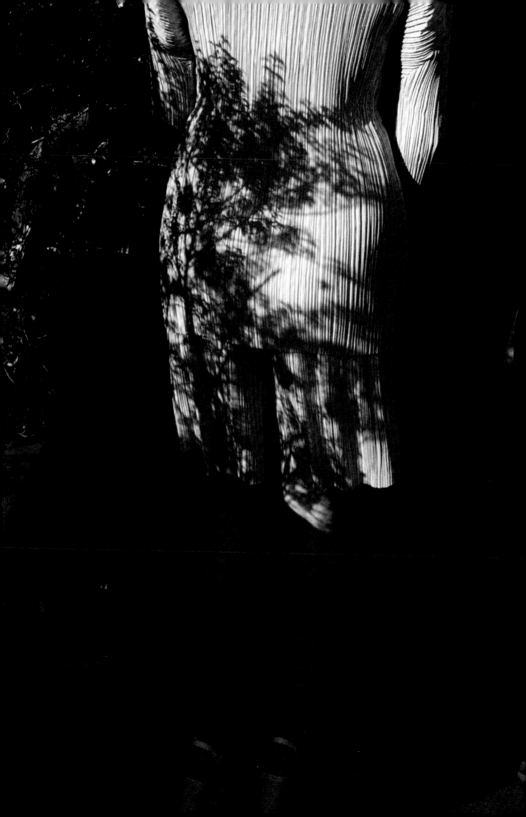

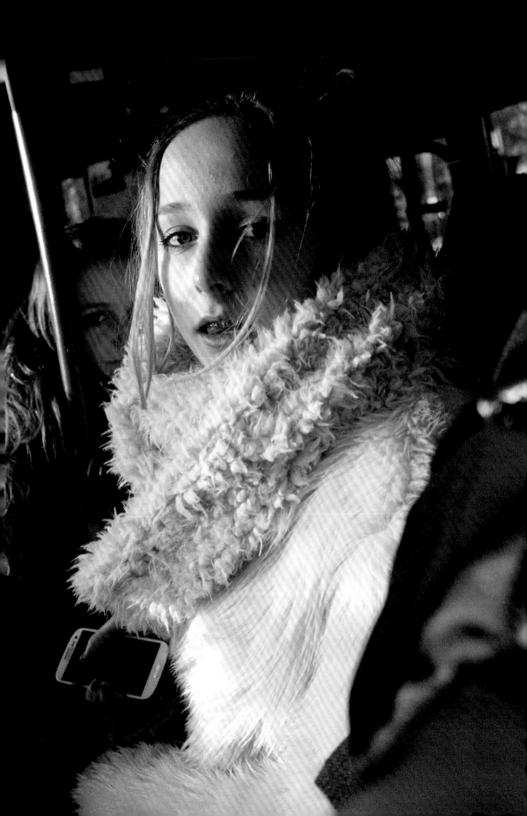

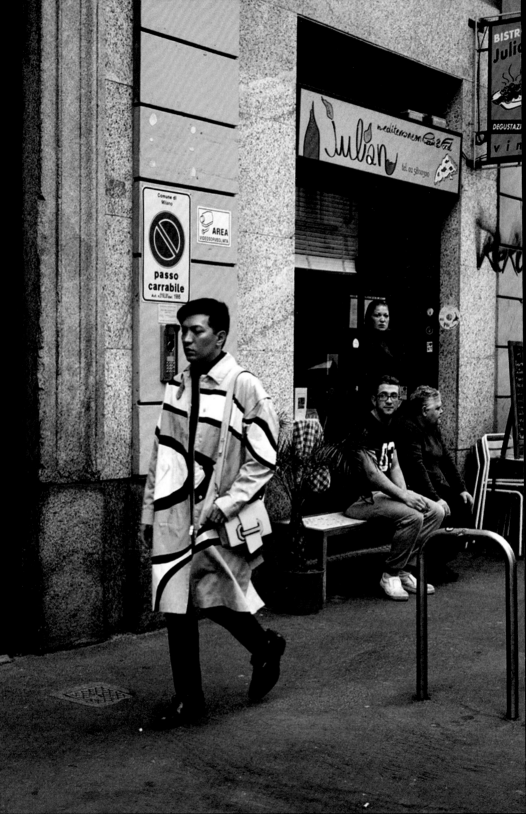

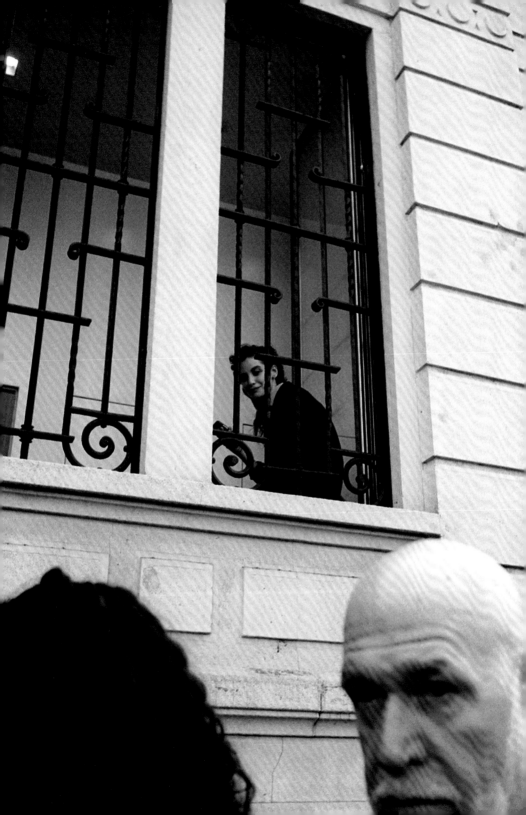

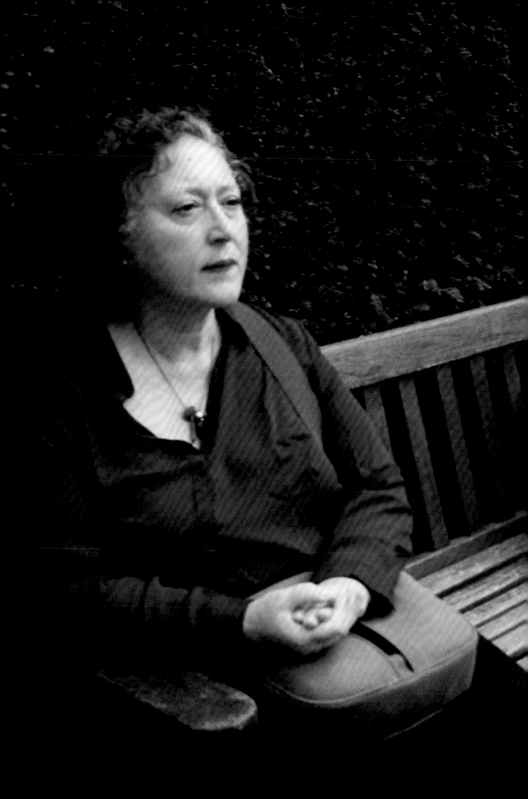

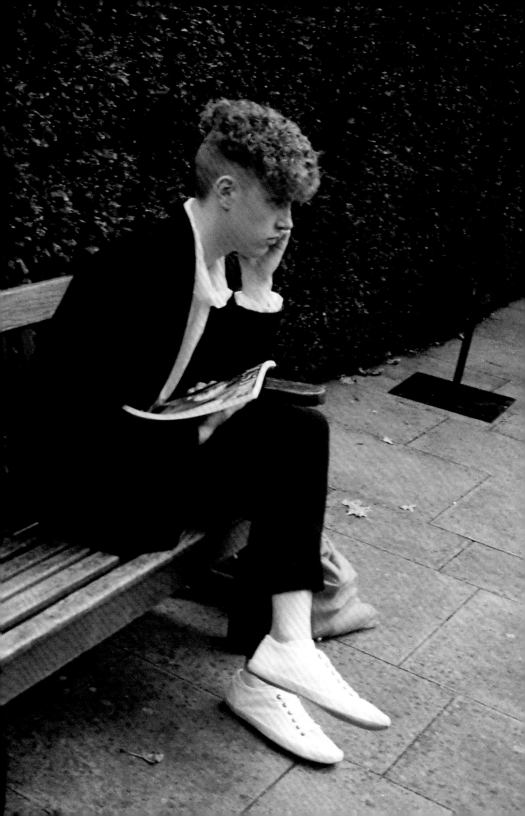

#pink_suit
#white_and_black
#editor_in_paris
#office_look
#google_cap
#long_trench_coat
#london_attitude
#481_4th_avenue
#woman_power
#french_chic
#rain_coat
#cocacola
#red_sunglasses
#sneakers
#eye_contact
#fashion_people
#at_dior_show
#pearl_look
#gold_woman
#dimple_woman
#blue_silk_tie
#eyes_closed
#pigeon_moment
#street_details

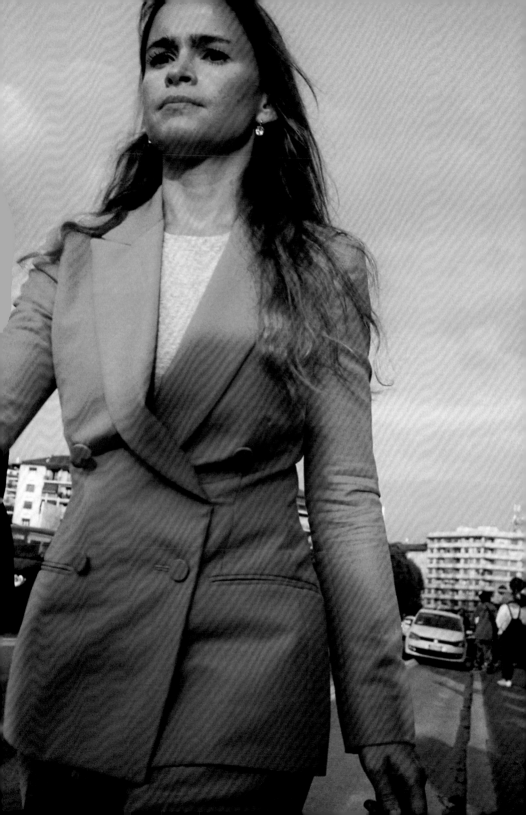

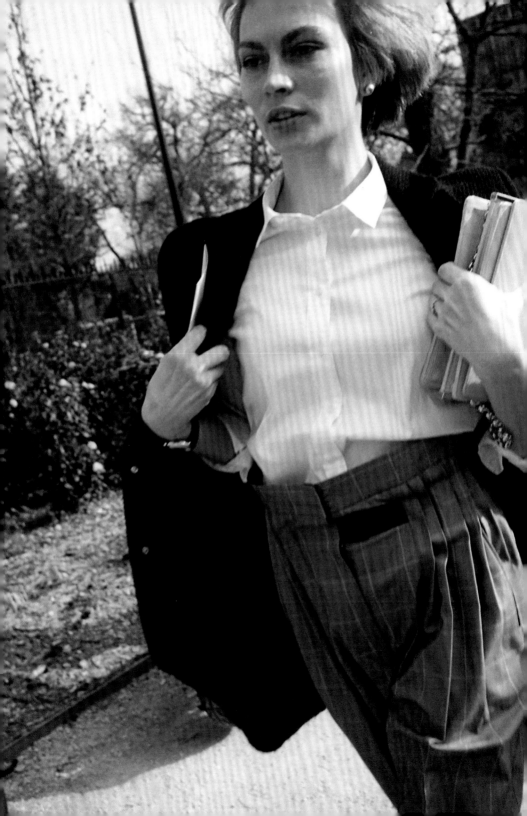

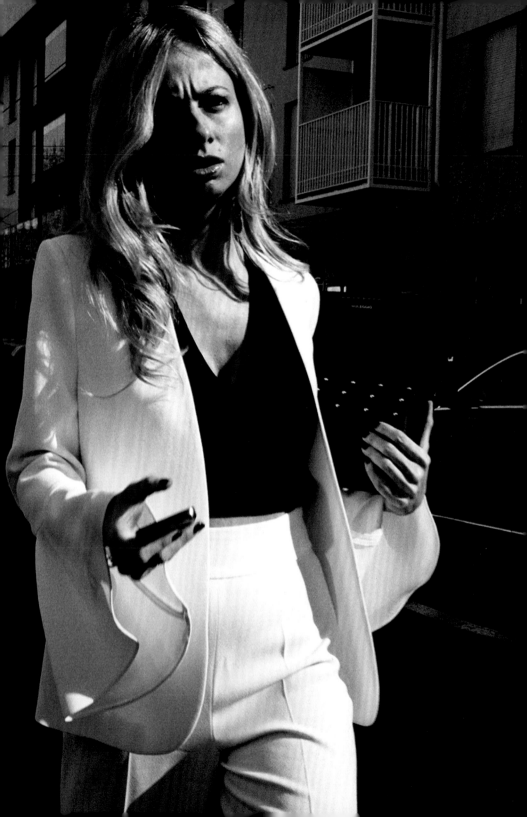

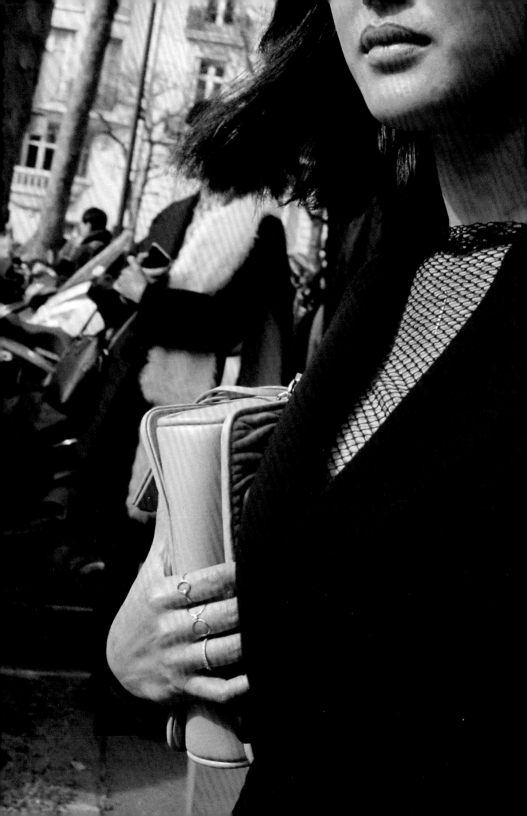

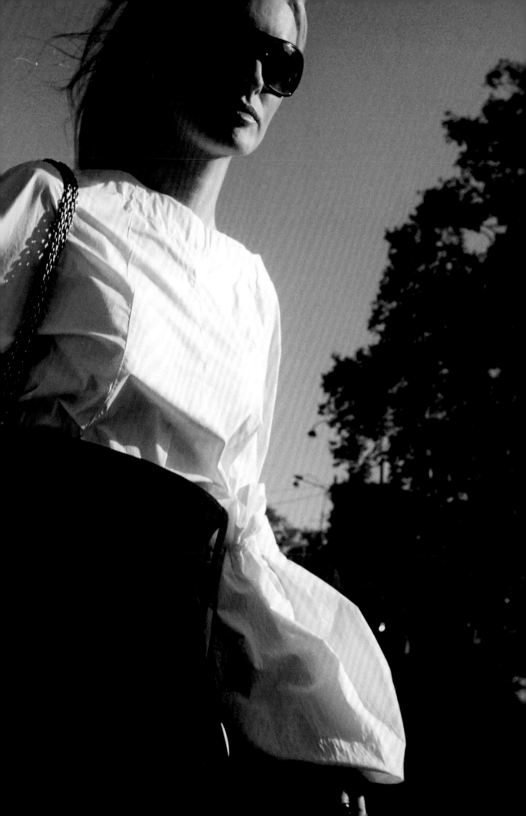

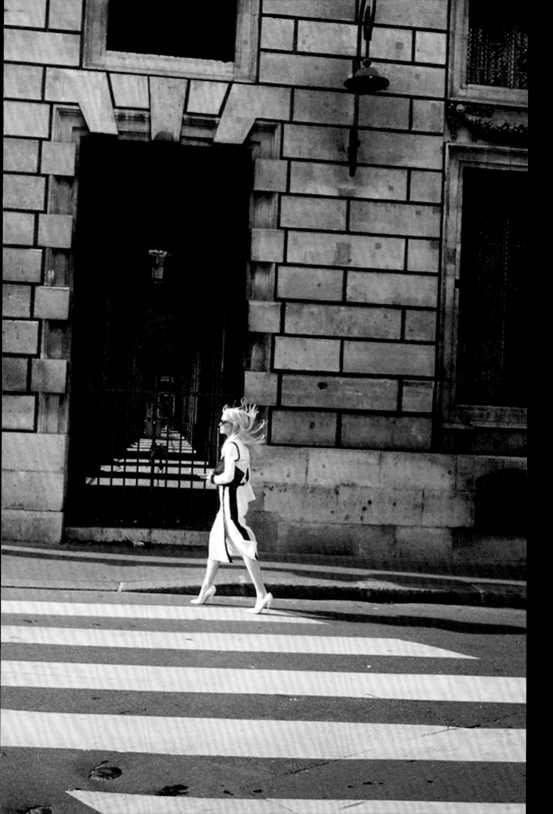

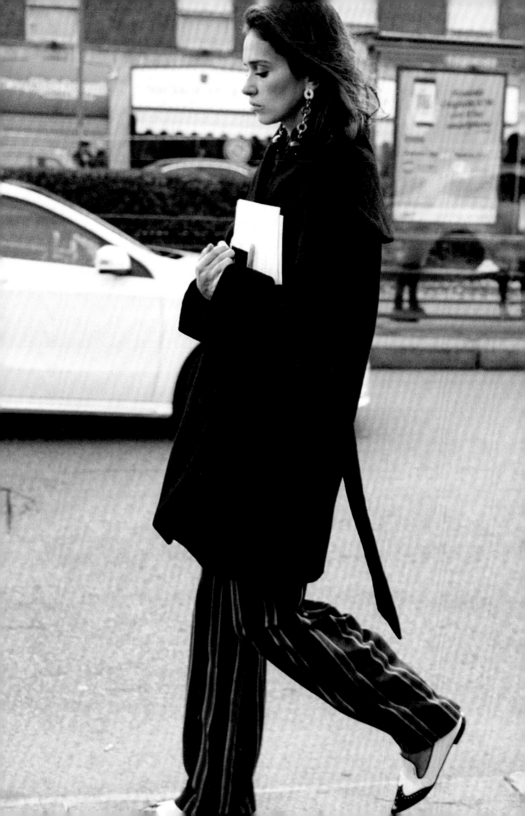

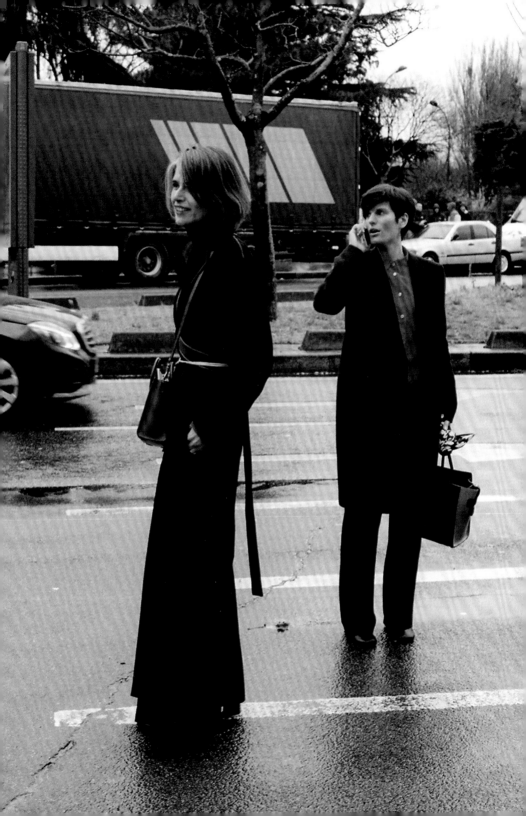

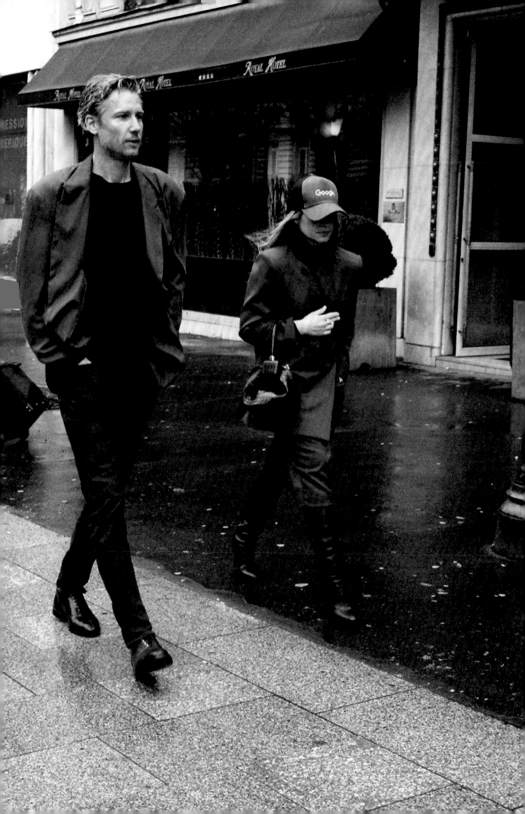

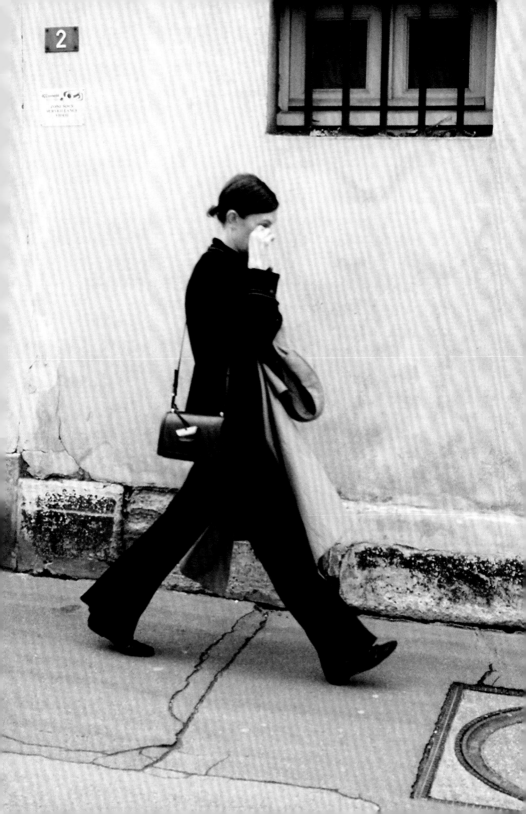

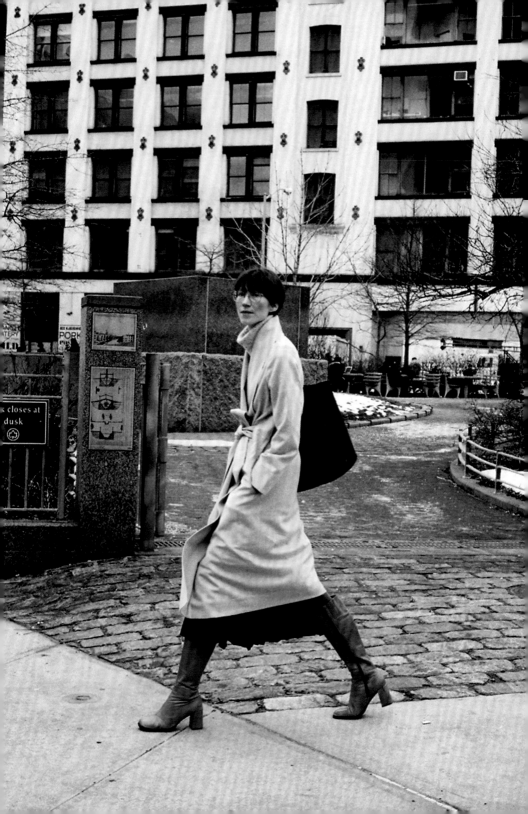

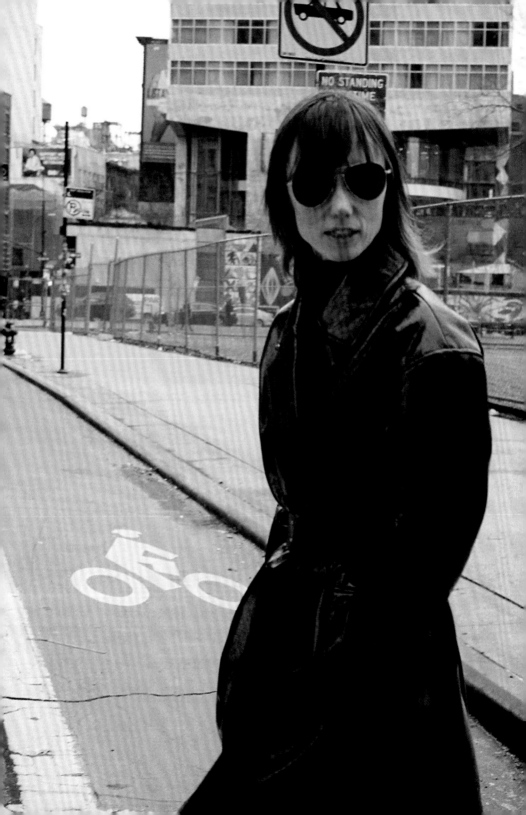

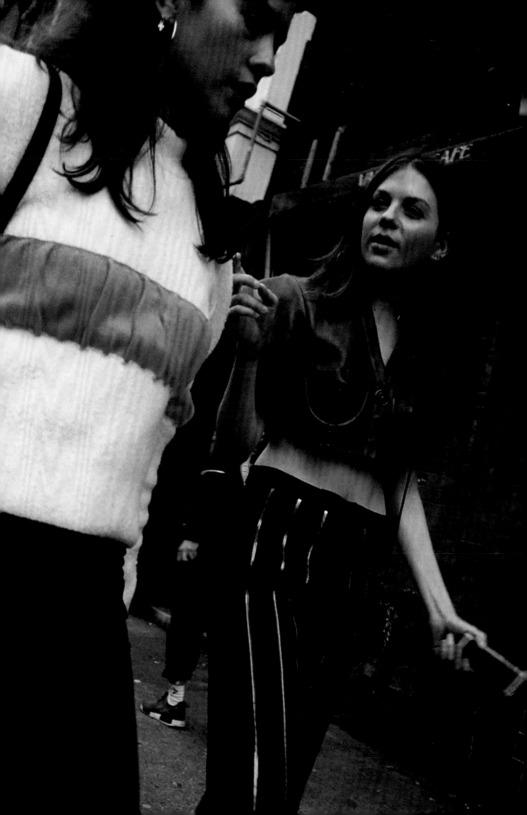

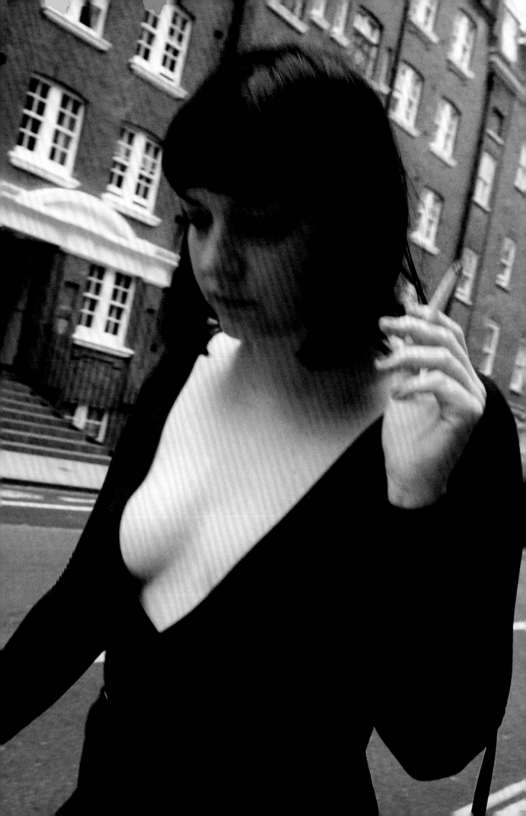

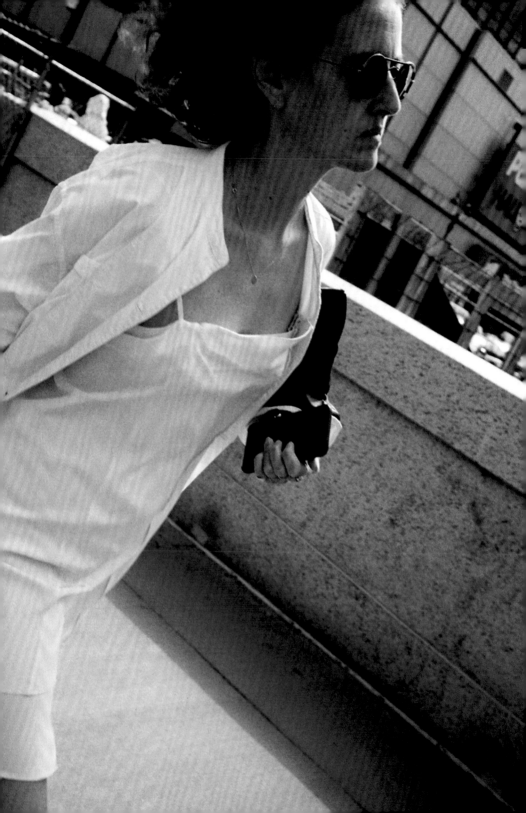

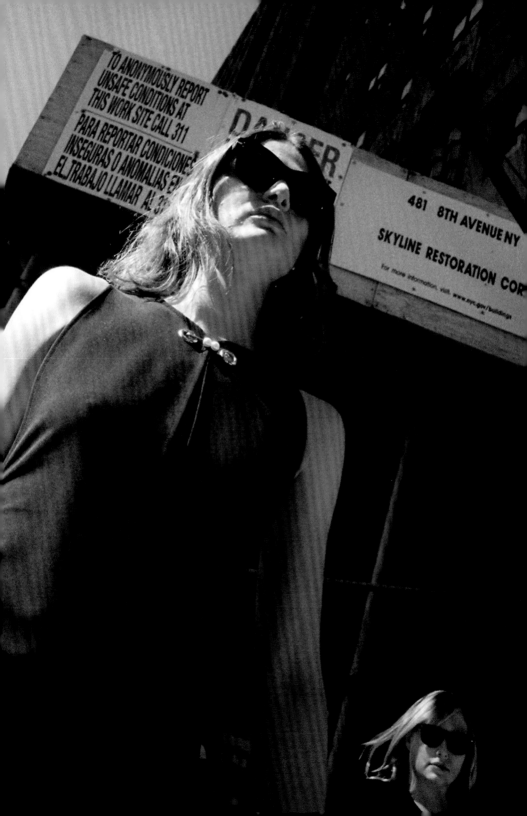

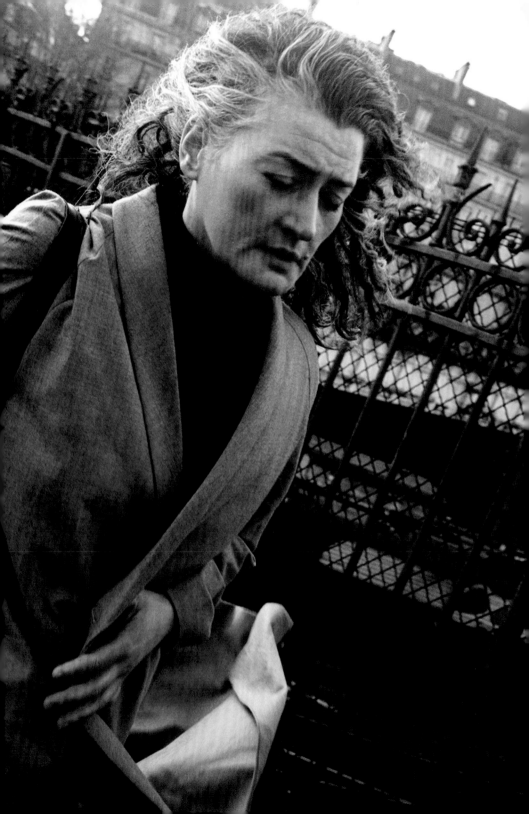

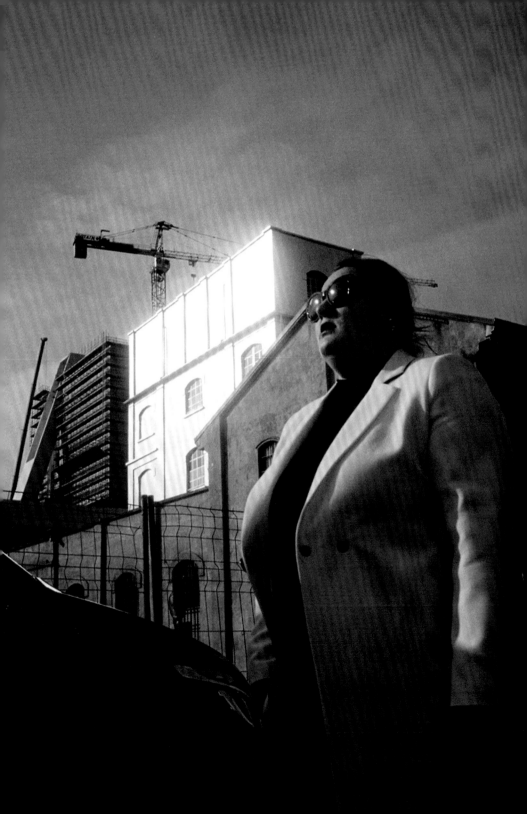

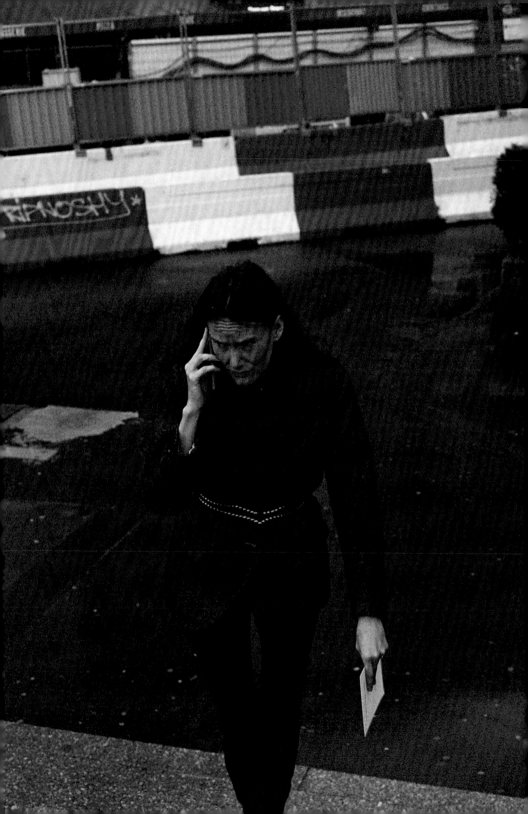

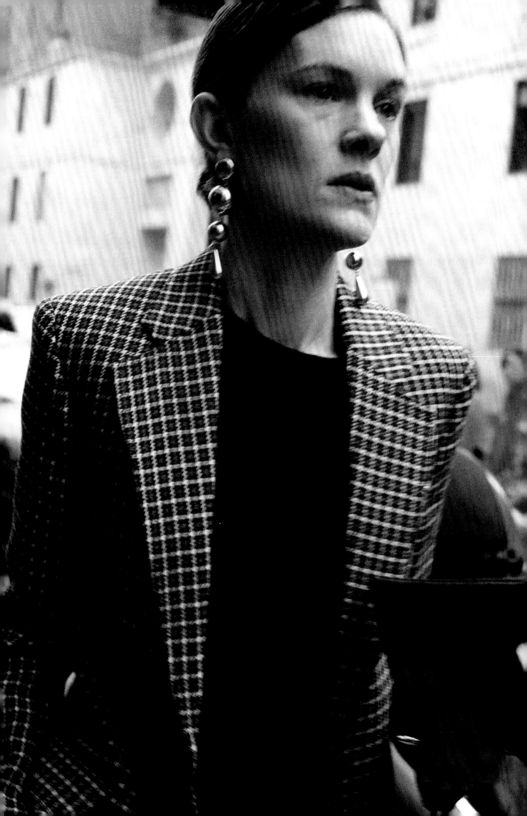

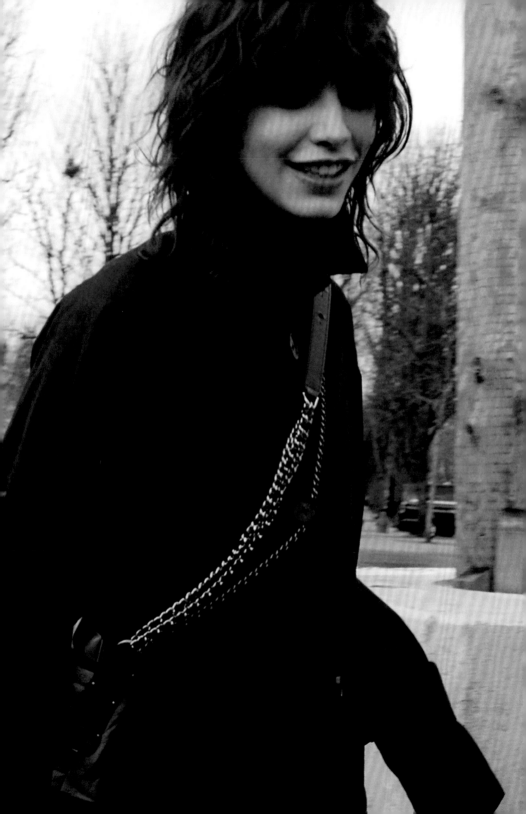

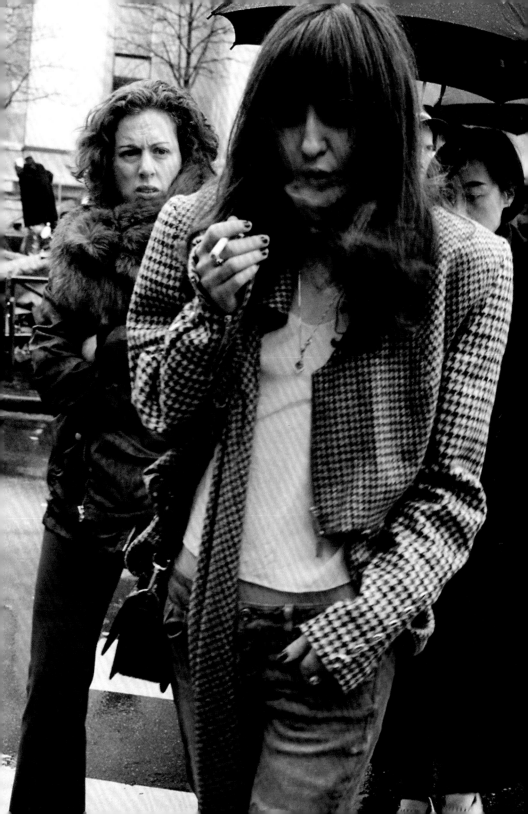

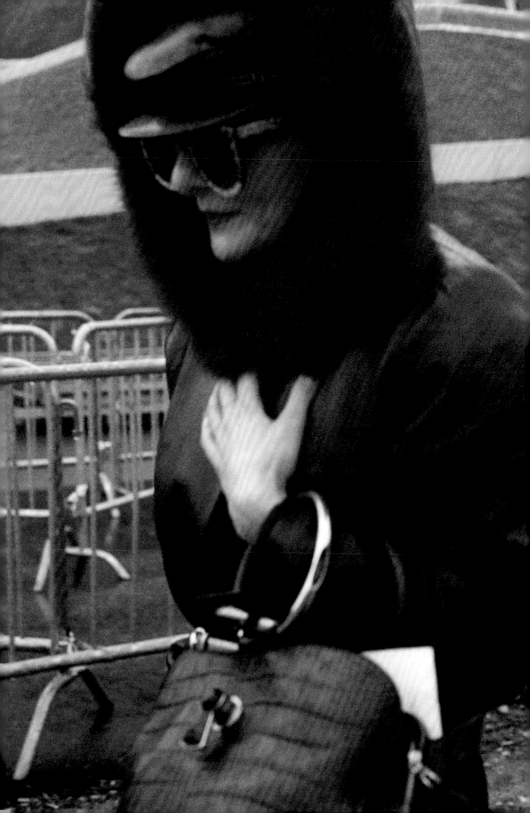

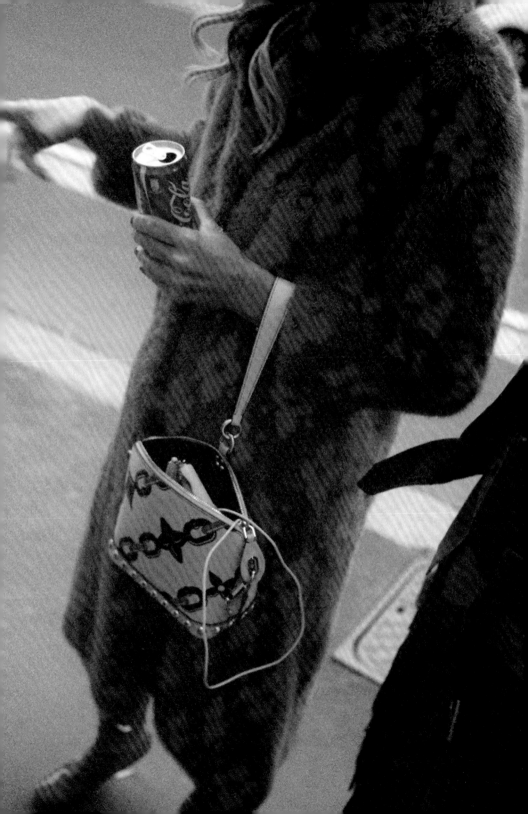

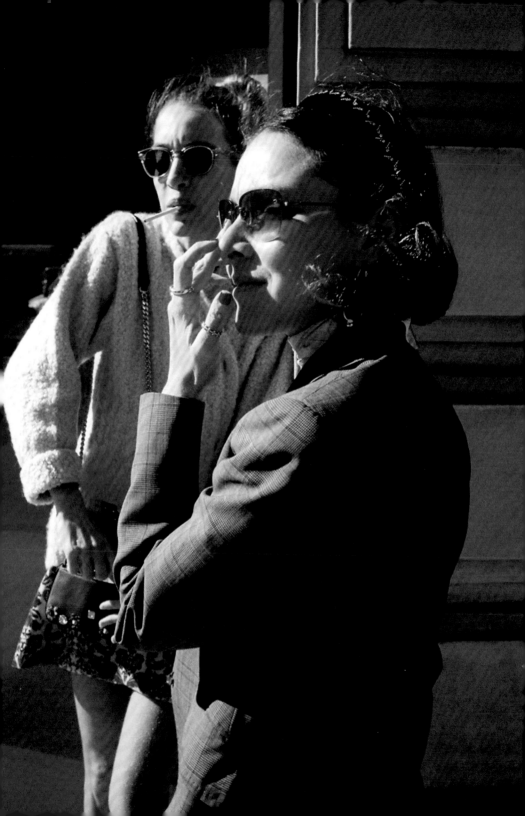

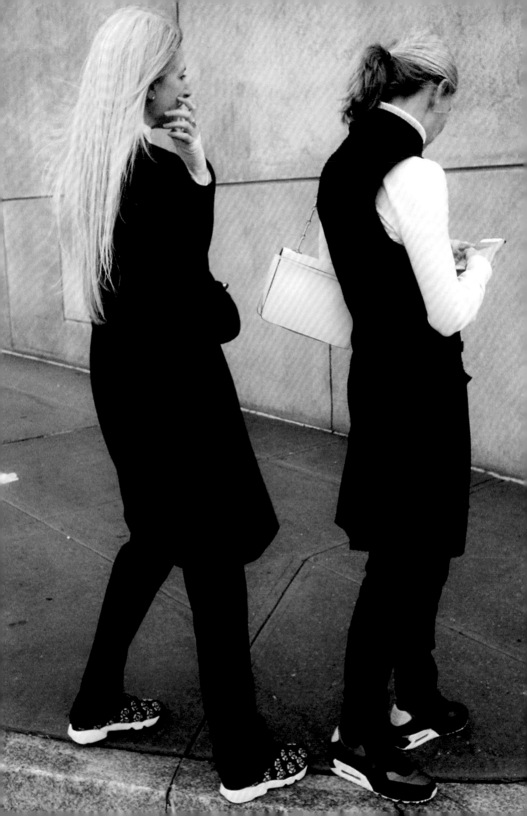

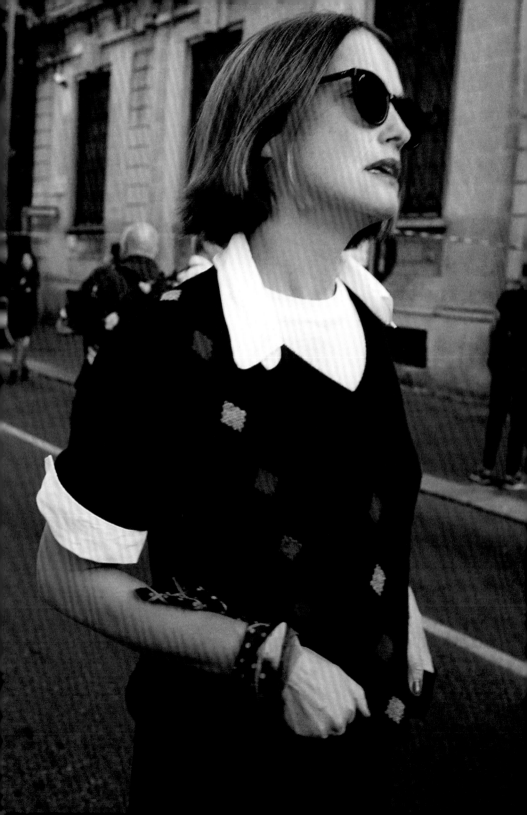

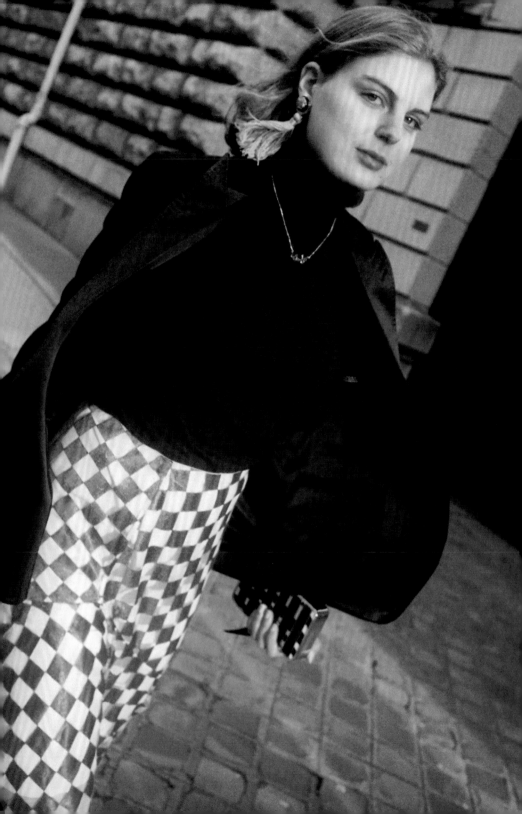

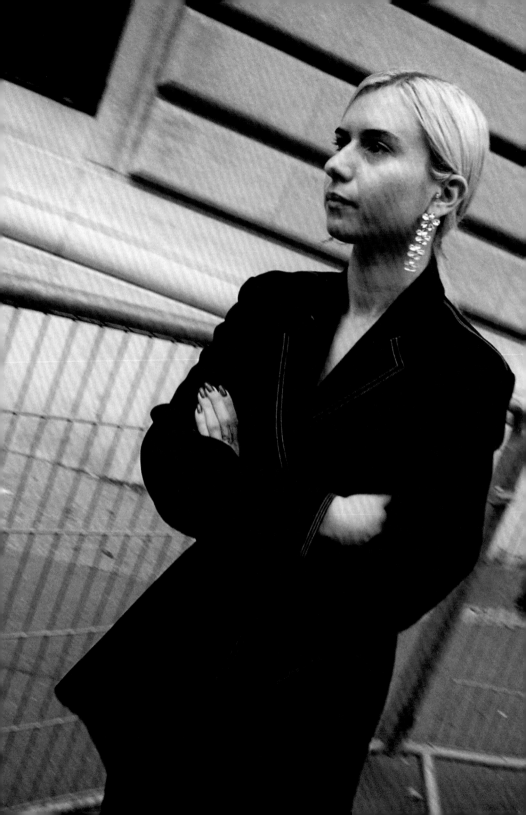

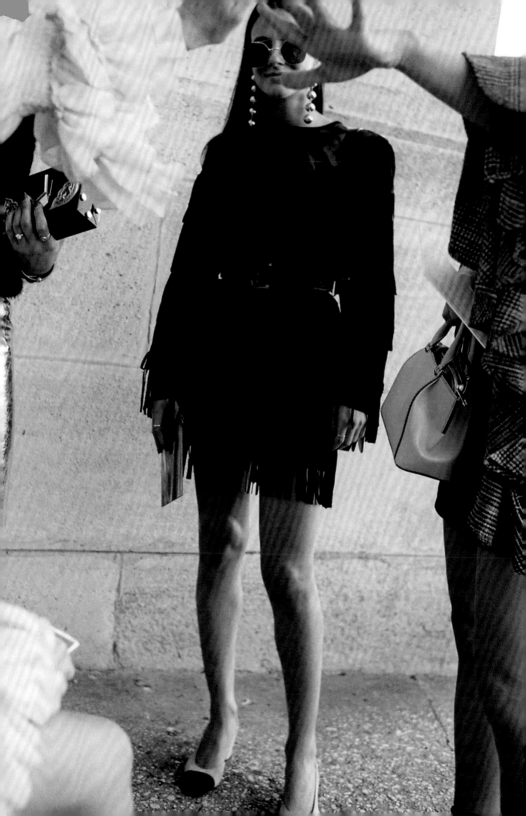

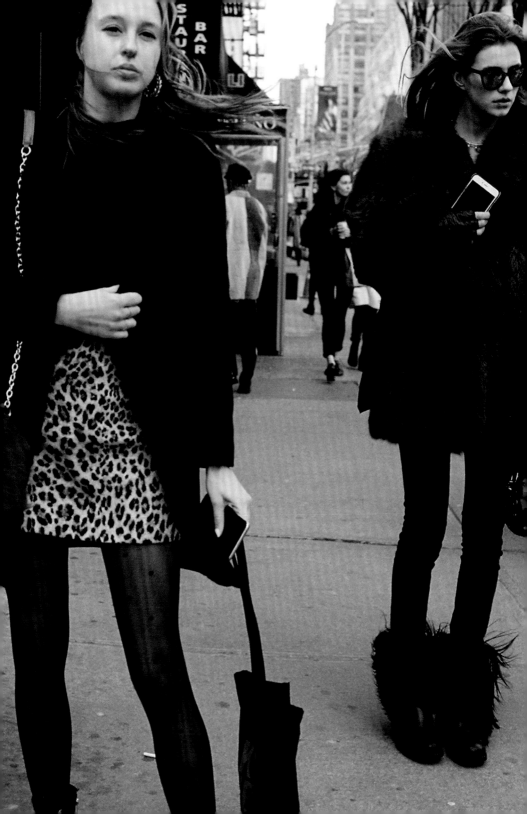

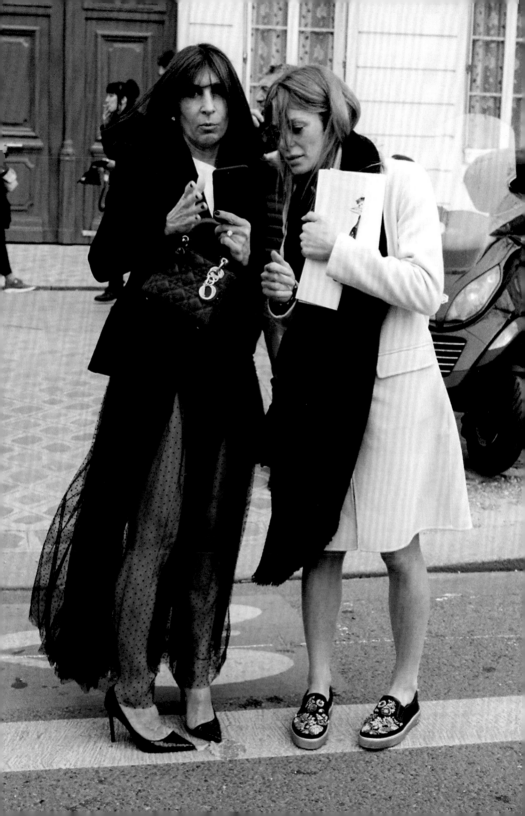

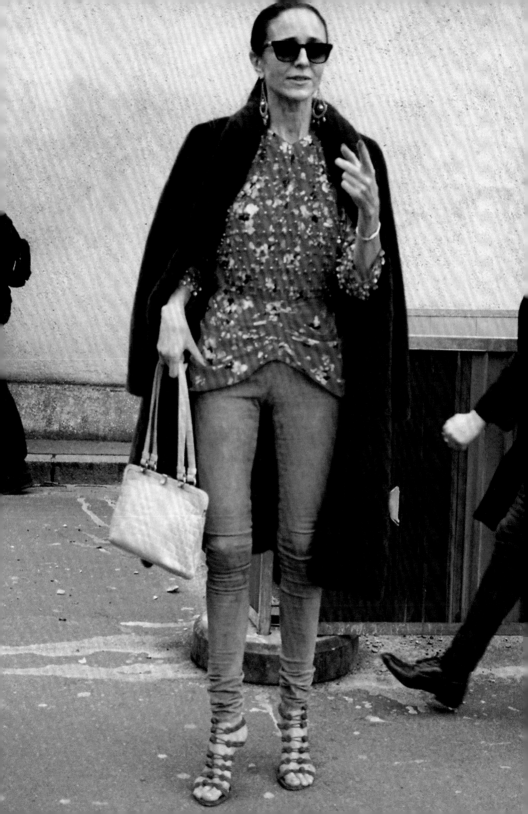

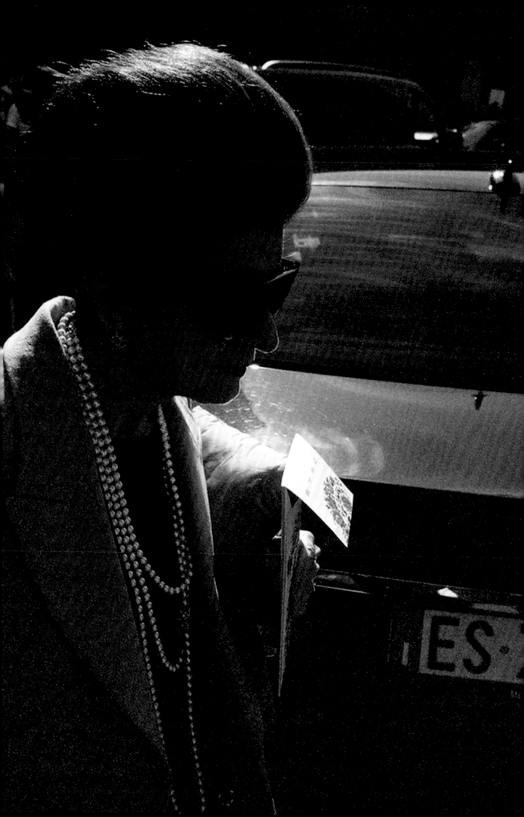

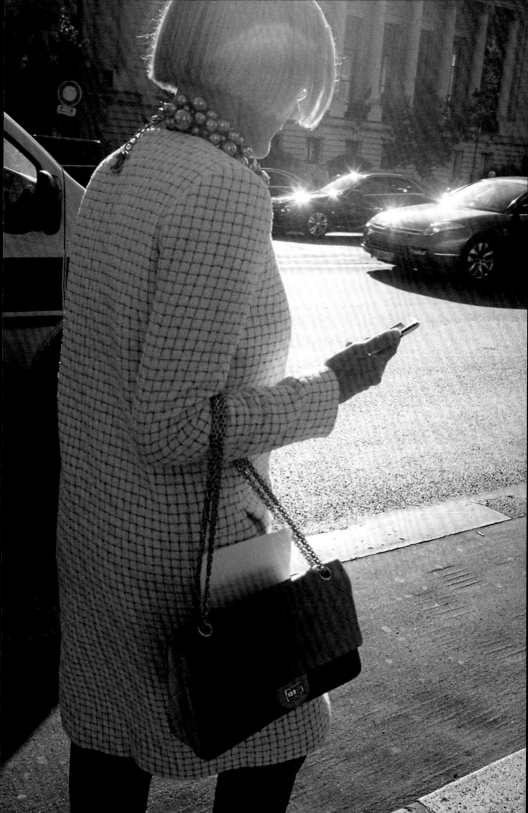

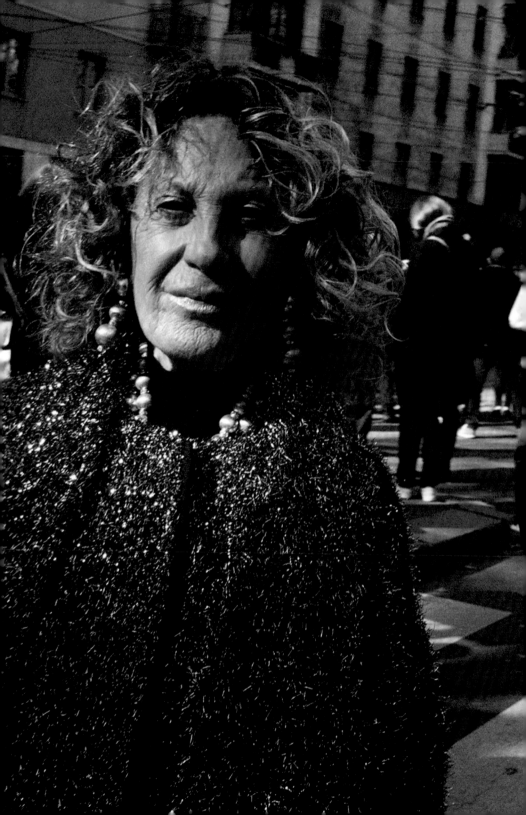

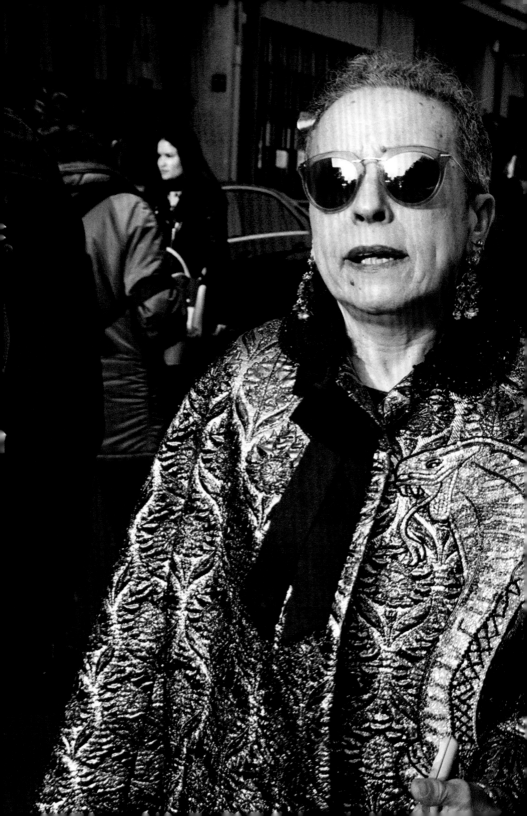

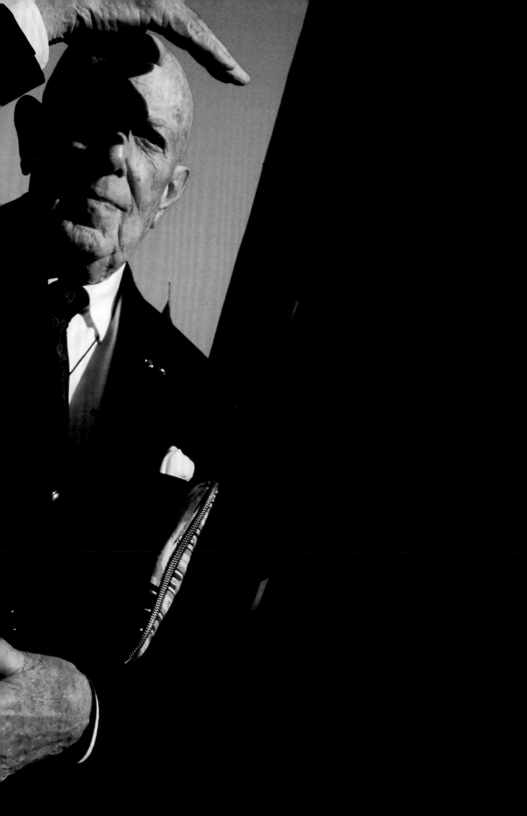

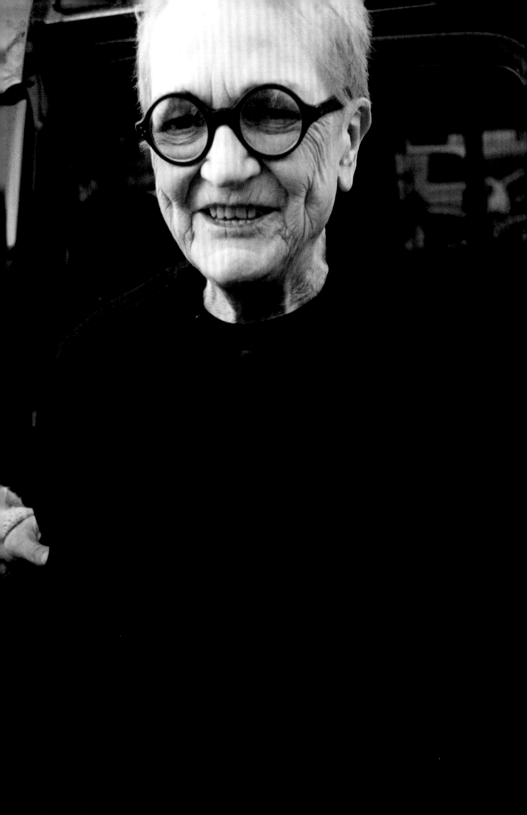

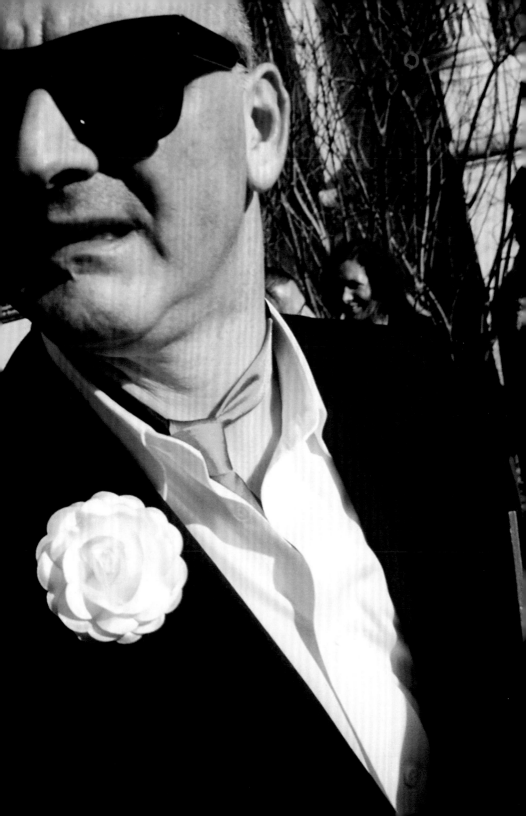

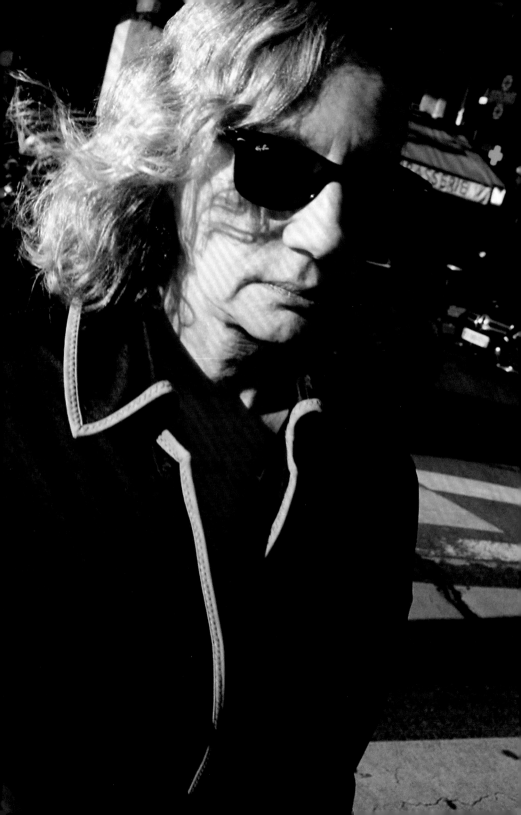

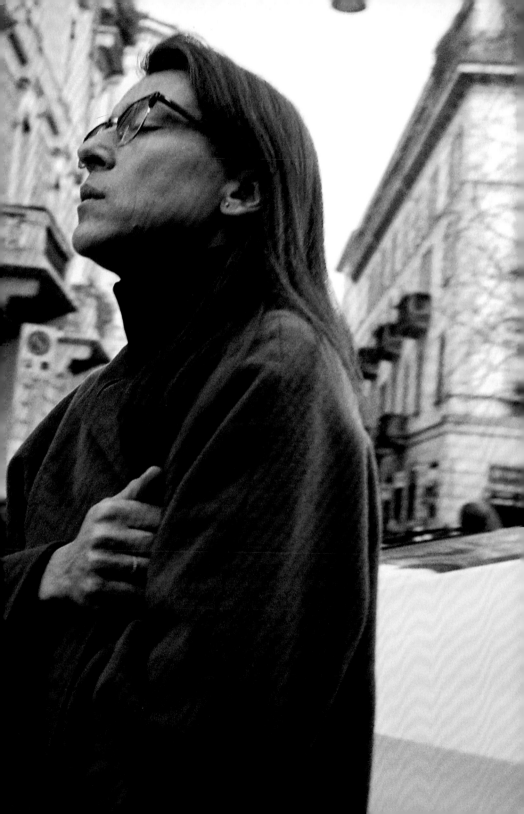

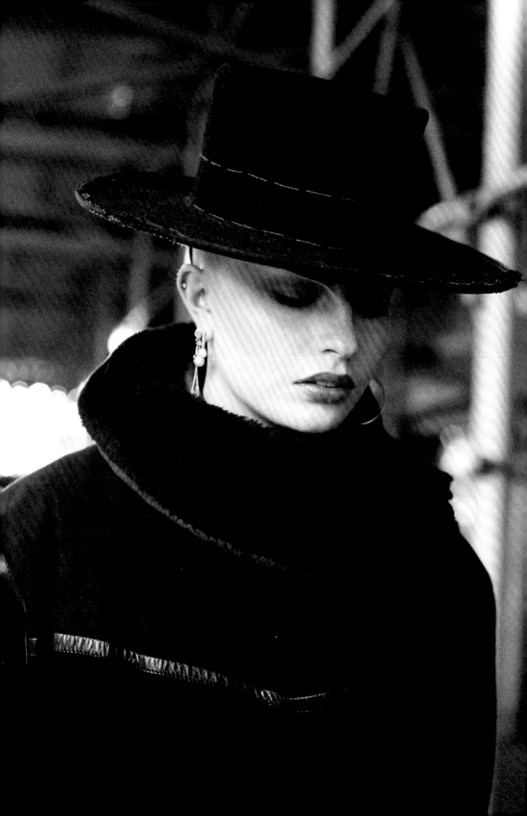

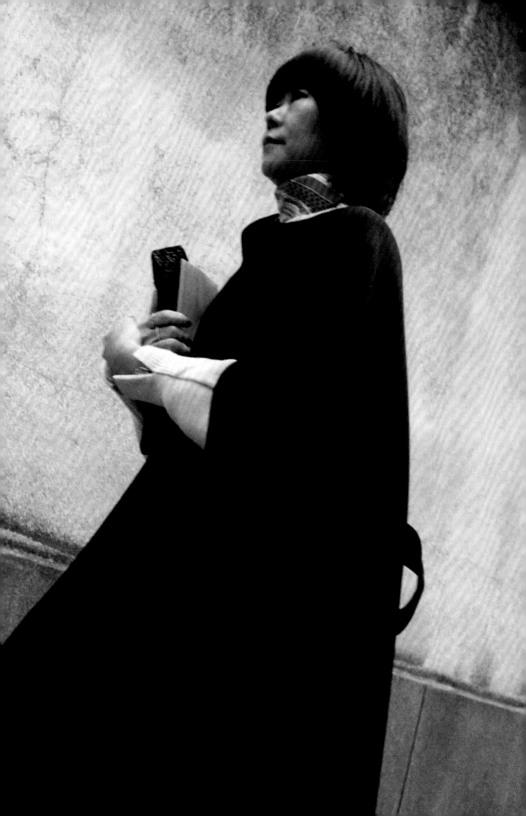

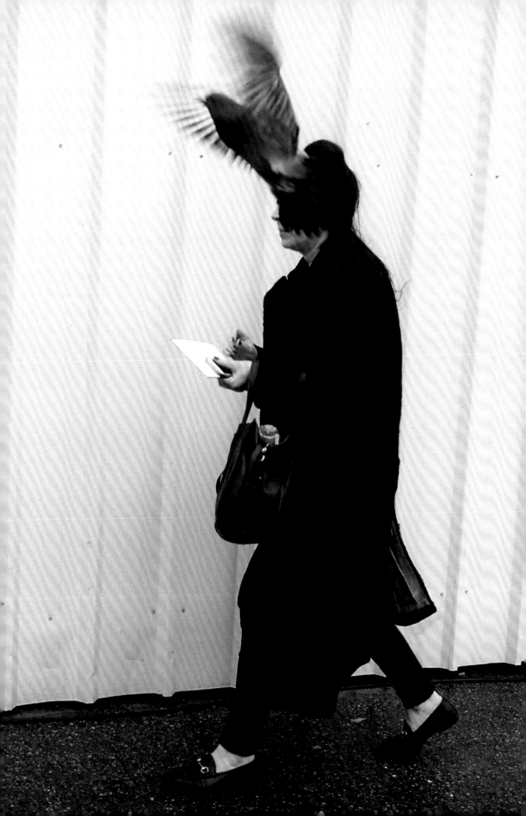

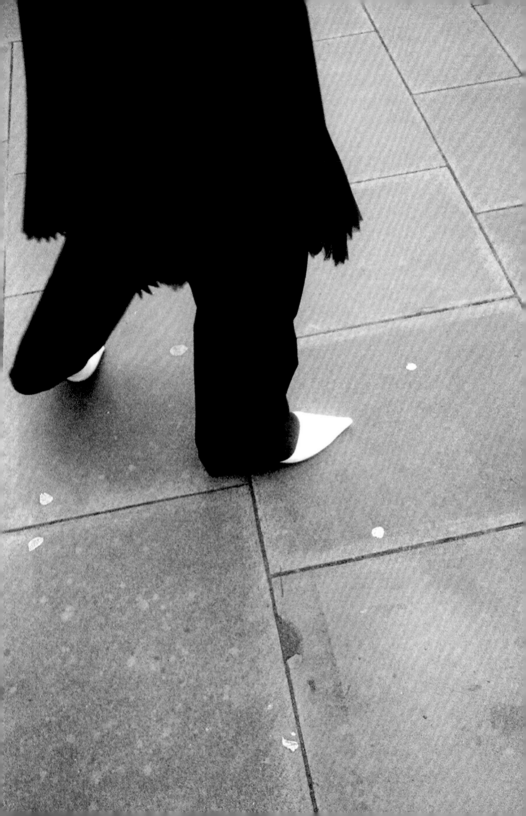

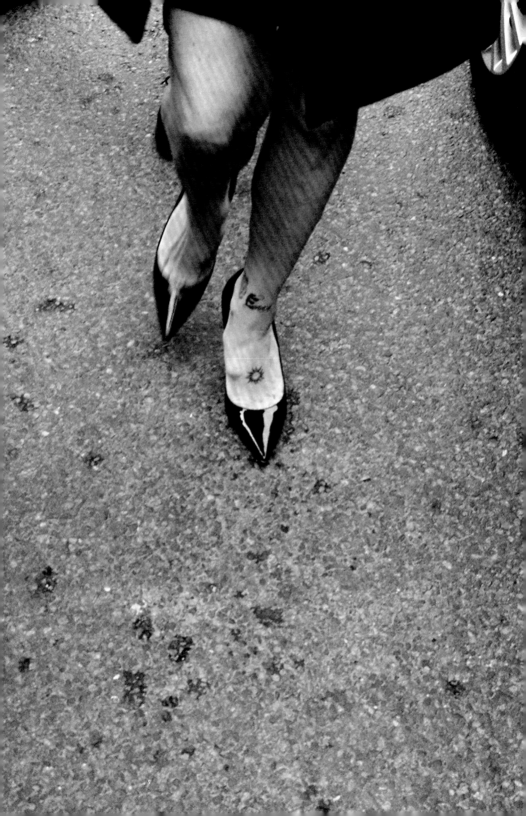

#model_shirts
#early_morning_face
#cigarette_iphone_case
#walking
#model_portrait
#casting_look
#red_polo_neck
#sunny_day
#after_fashion_show
#model_face
#street_interview
#profile_view
#bike_look
#model_off_duty
#leather_jacket
#big_size_padding
#backpacker
#flying_spongebob
#street_walk
#model_after_chanel_show

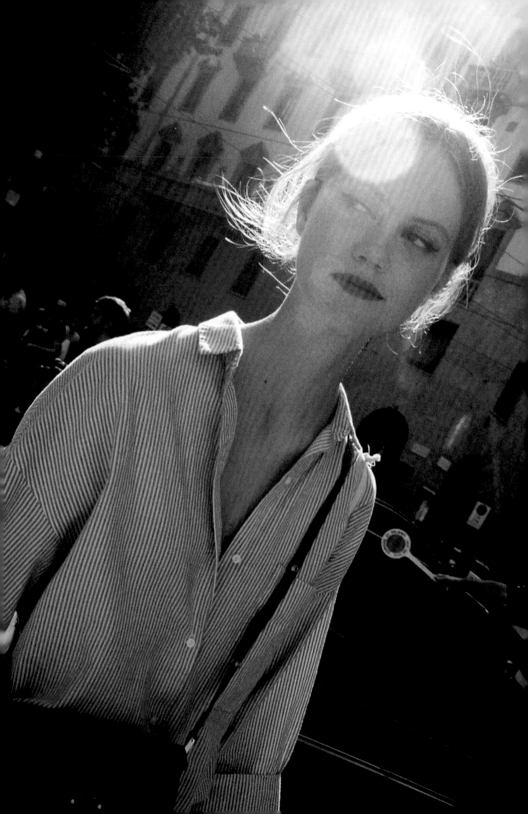

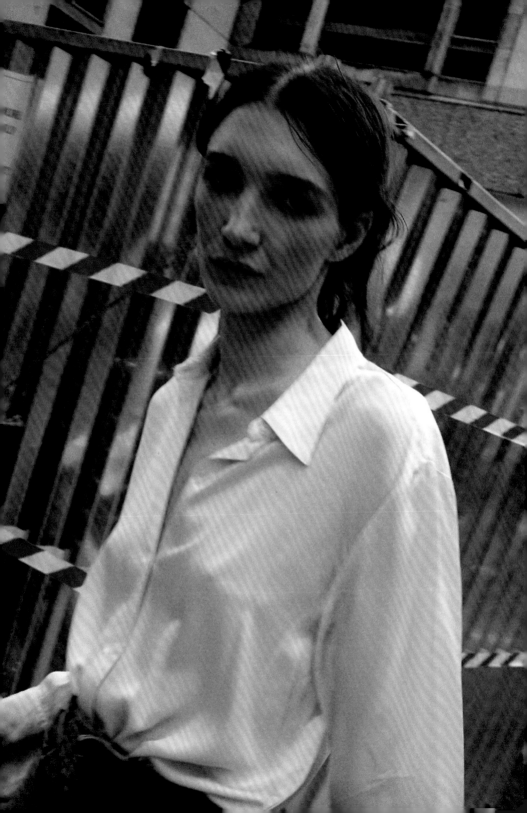

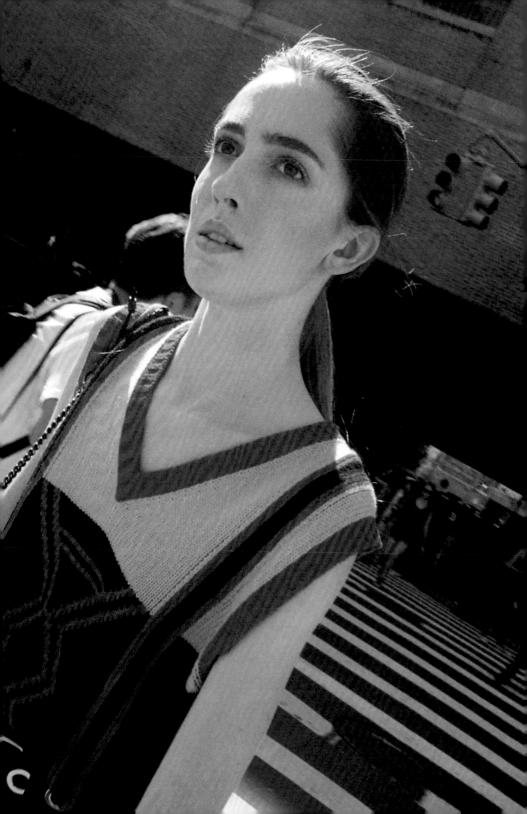

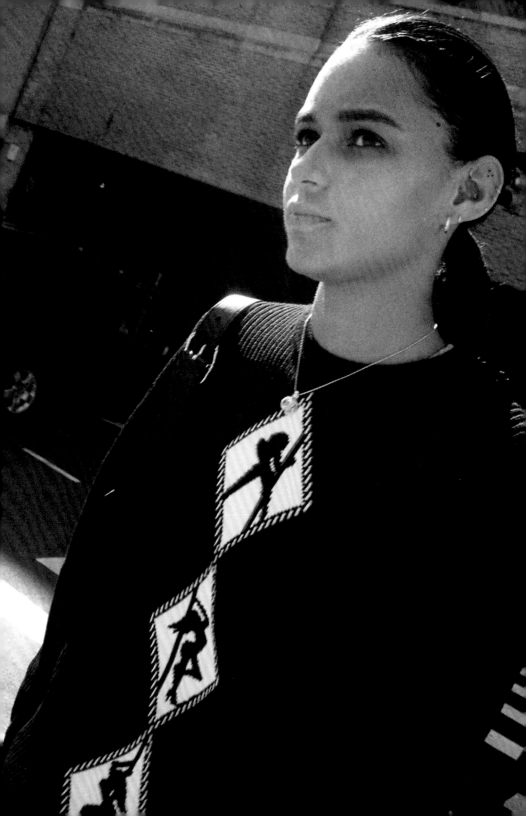

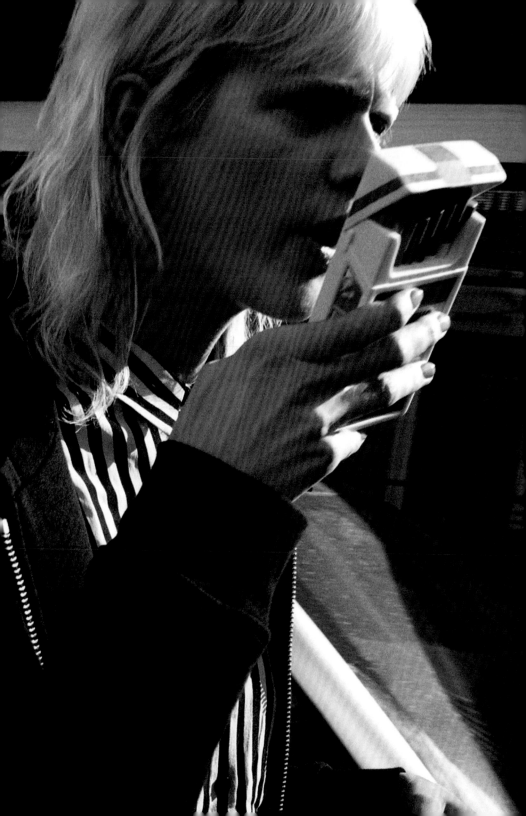

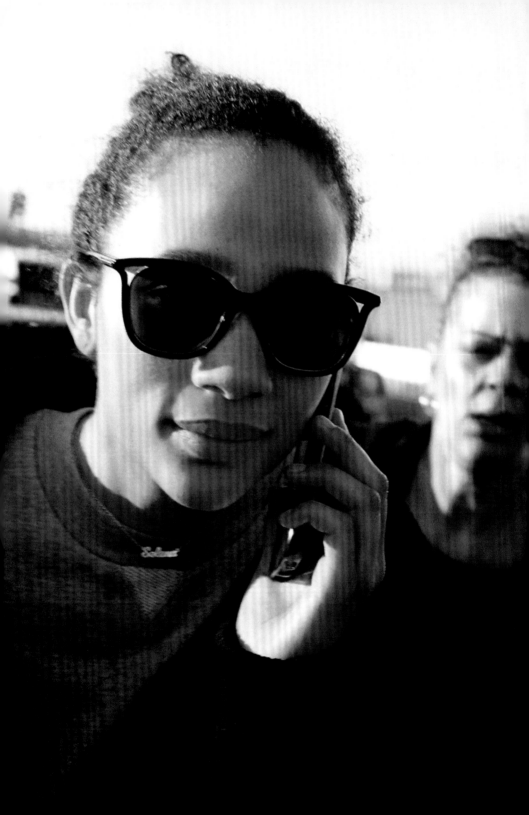

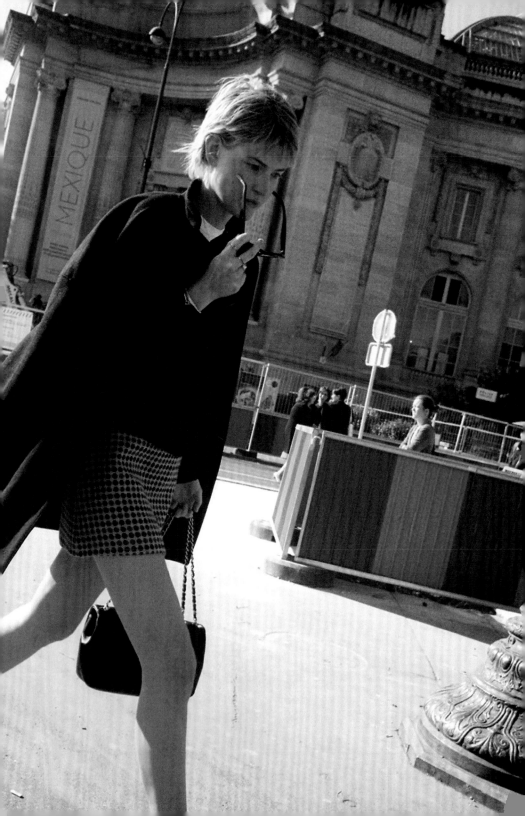

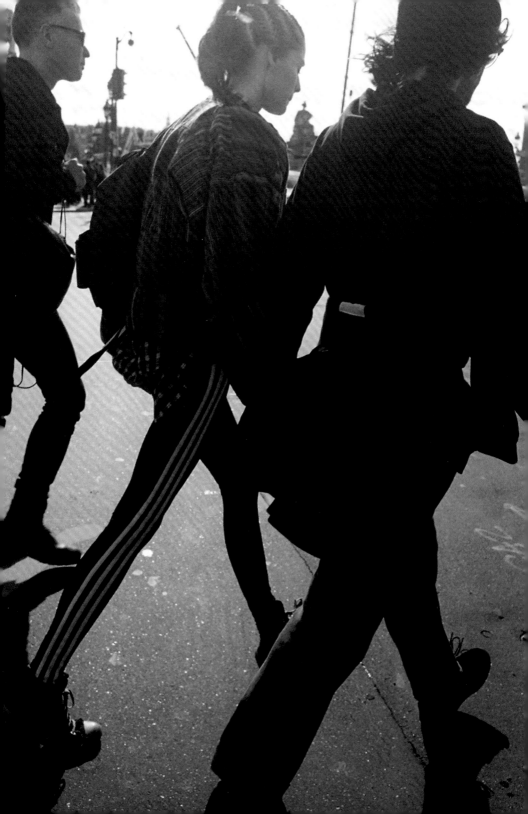

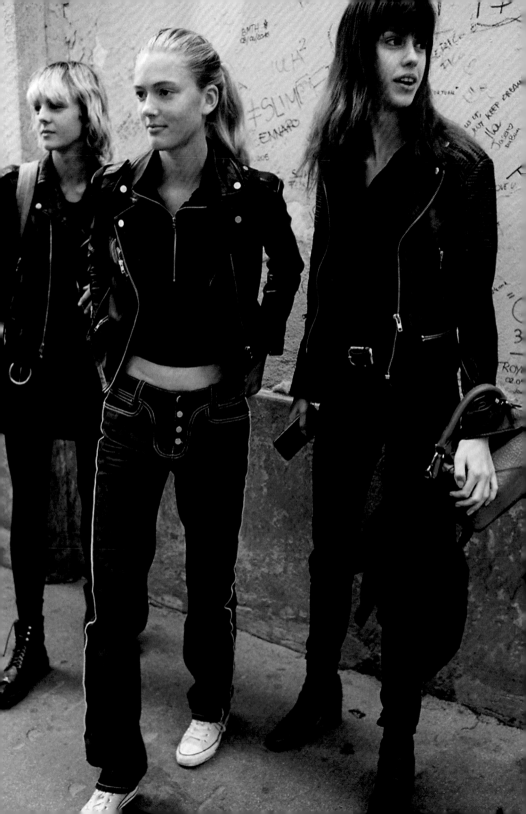

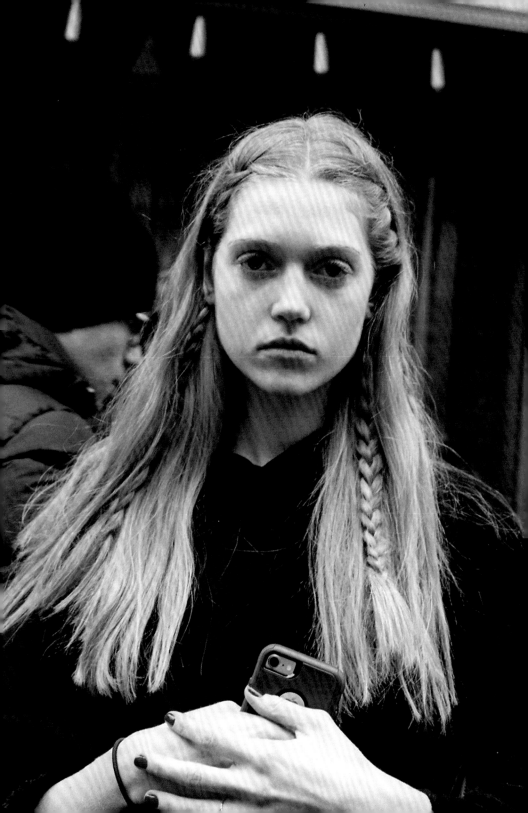

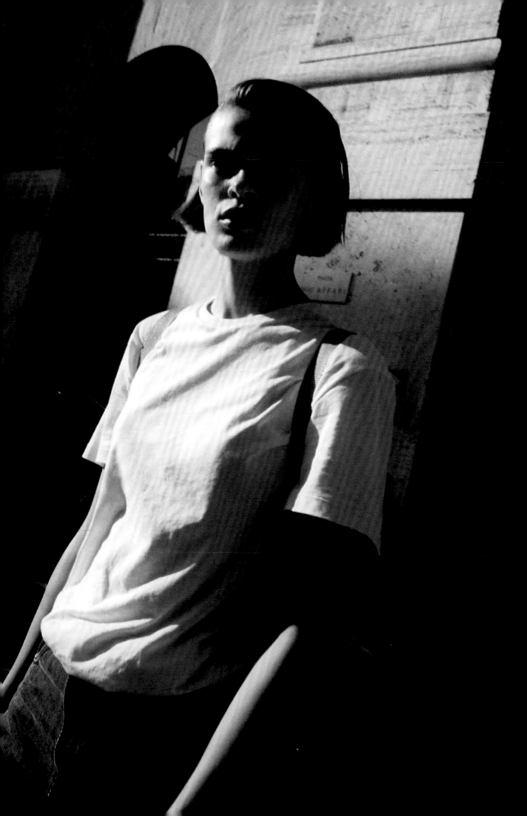

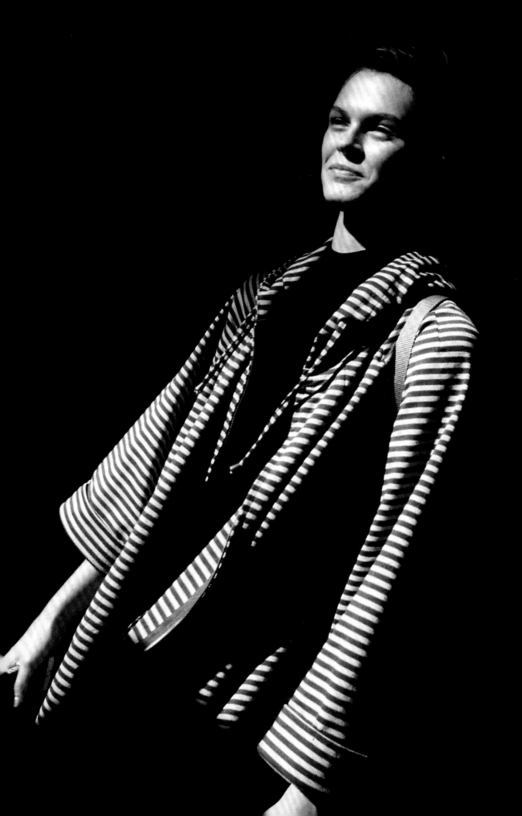

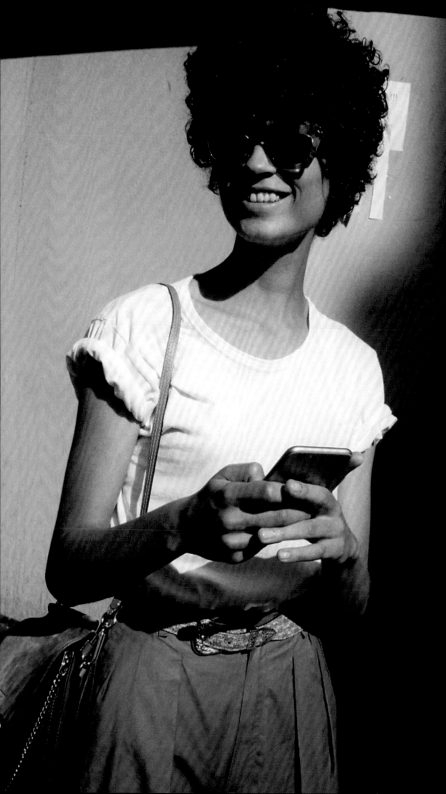

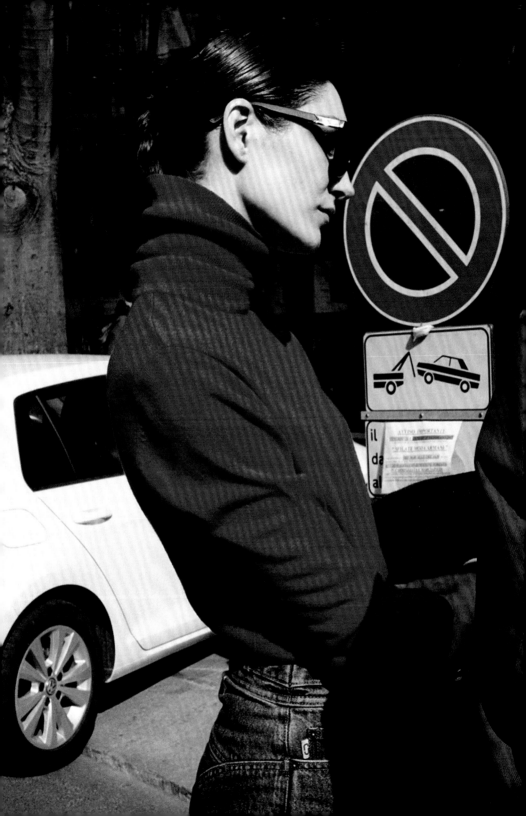

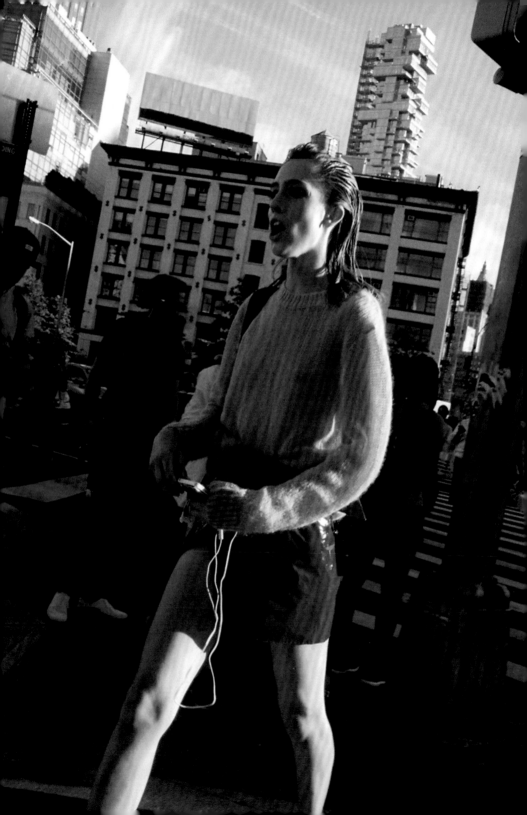

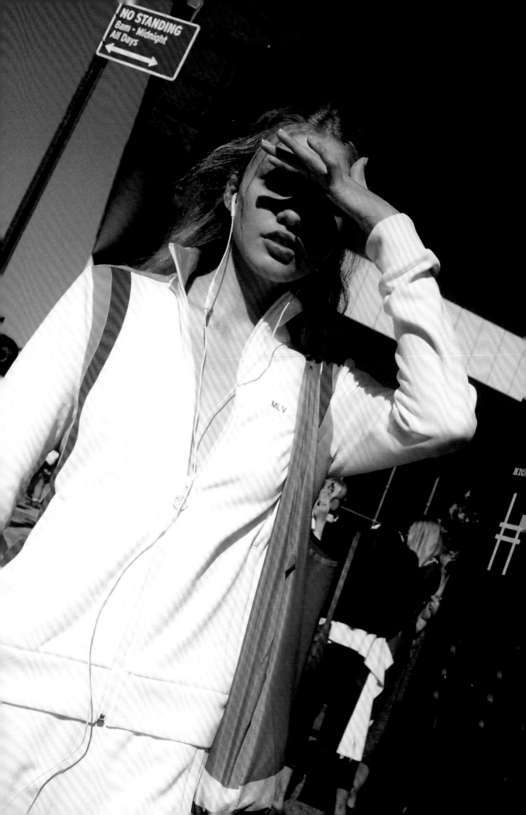

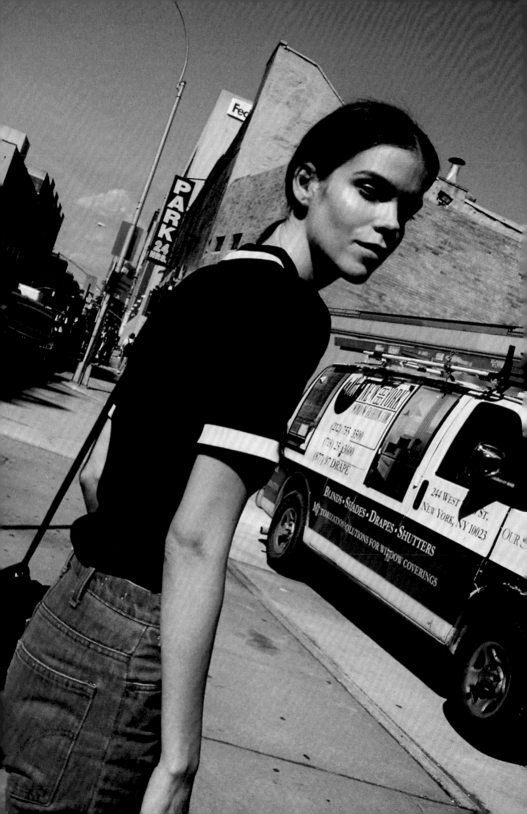

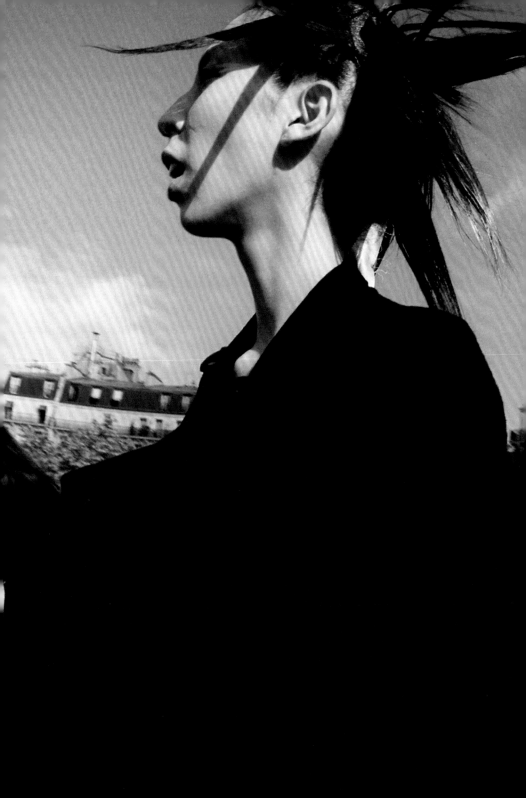

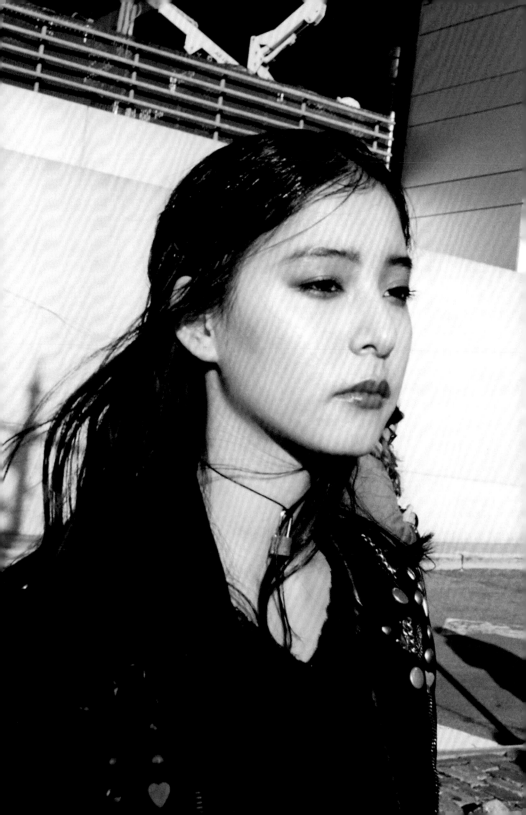

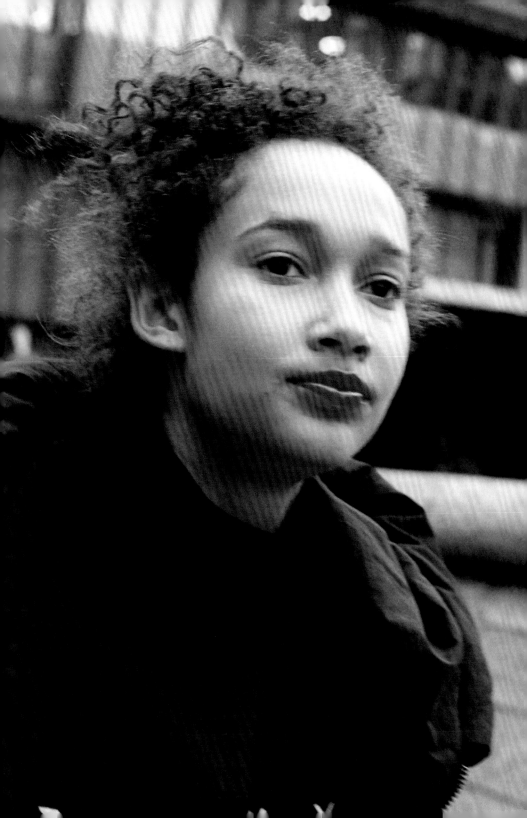

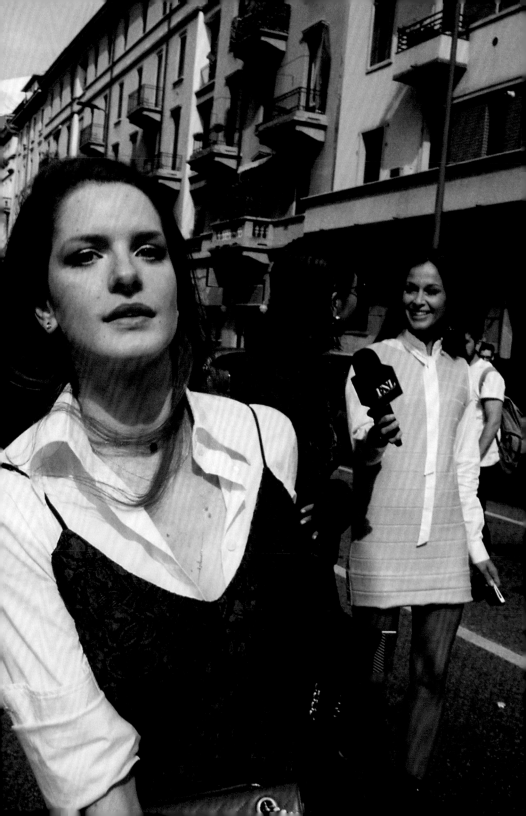

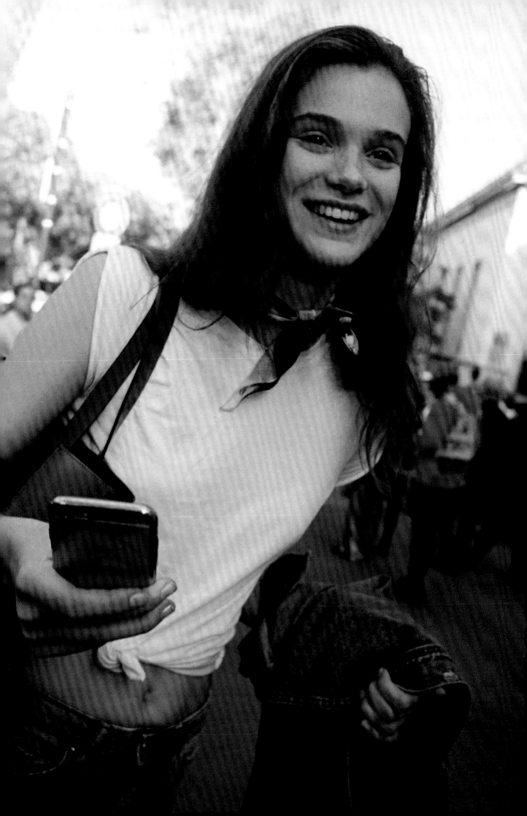

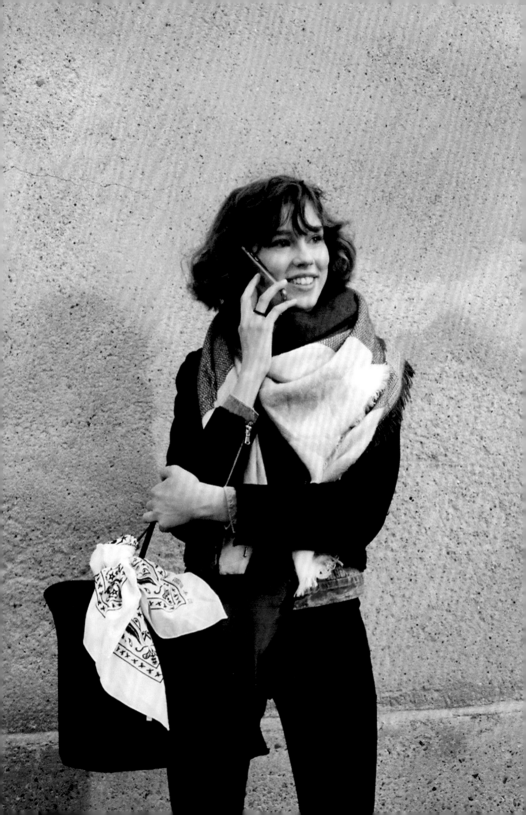

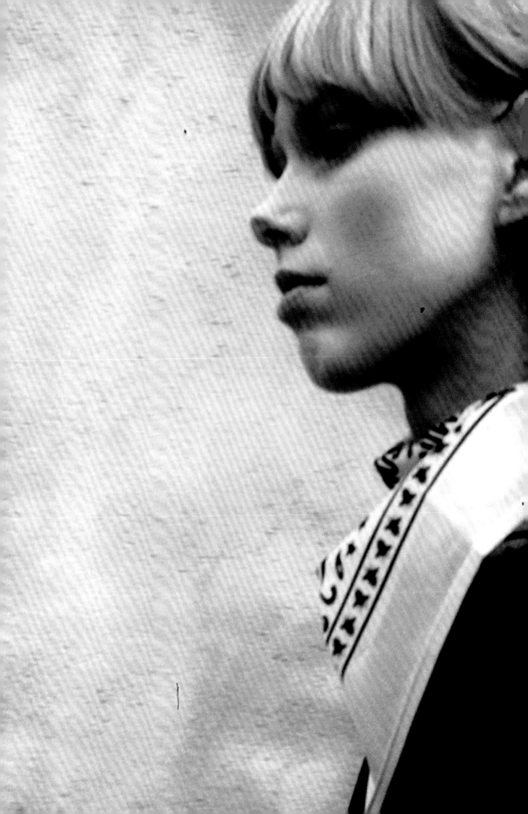

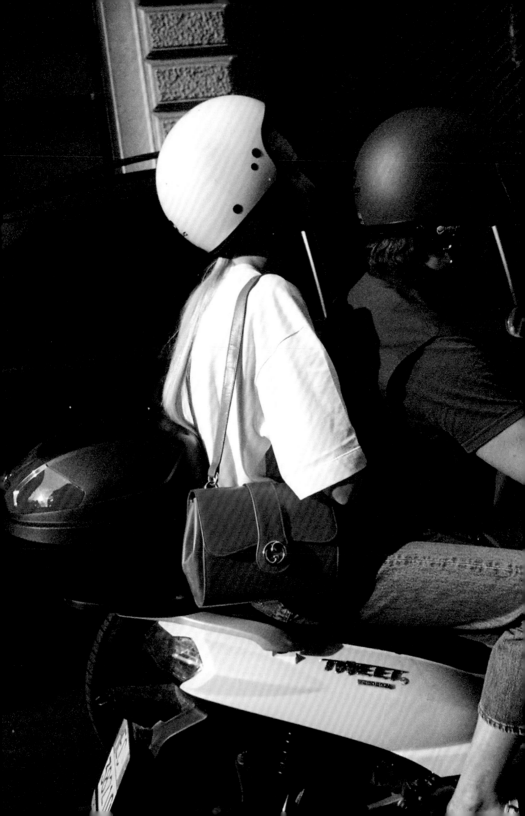

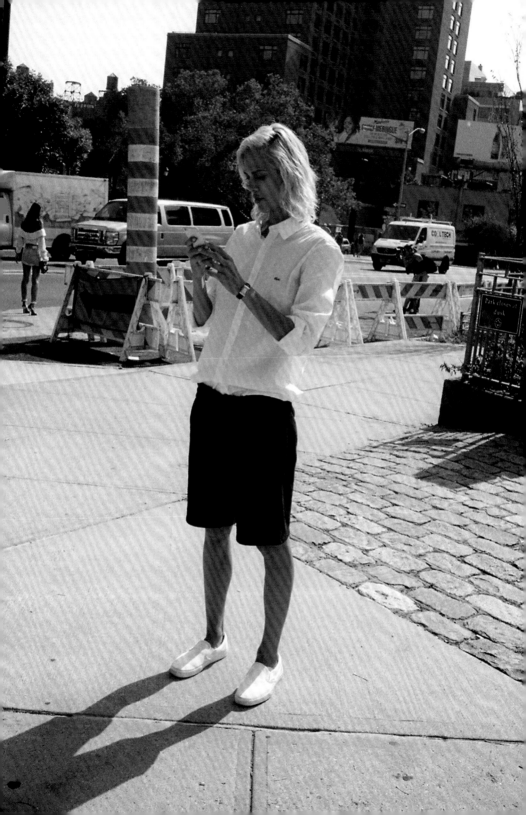

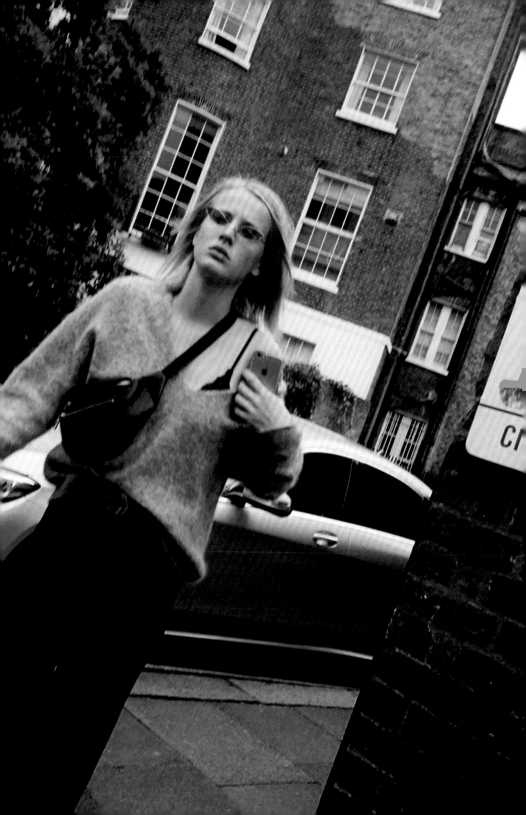

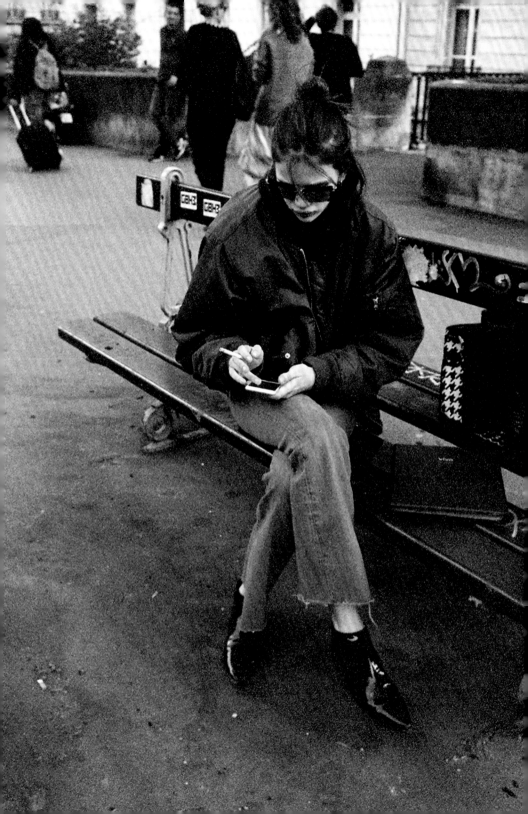

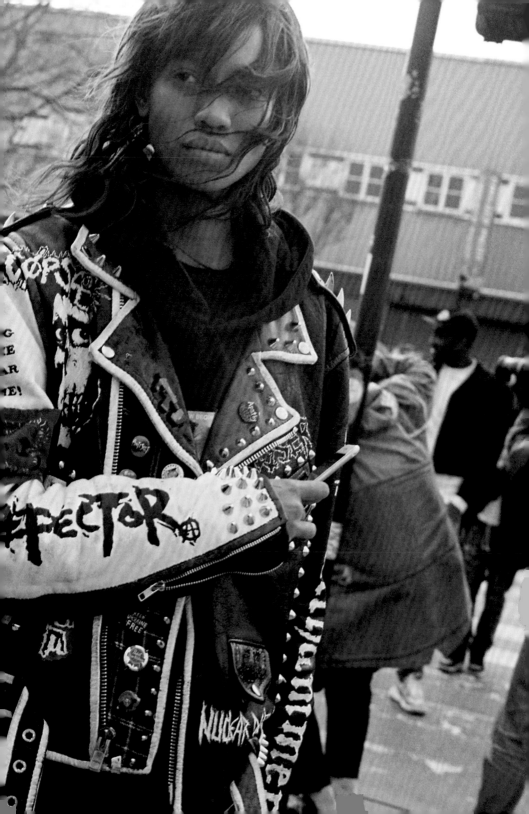

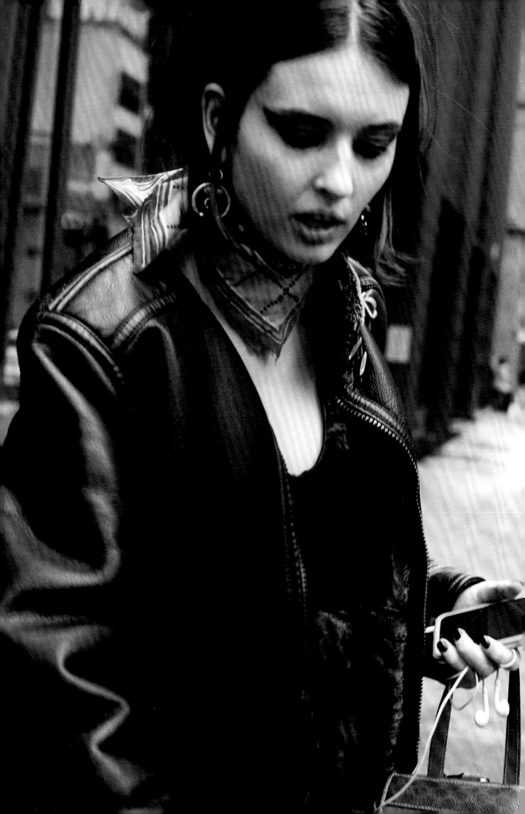

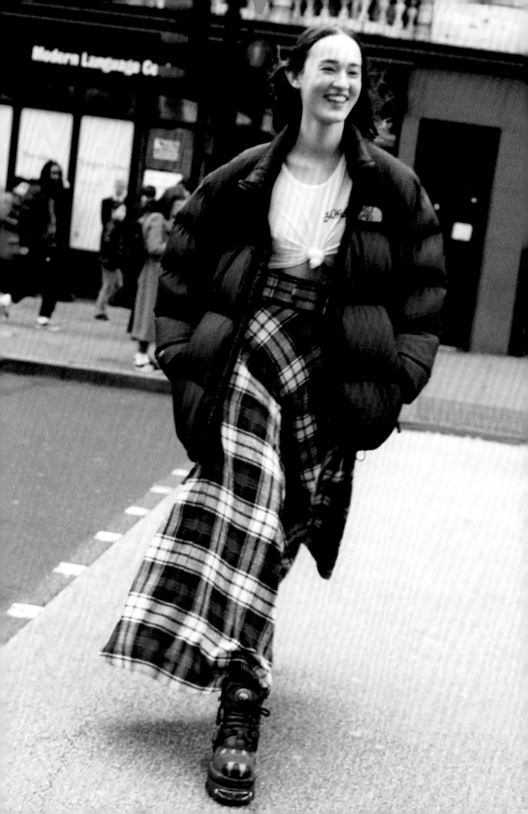

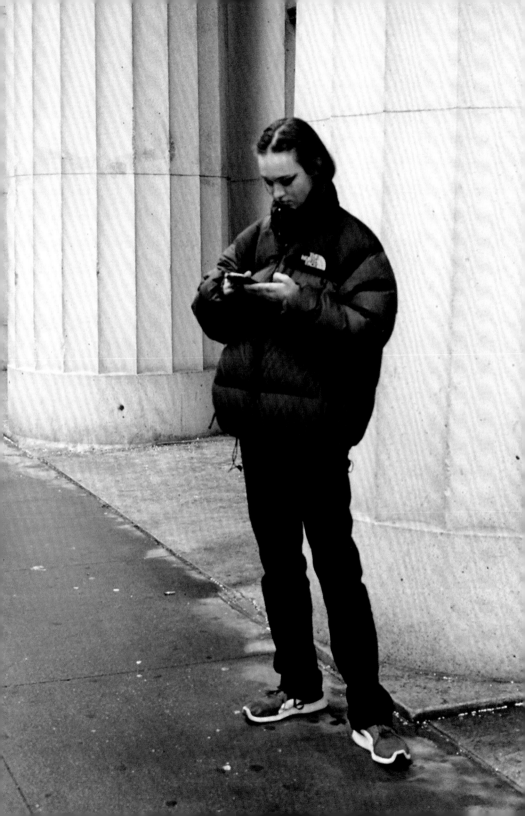

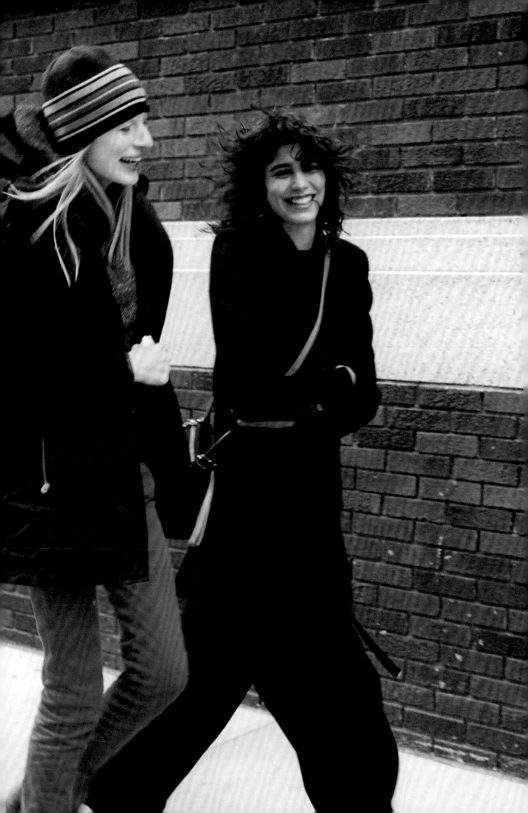

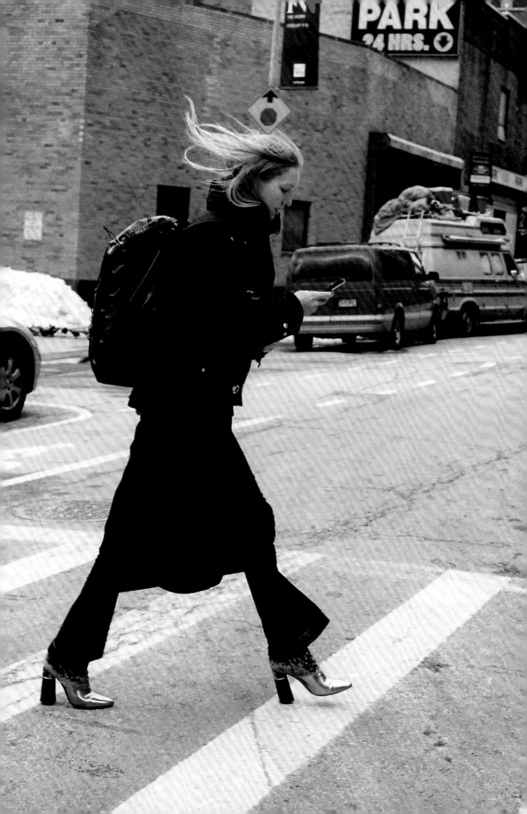

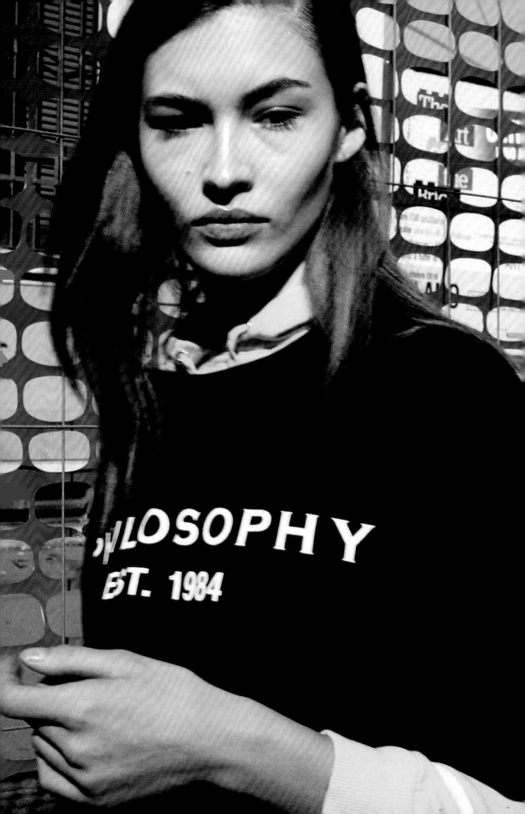

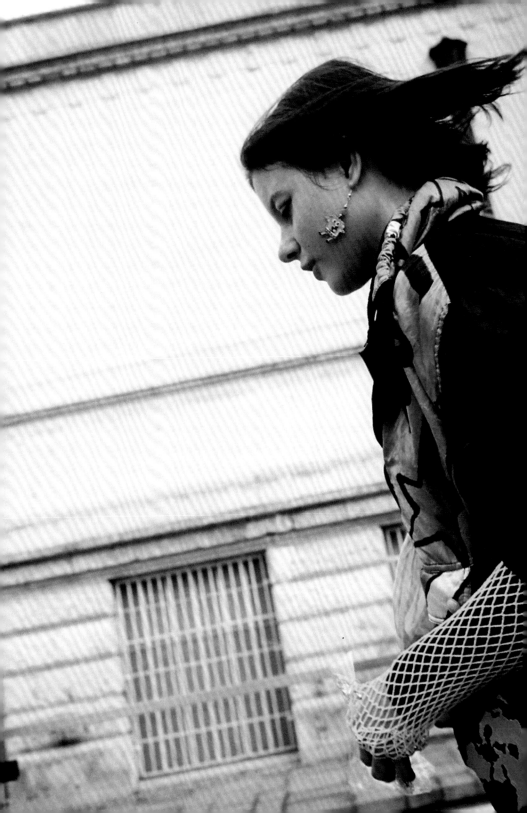

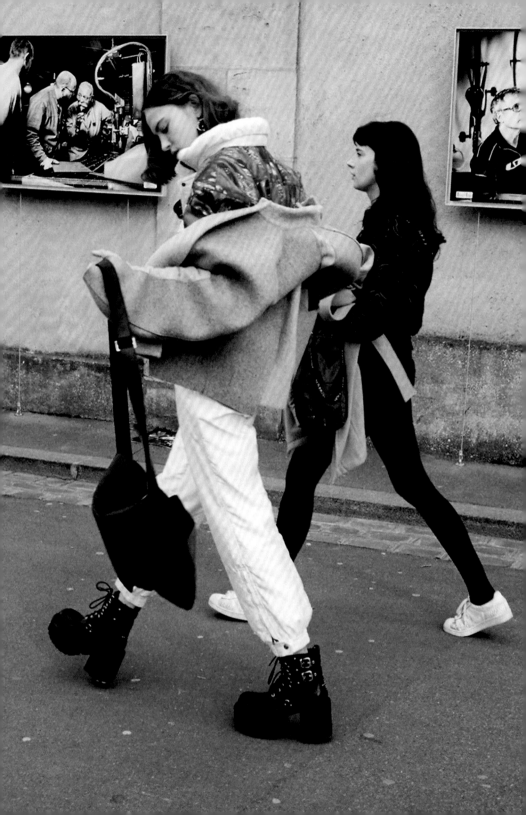

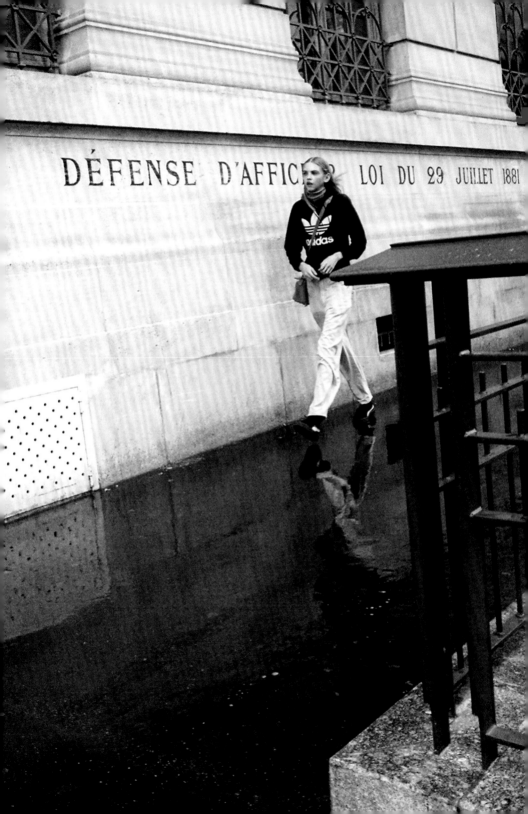

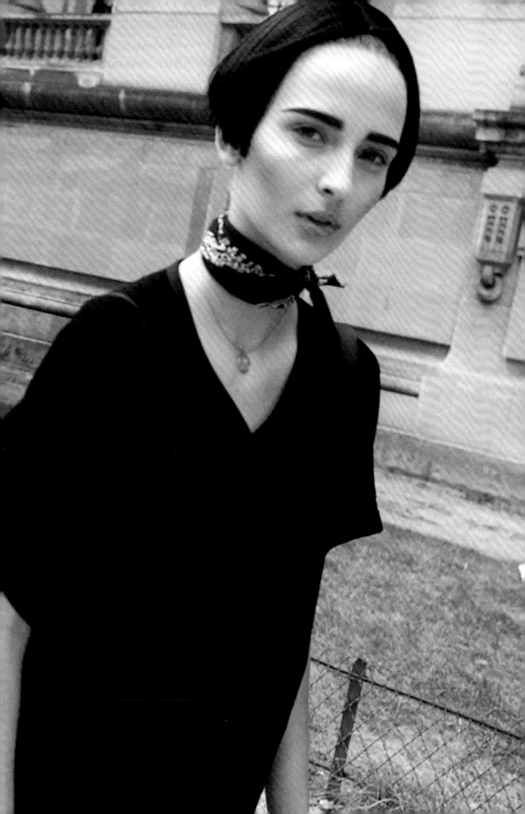

#white_shirts_woman

#crossing

#event_truck

#summer_breeze

#fur_day

#walking

#in_the_crowd

#early_morning

#photogenic
#winter_face
#snowy_day
#belt_over_coat
#milano_bus
#high_fashin
#break_time
#waiting_line
#ticketing
#tall_models

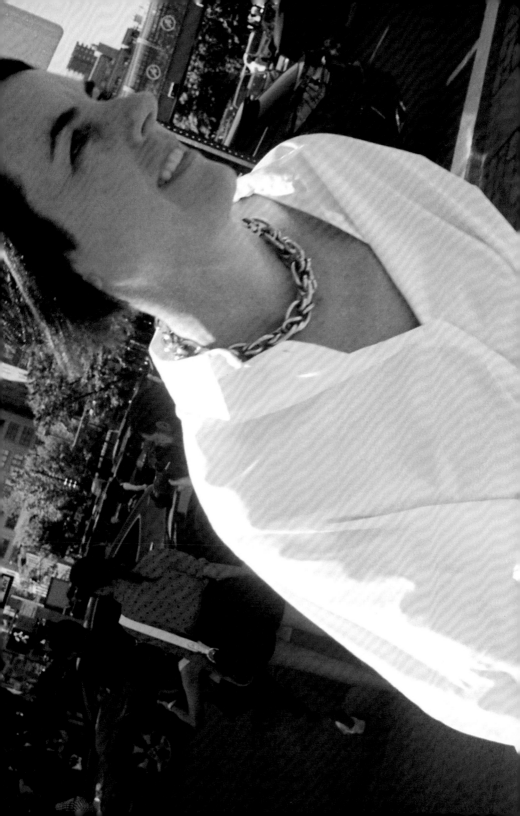

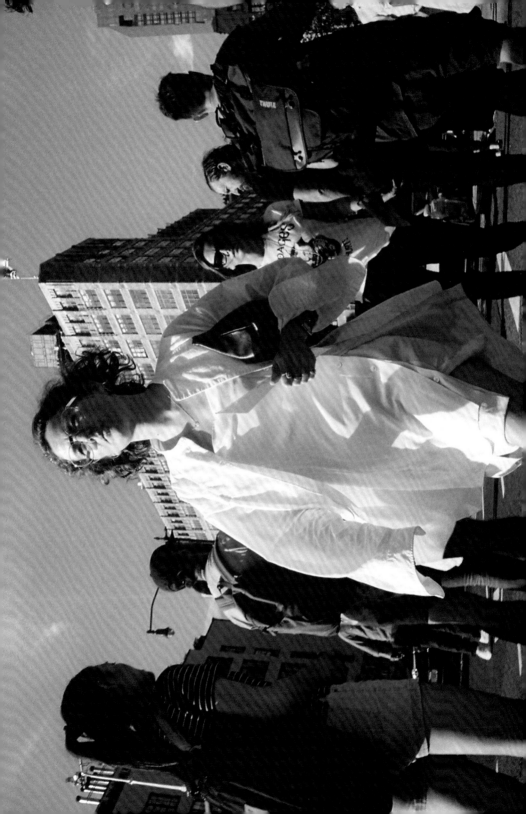

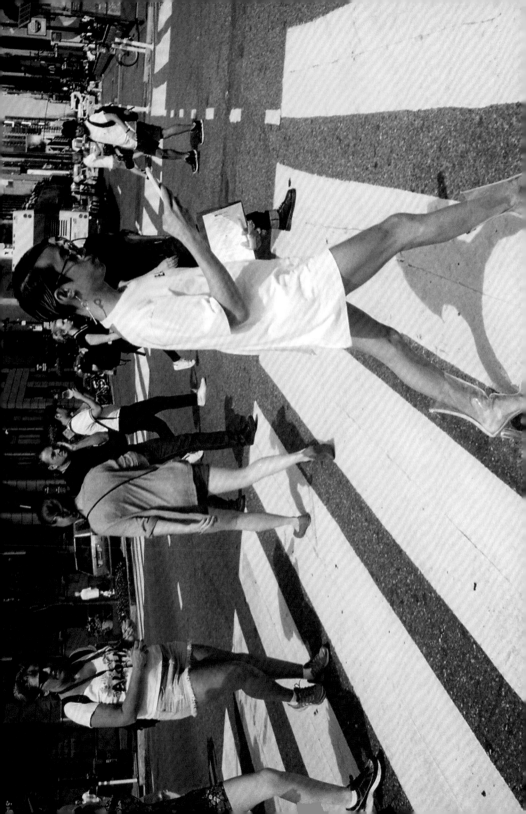

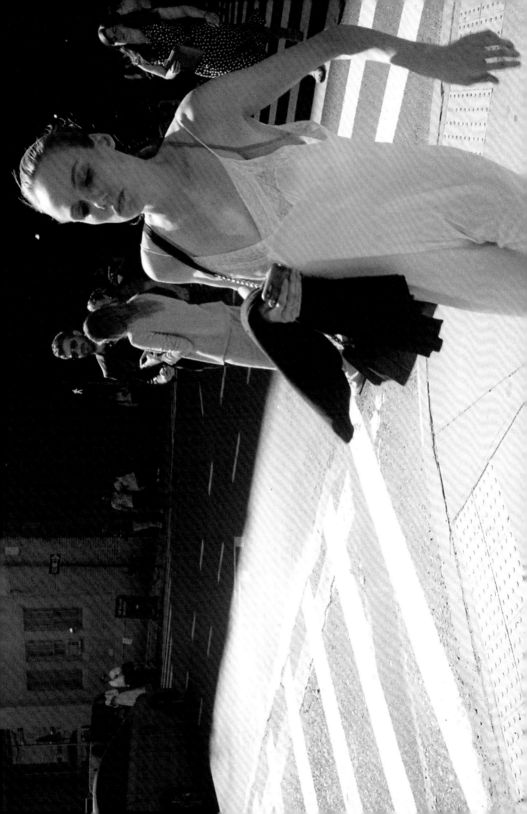

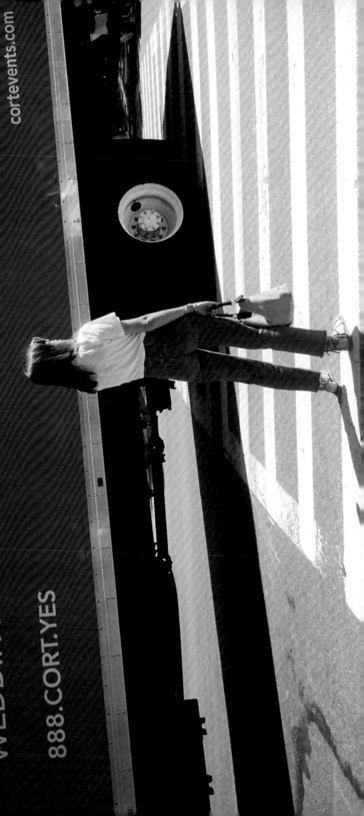

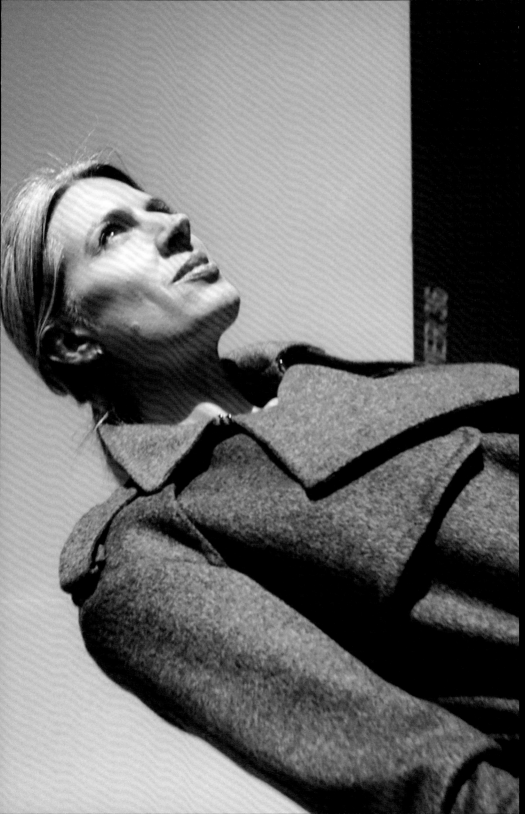

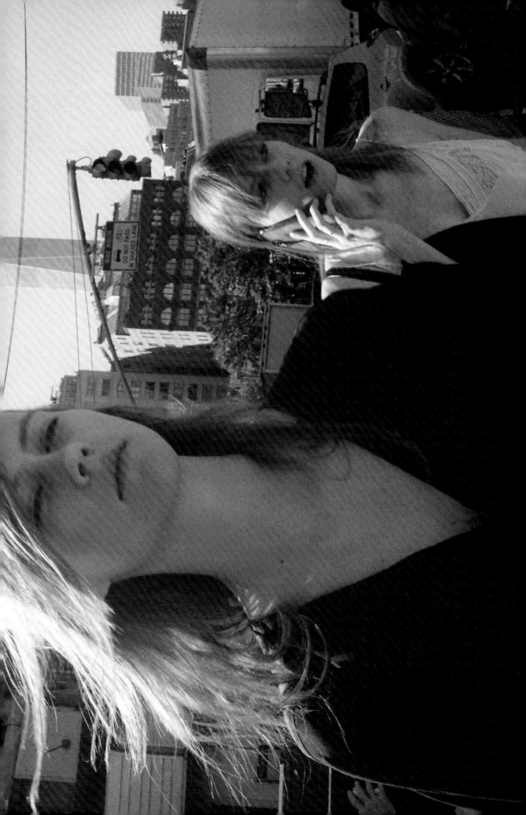

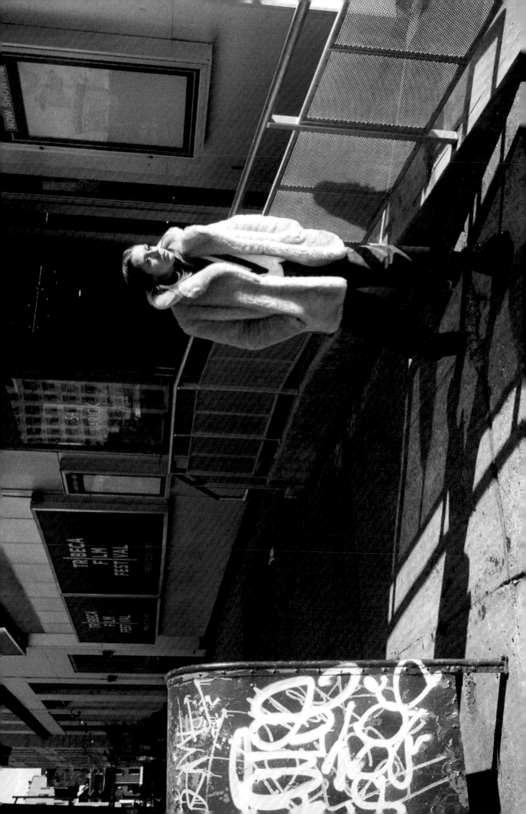

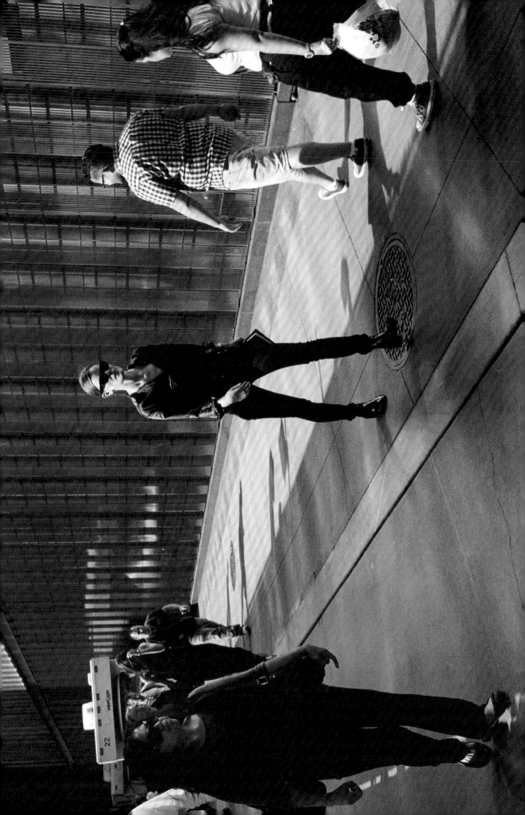

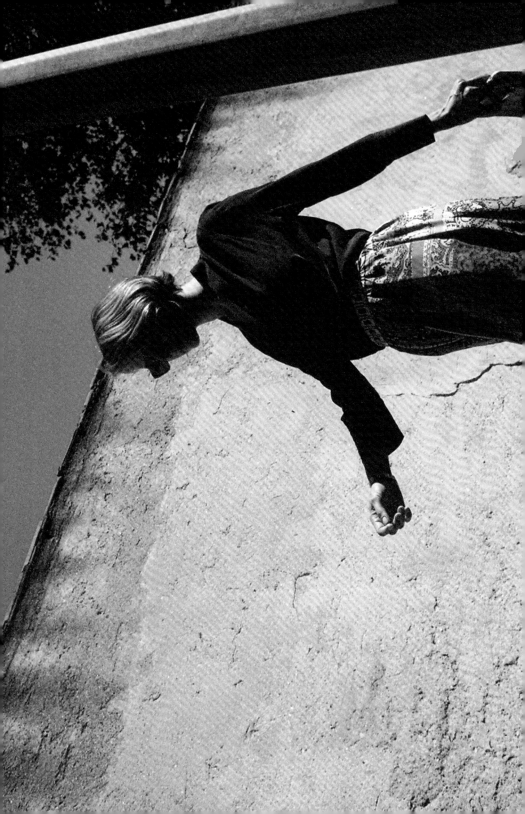

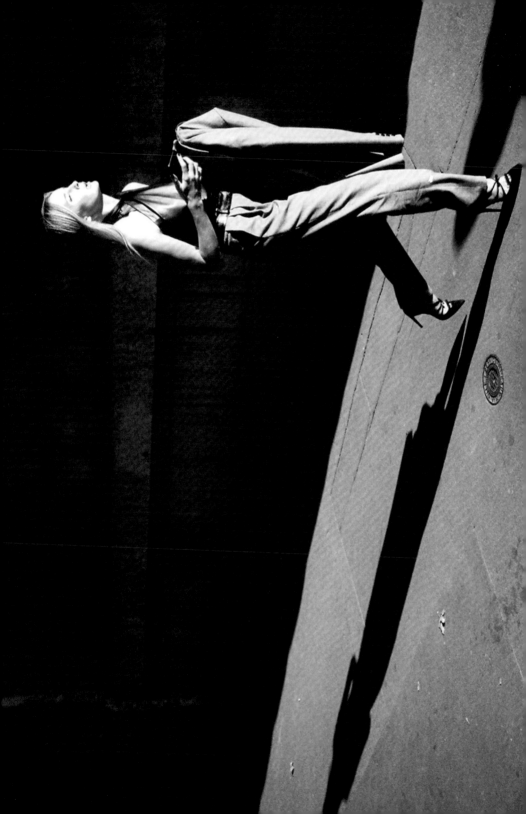

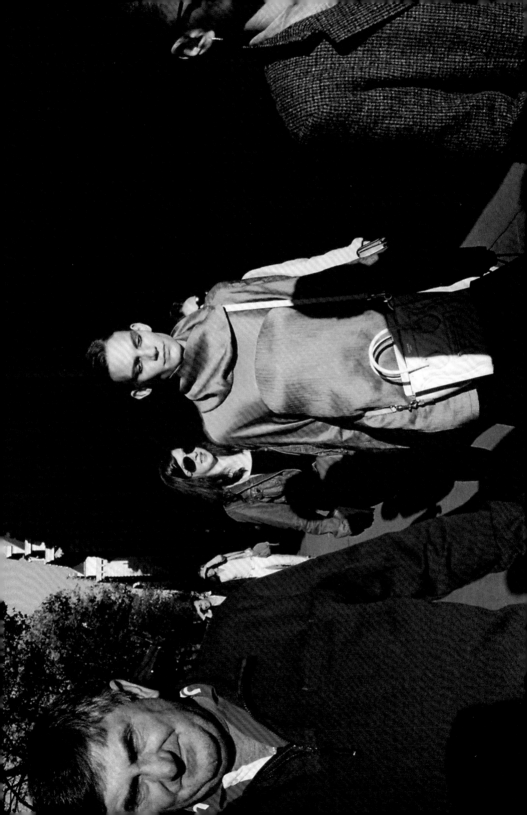

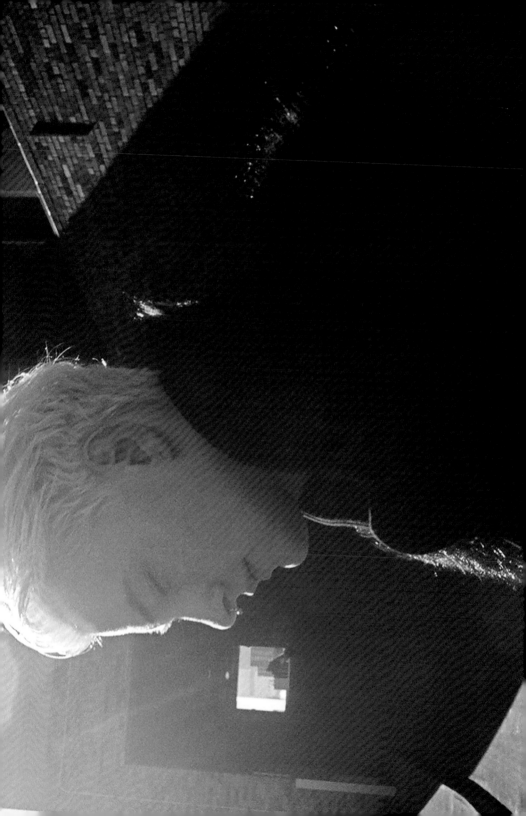

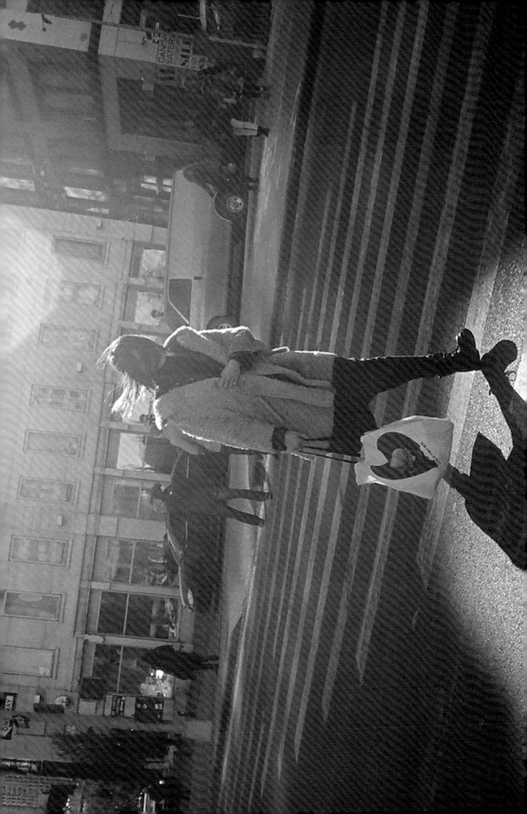

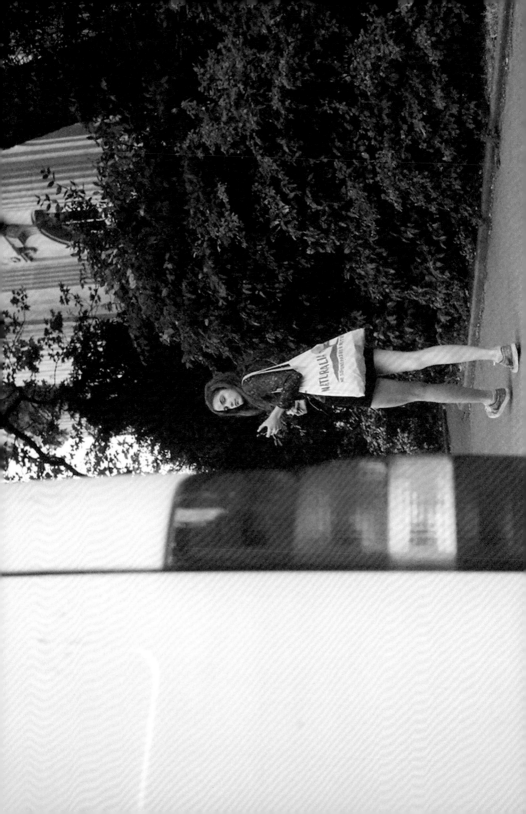

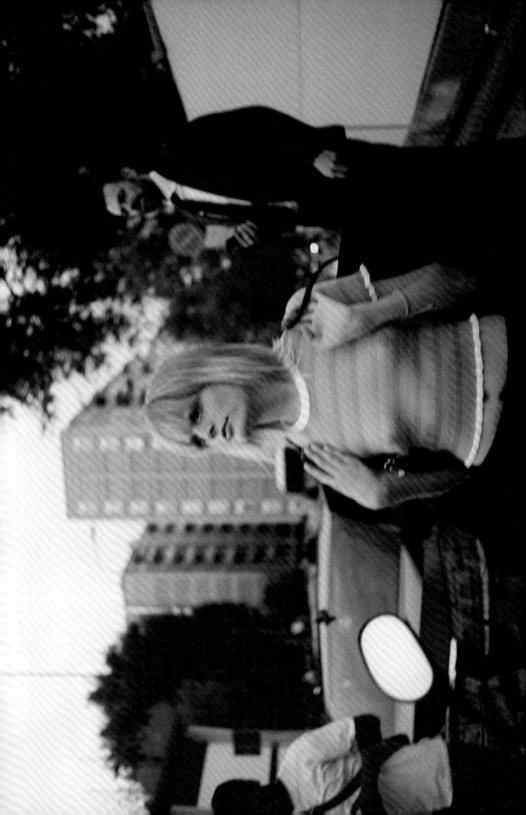

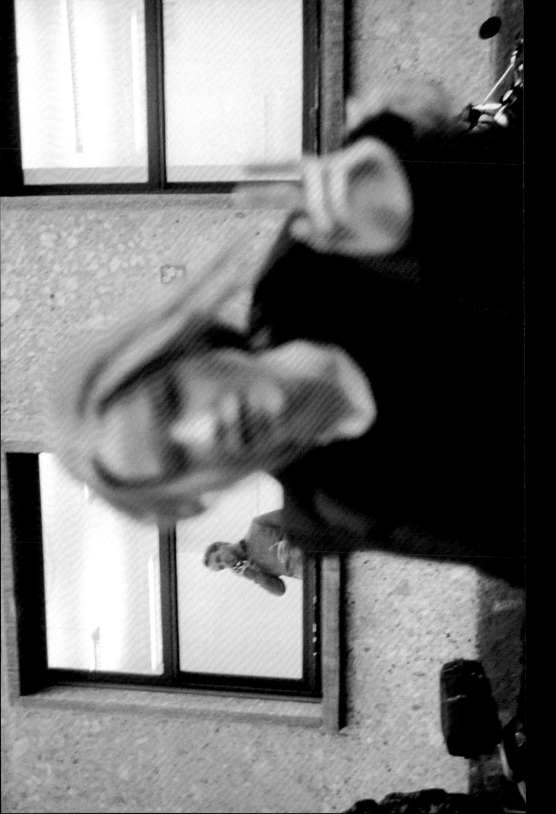

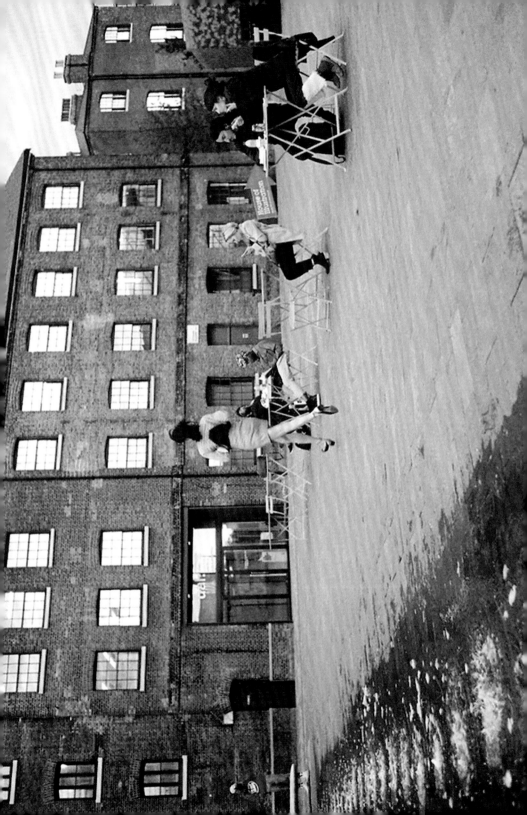

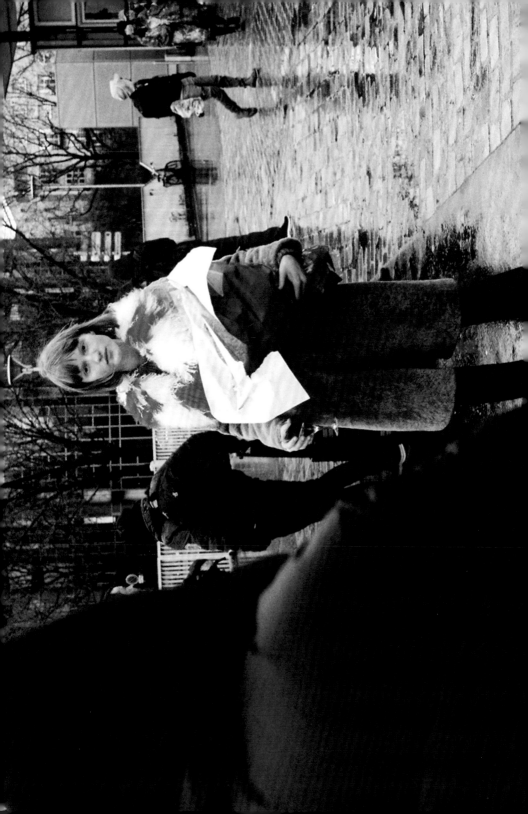

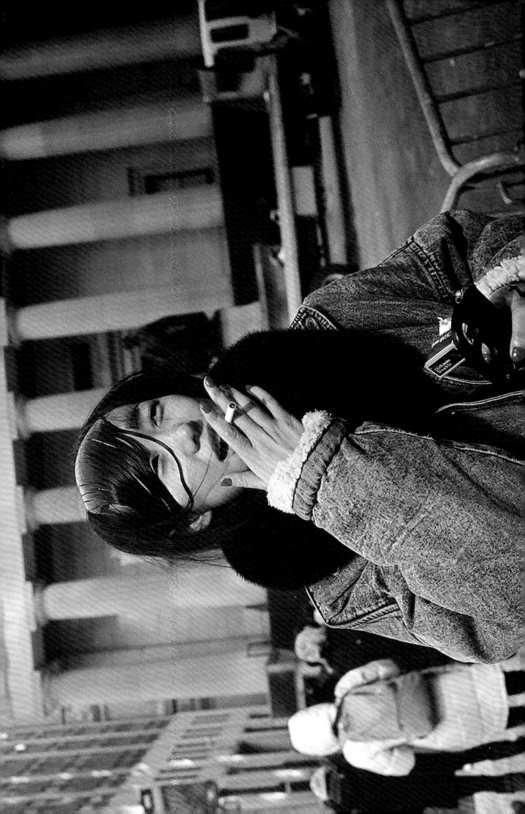

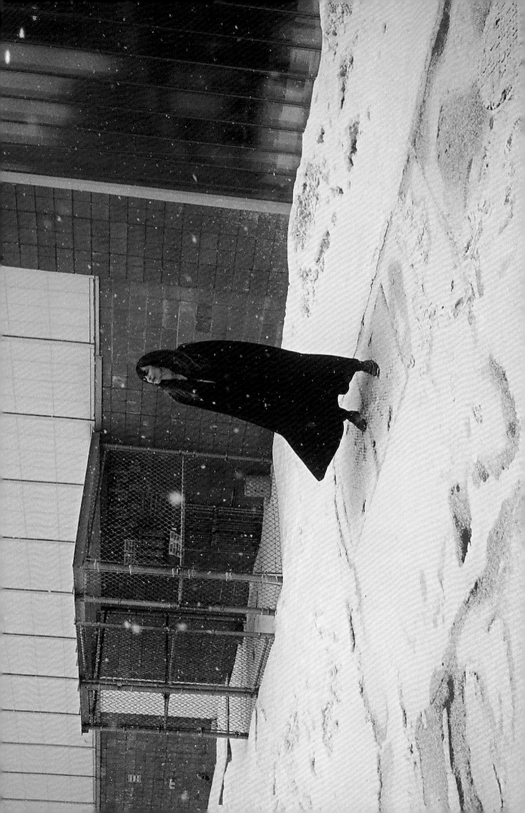

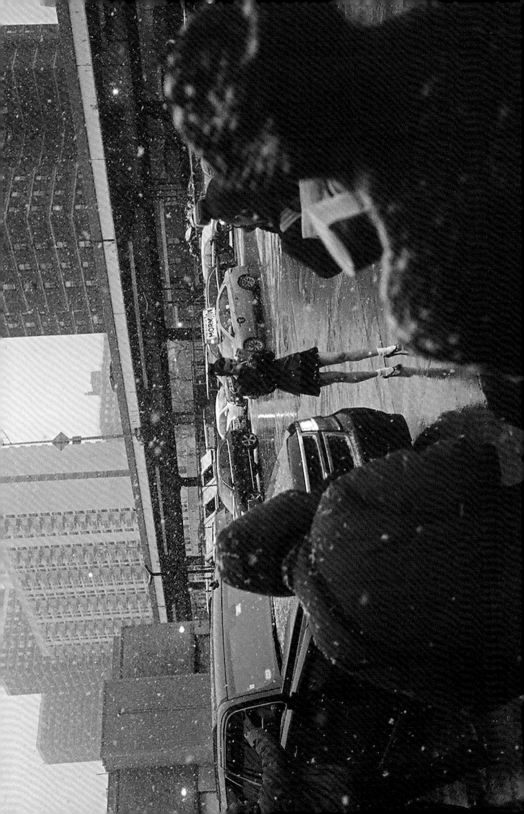

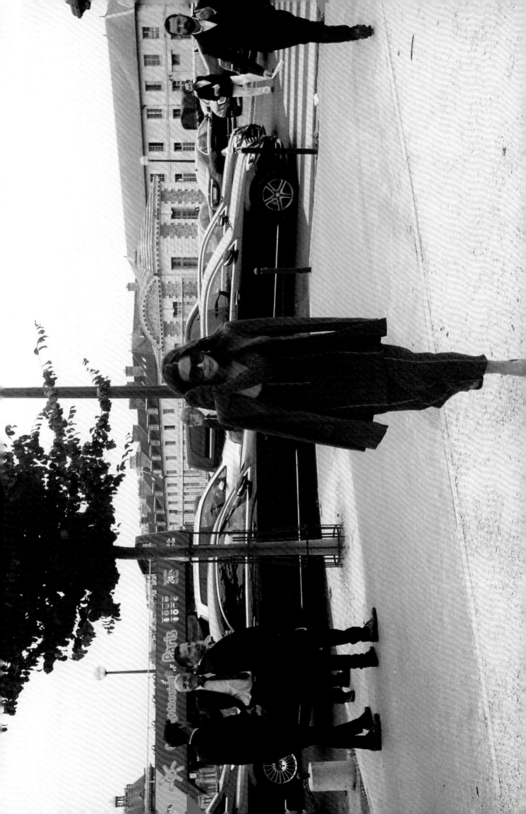

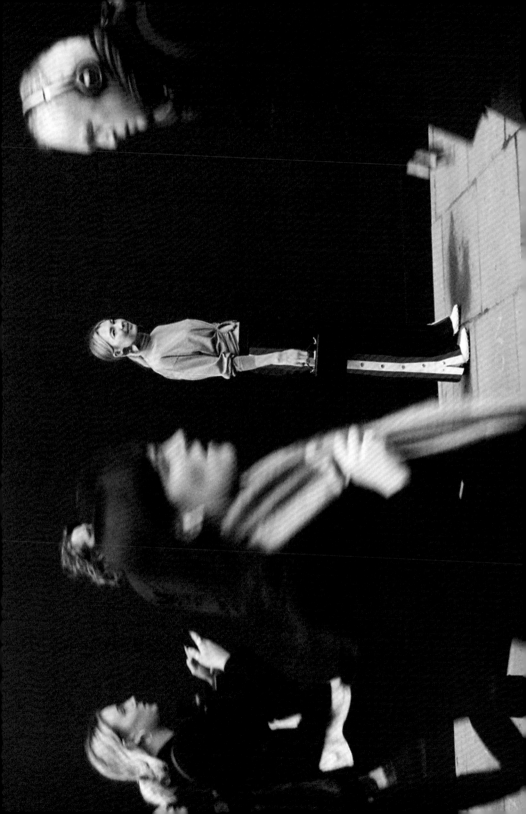

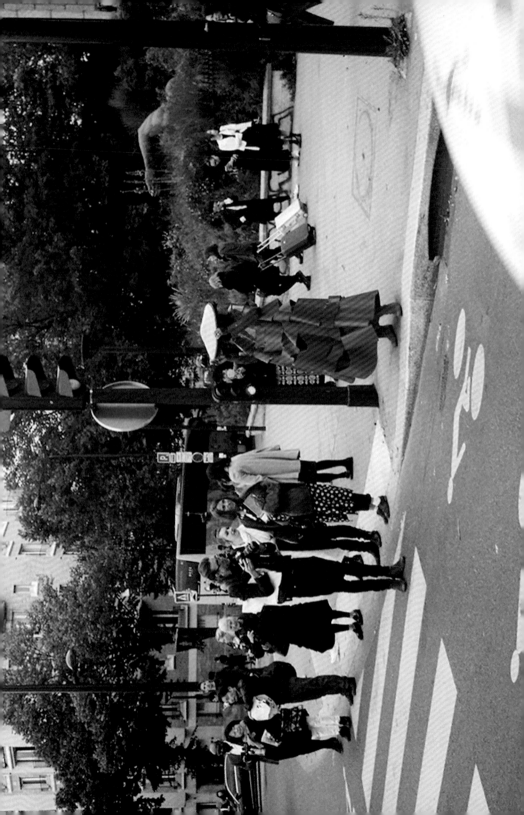

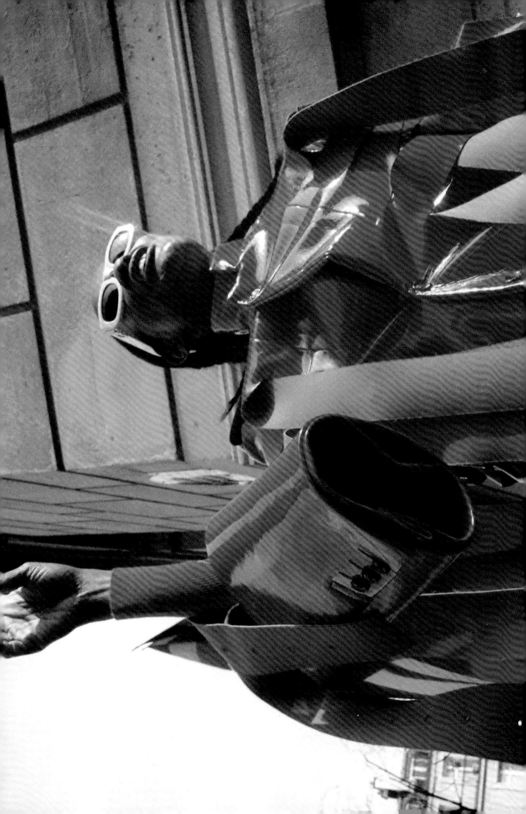

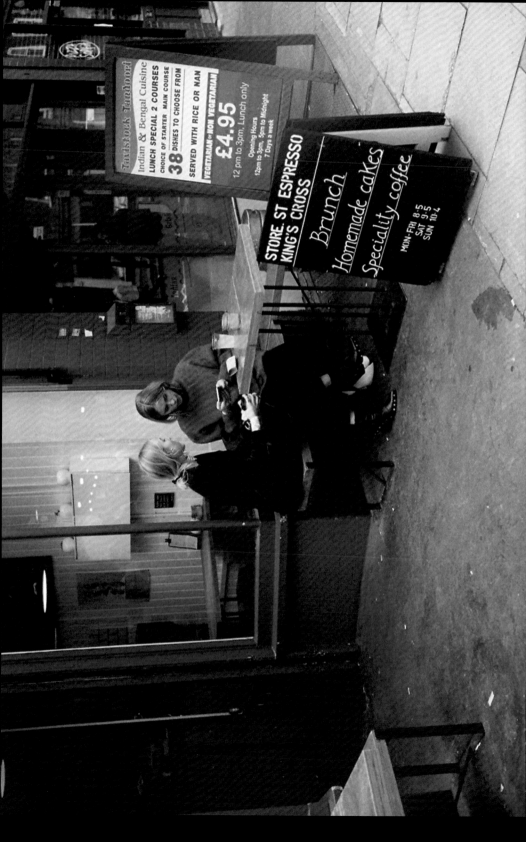

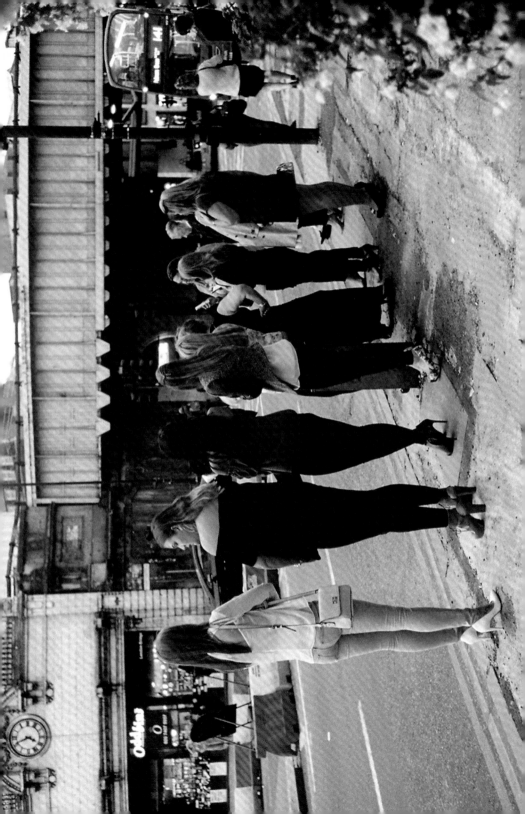

#street_walk

#stunning_bag

#important_call

#D&G_art

#eyes_wide_open

#security

#waiting_line

#hands

#editors

#phoebe_arnold

#gold_teeth

#faces_in_the_bus

#london_underground

#lion_hat

#cold_day

#gesture

#street_talk

#waiting_face

#winter_talk

#celebrity_on_the_street

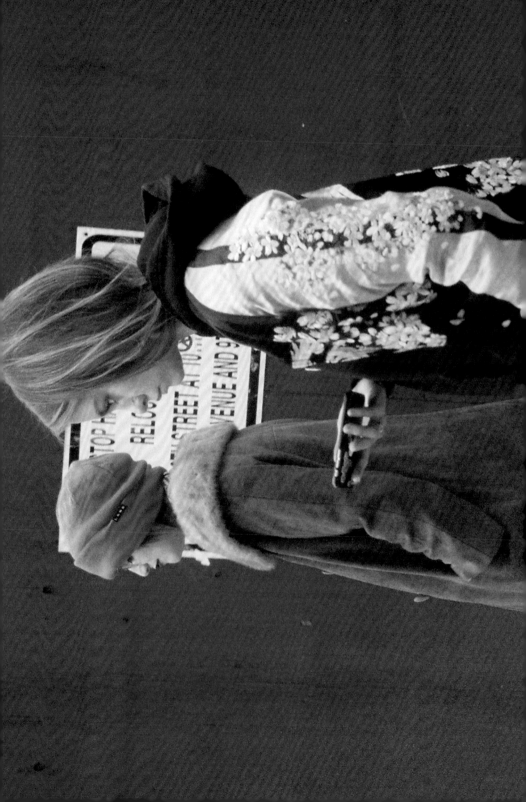

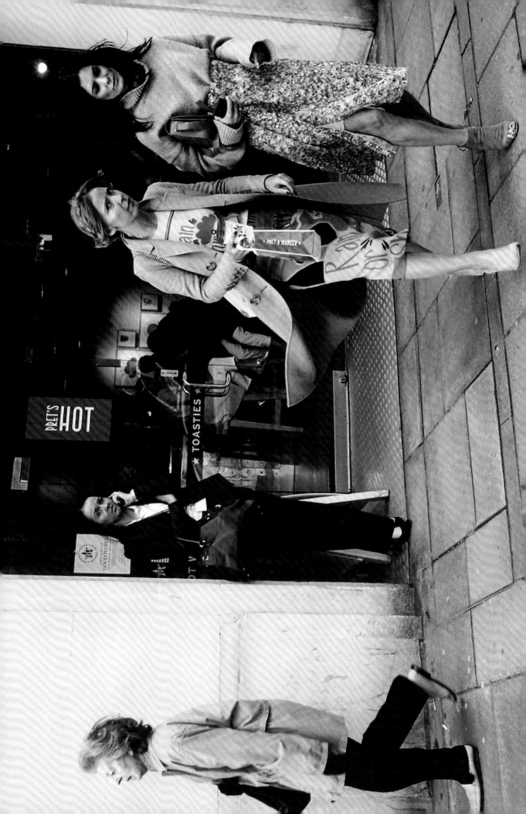

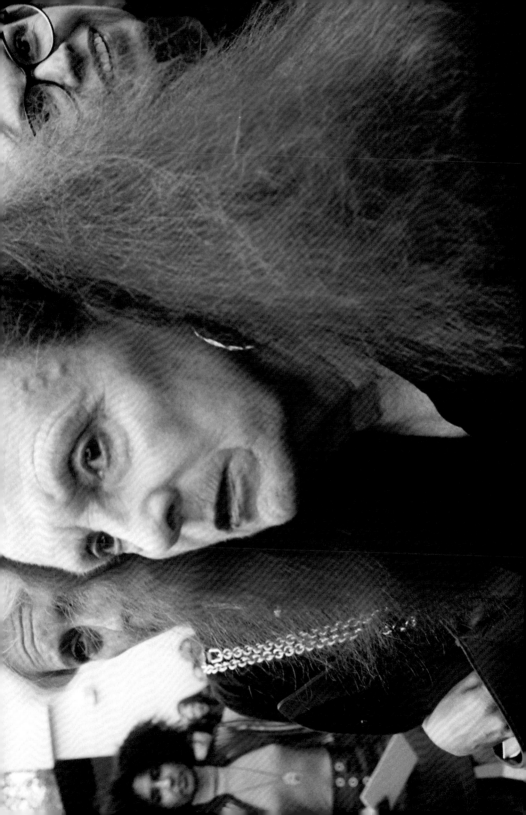

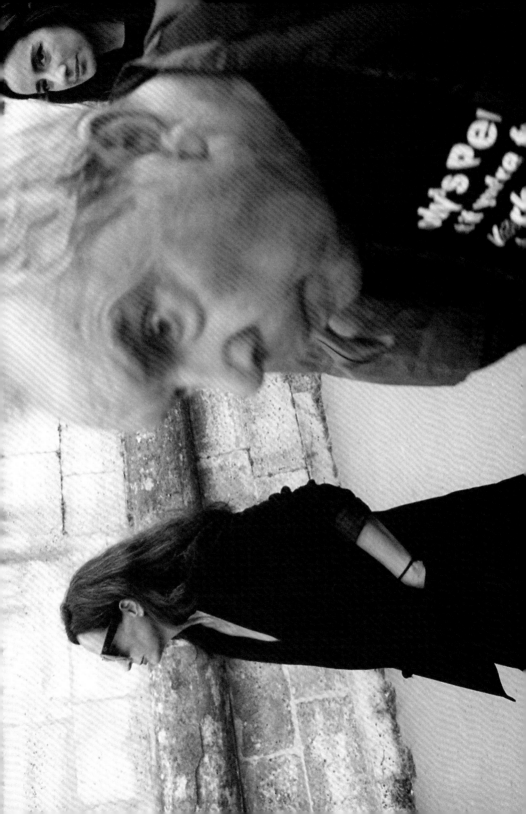

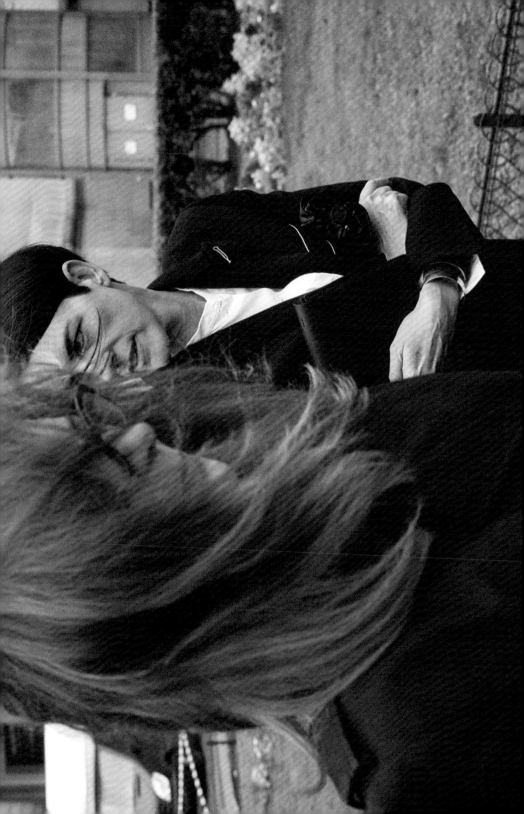

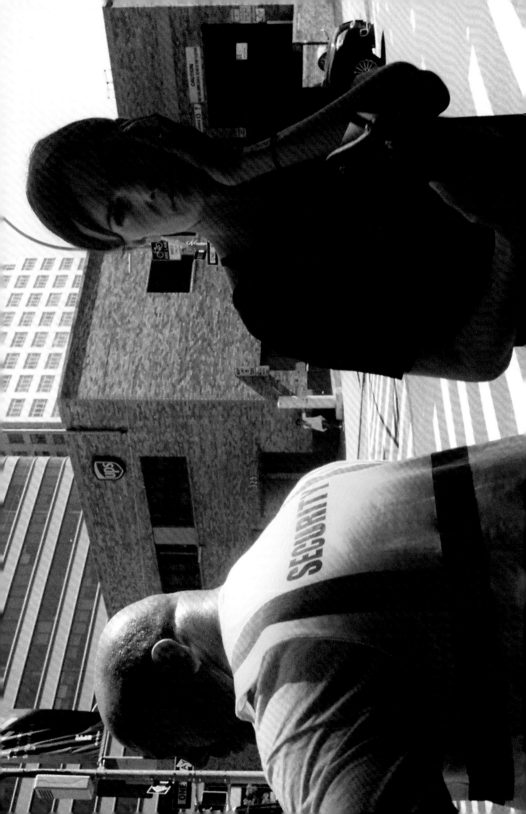

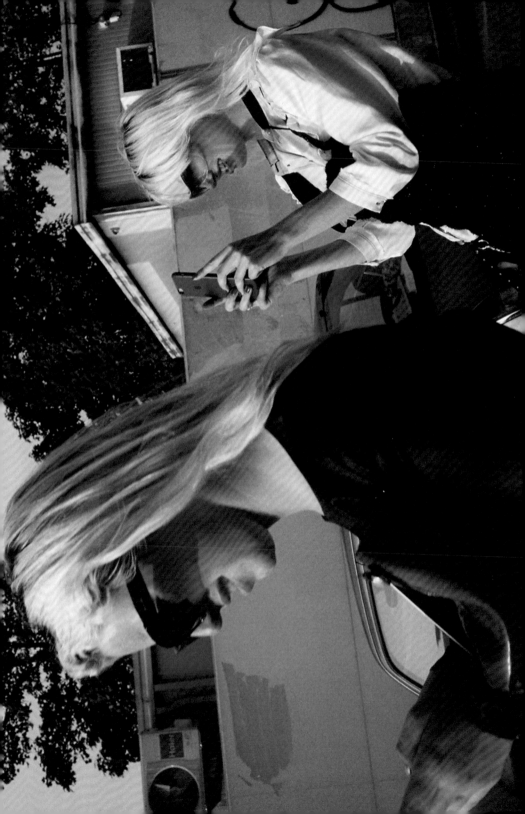

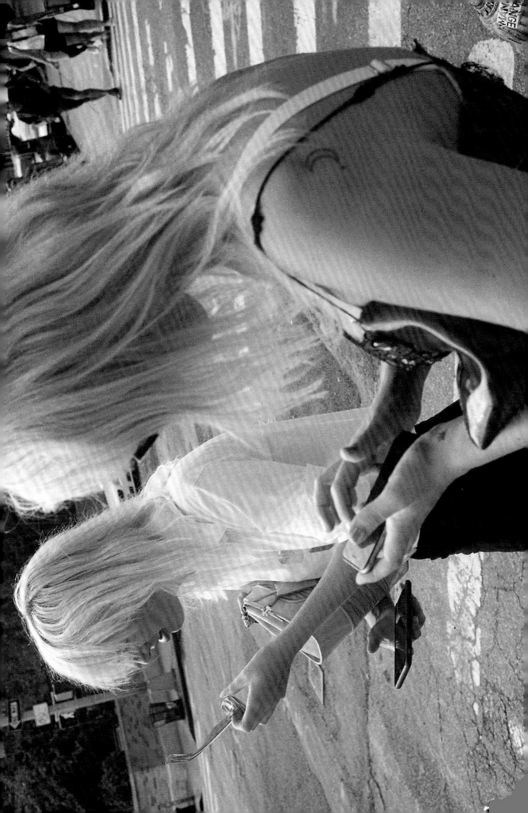

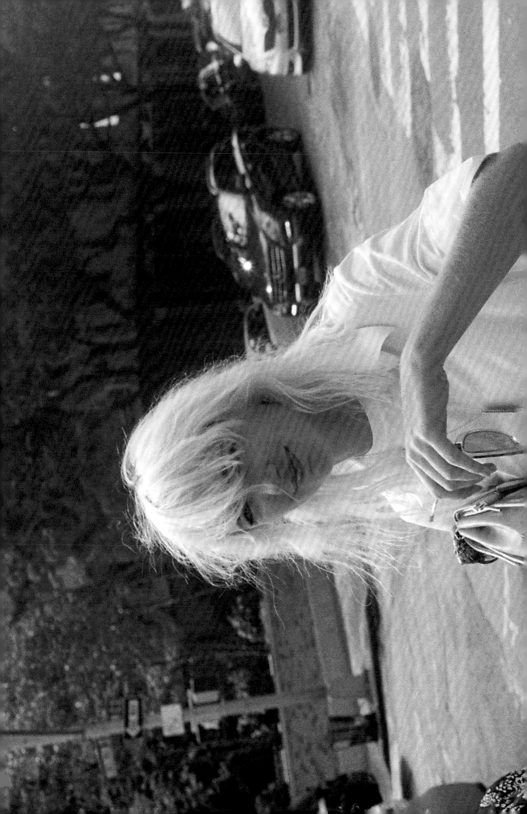

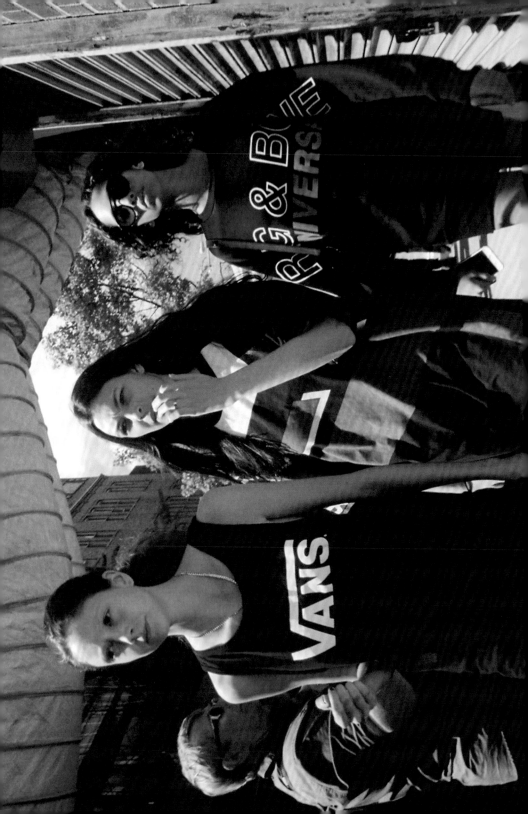

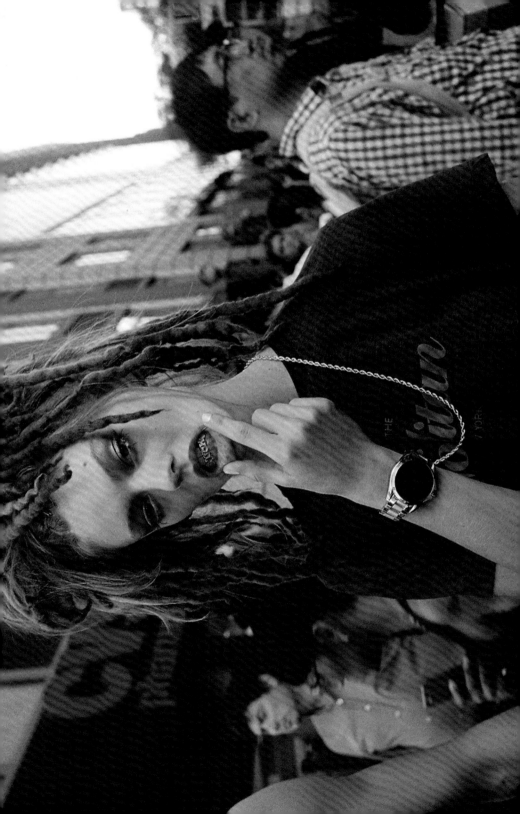

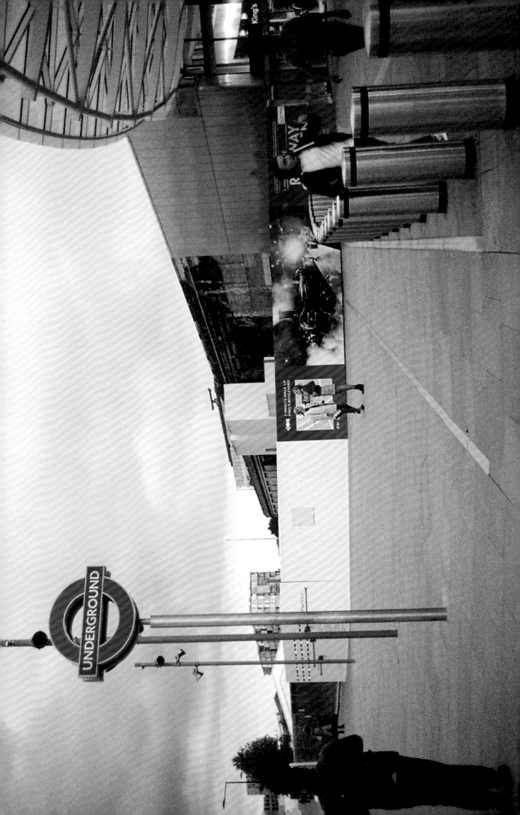

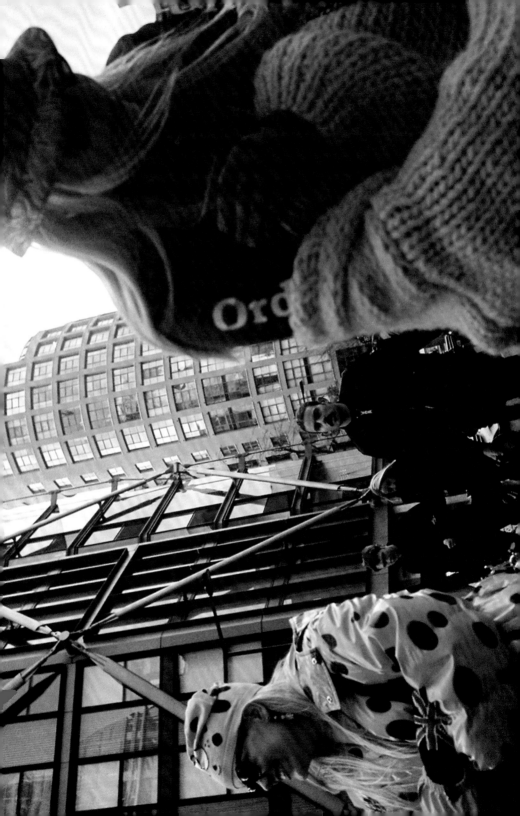

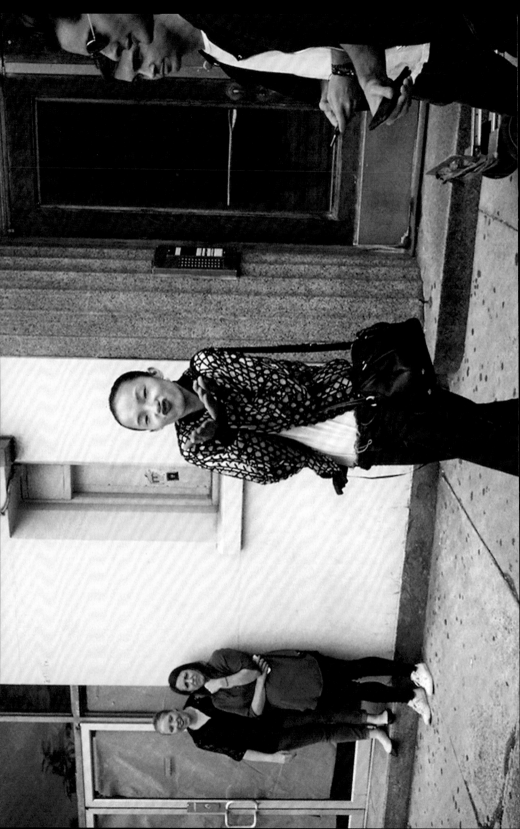

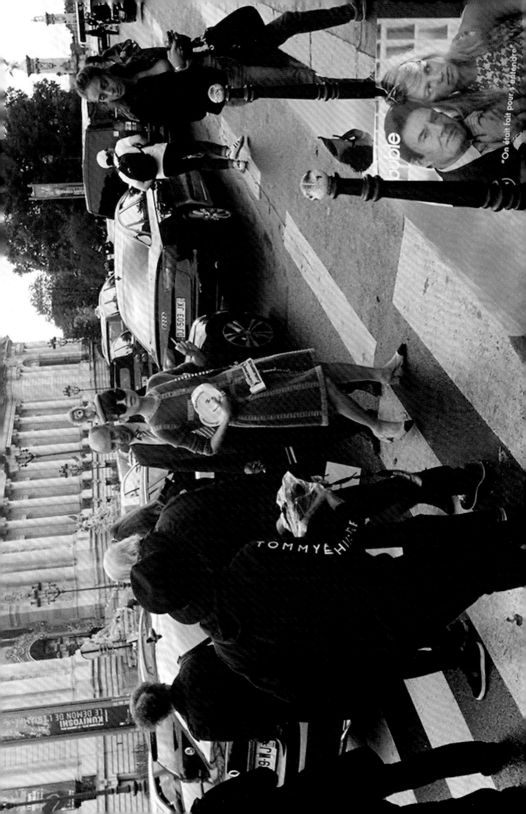

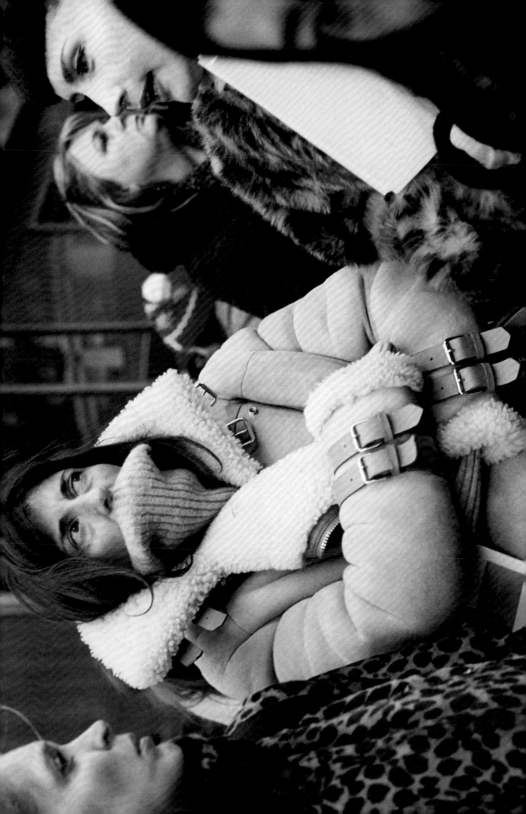

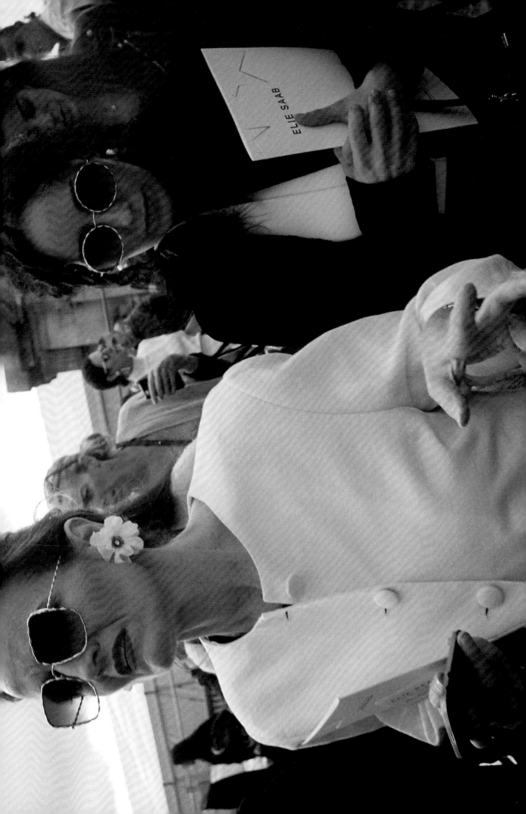

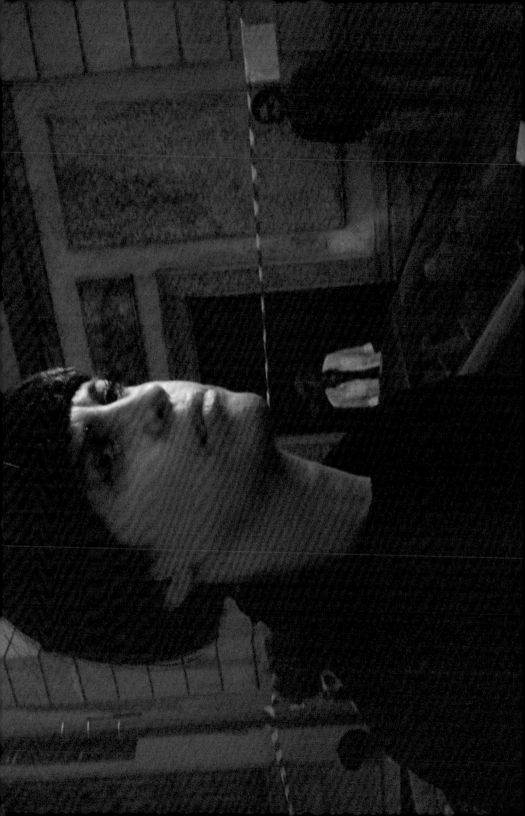

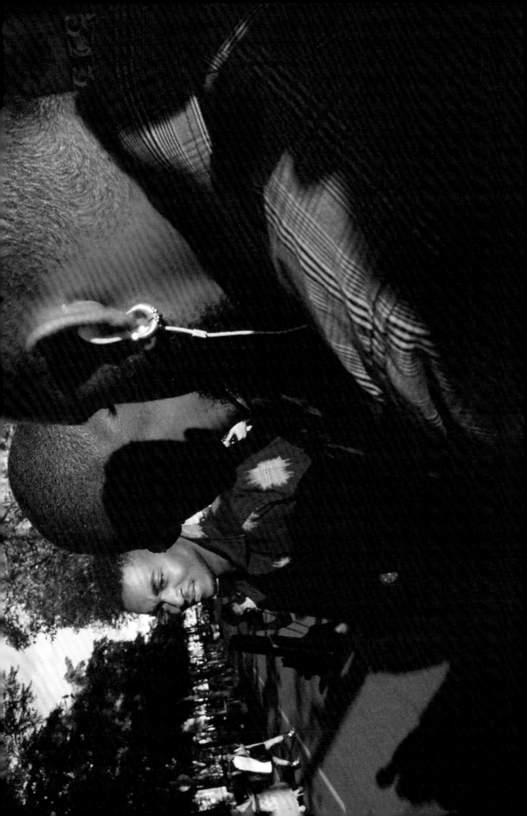

#big_earrings
#quick_smile
#J'ADIOR
#tight_stilettos
#silver_bag
#eyelashes
#winter_coat
#after_rain
#touching_sunglasses
#interesting_look

#tight_shot

#worried_face

#heavy_earring

#scarf_on_neck

#thigh_high_boots

#loafers

#neon_painting

#under_the_umbrella

#line_walking

#legs

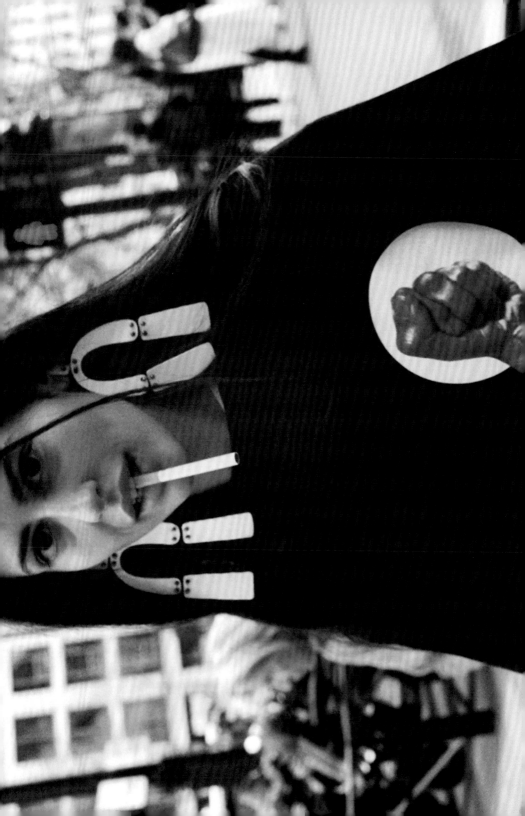

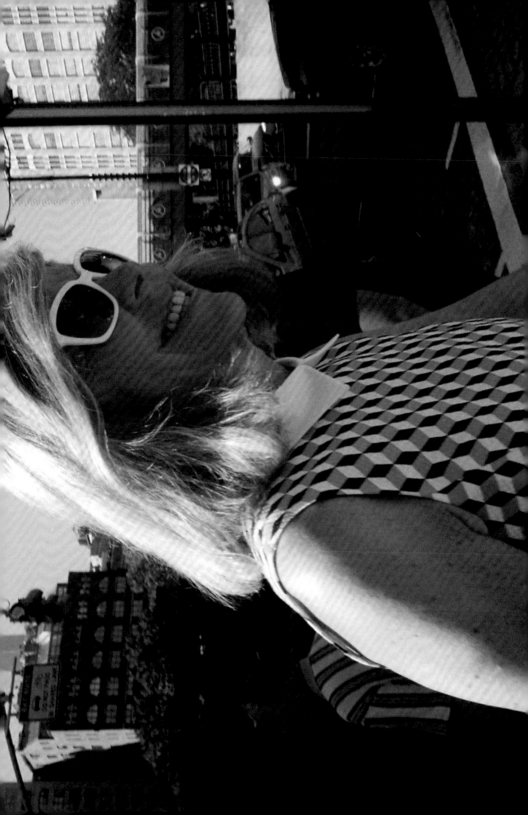

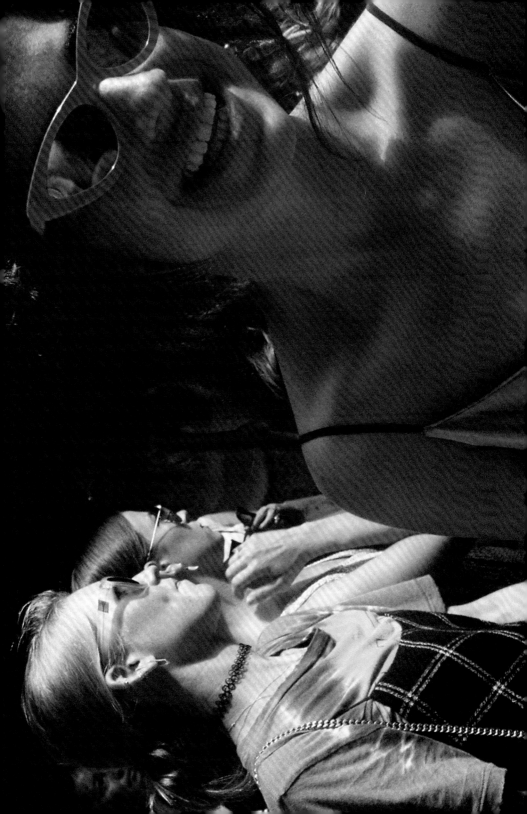

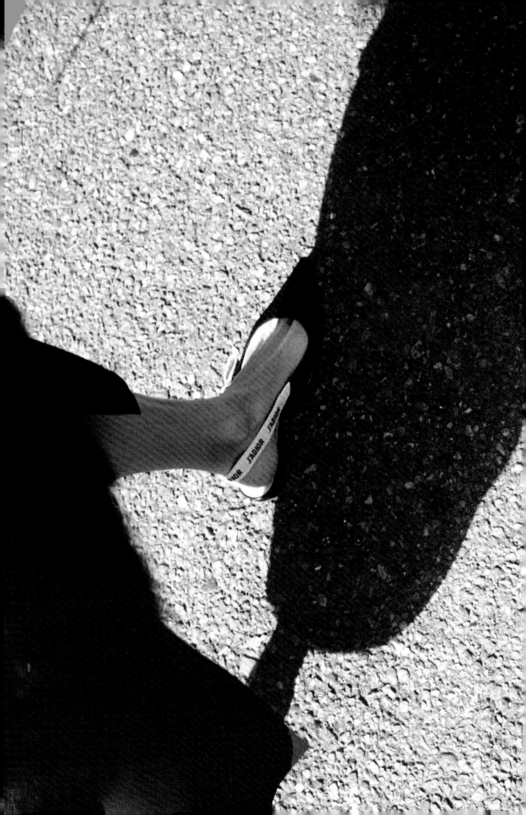

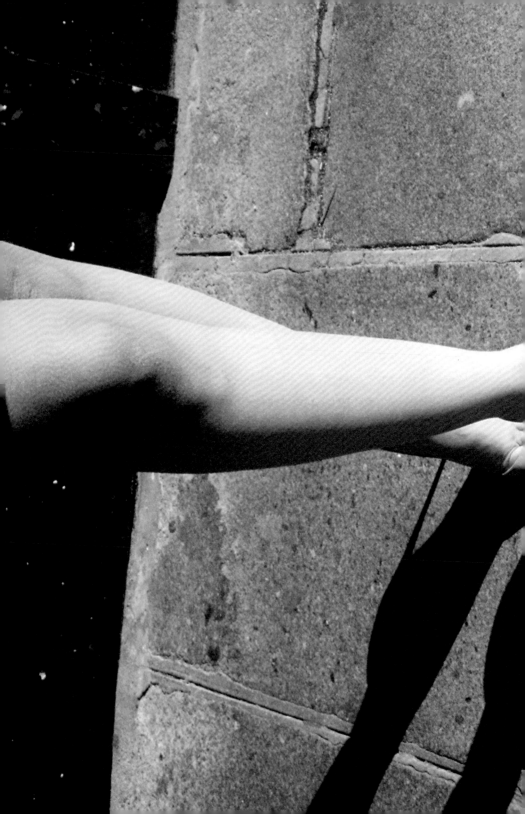

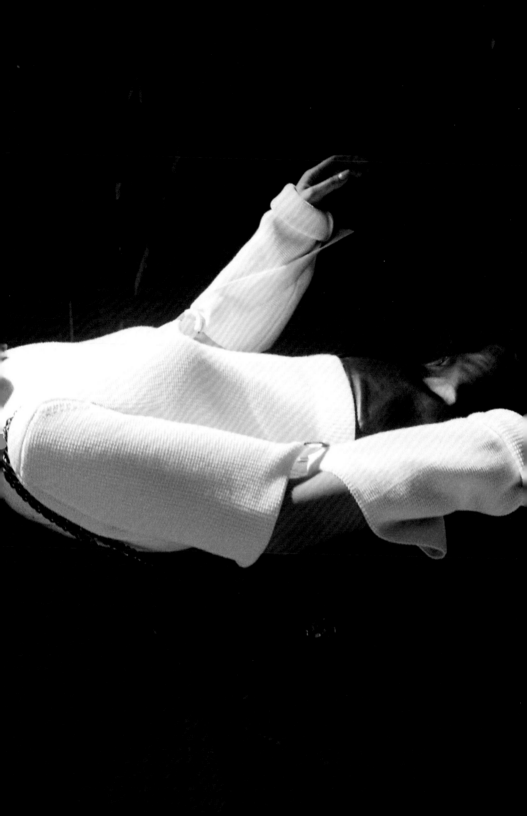

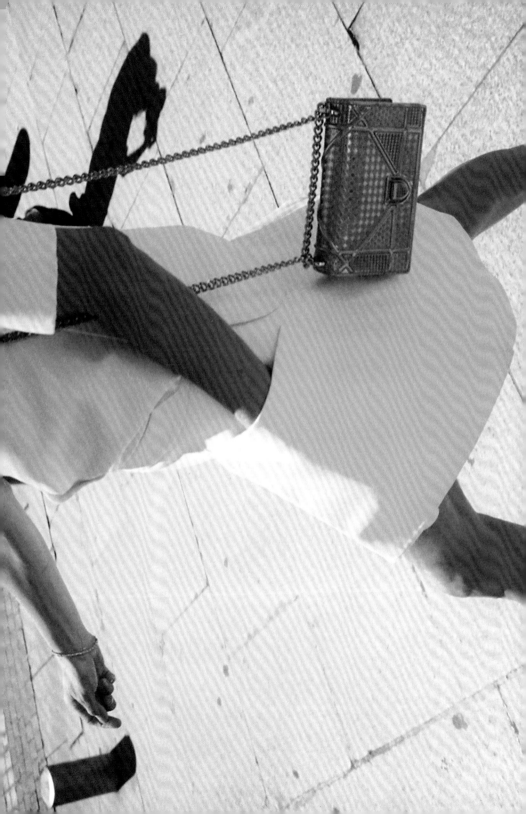

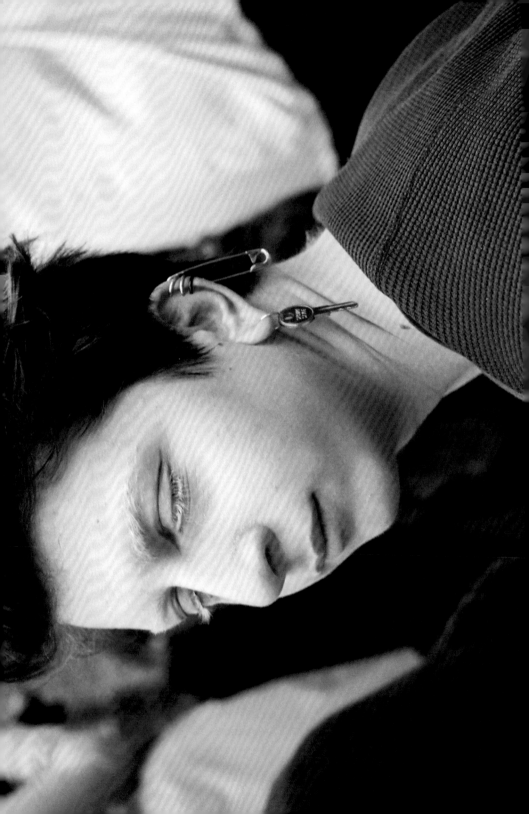

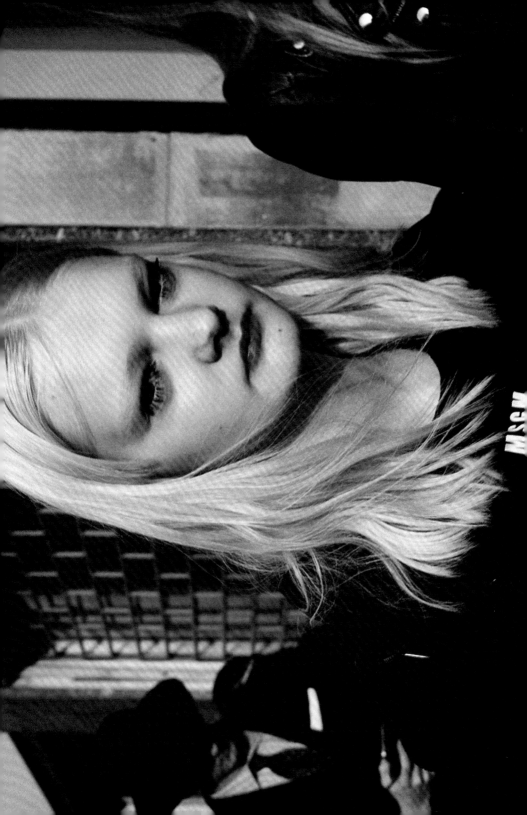

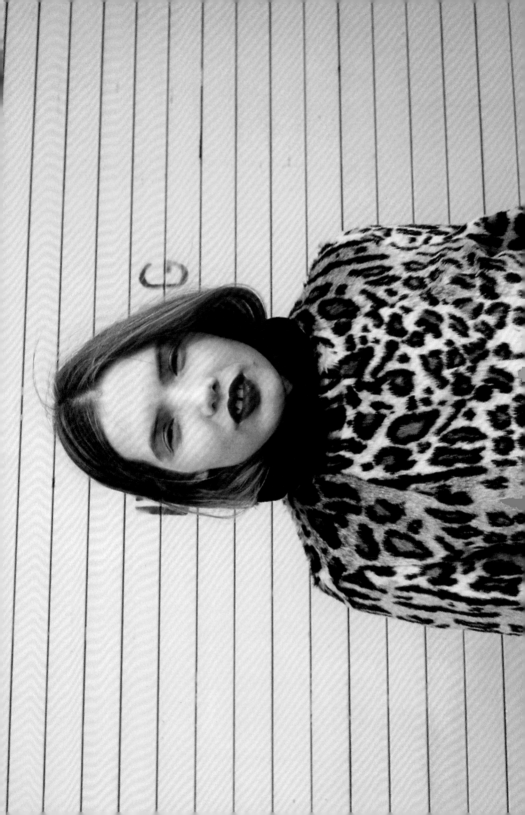

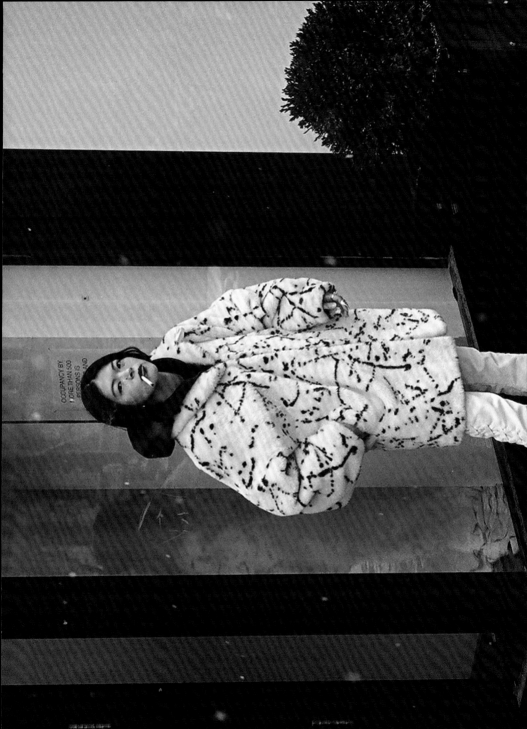

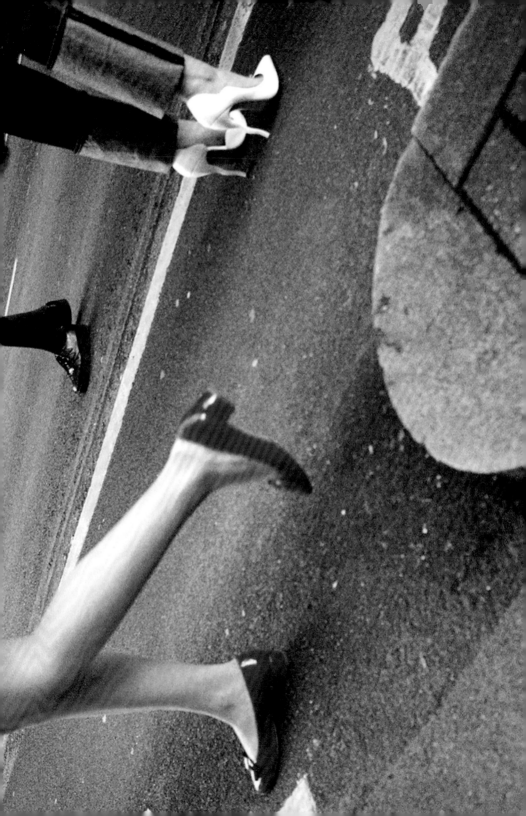

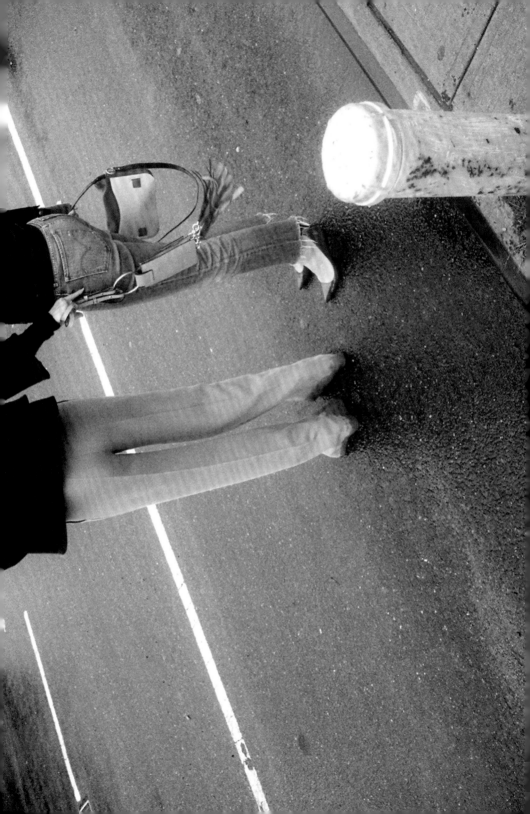

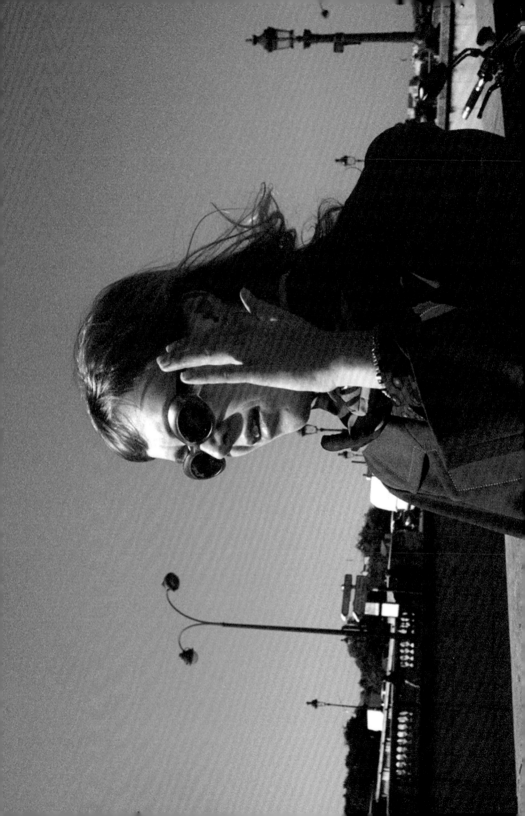

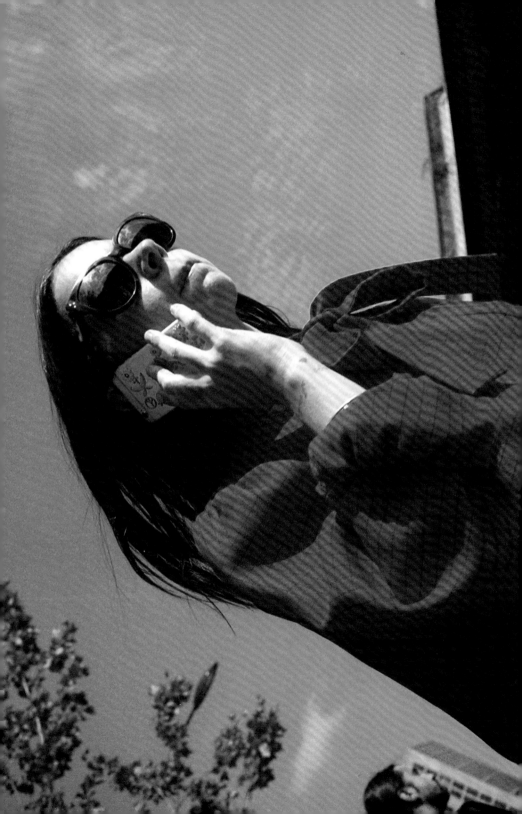

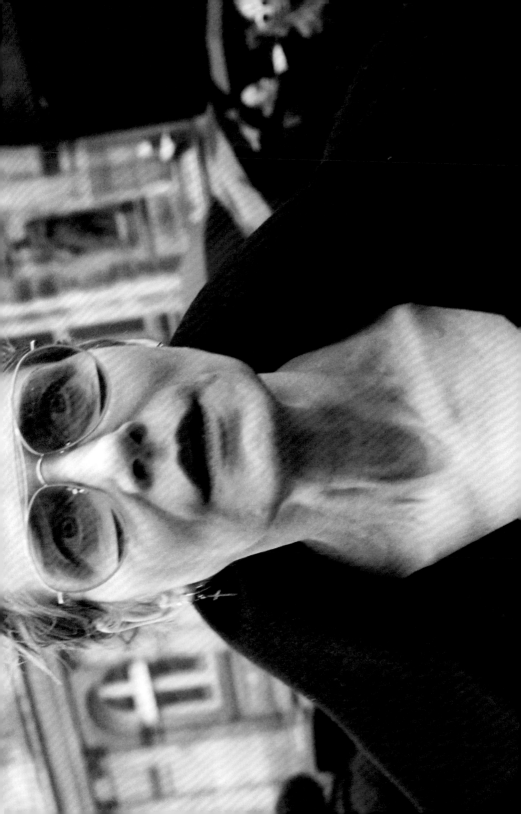

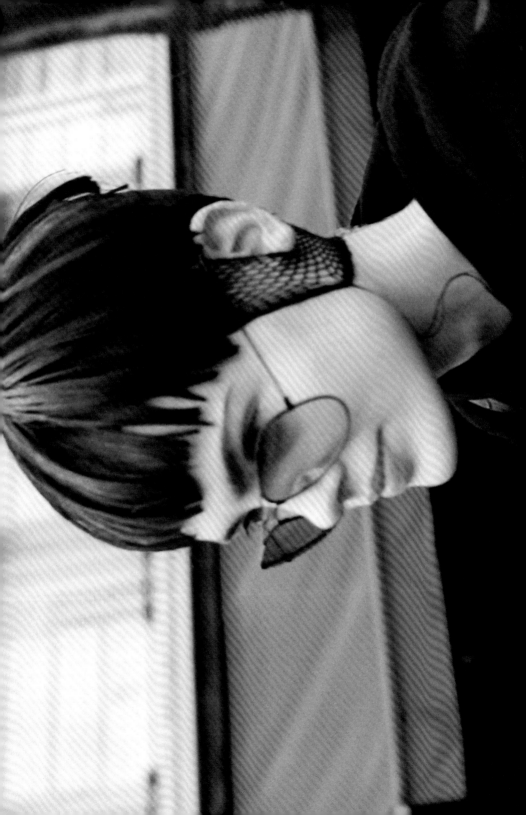

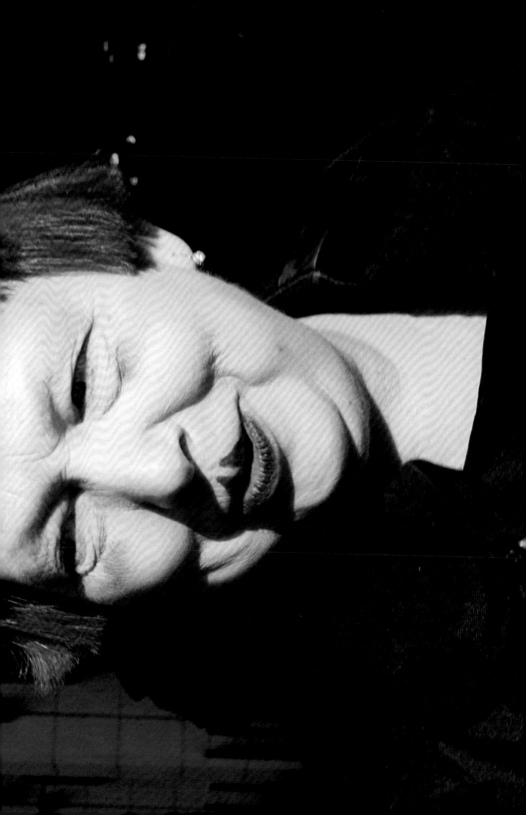

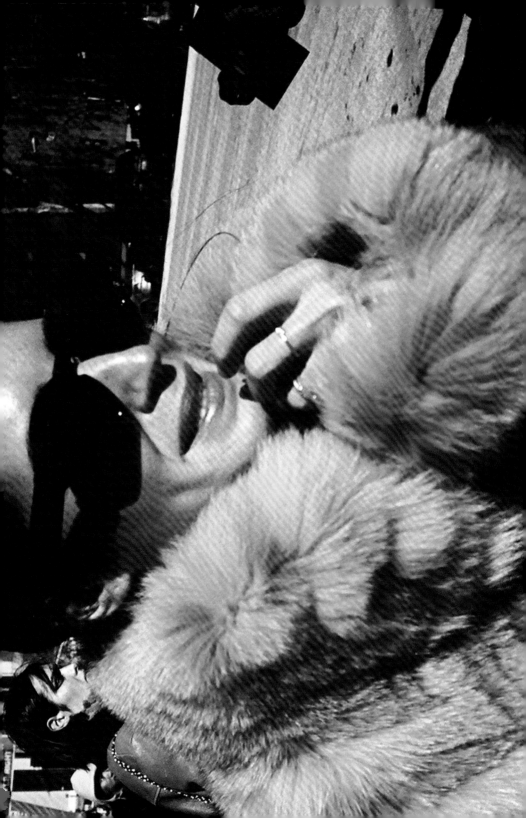

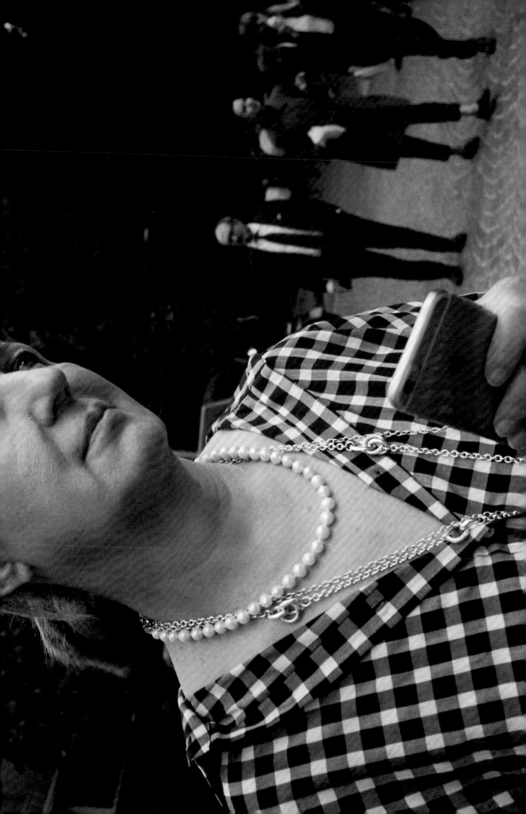

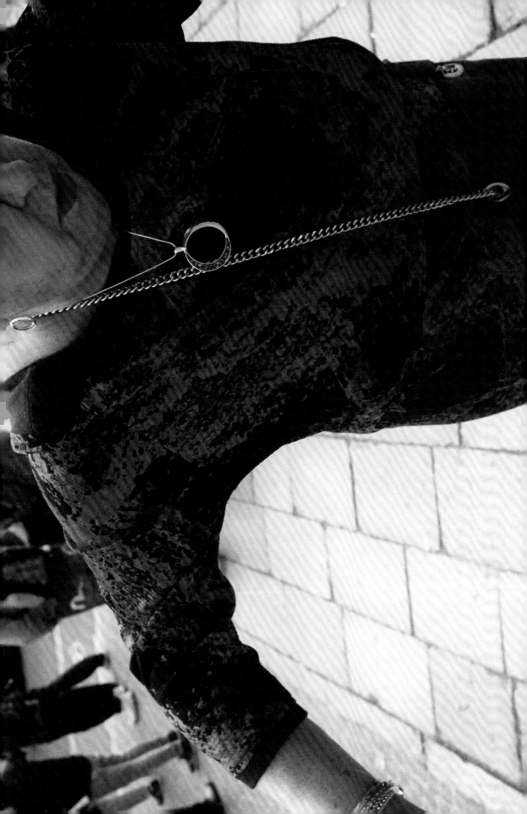

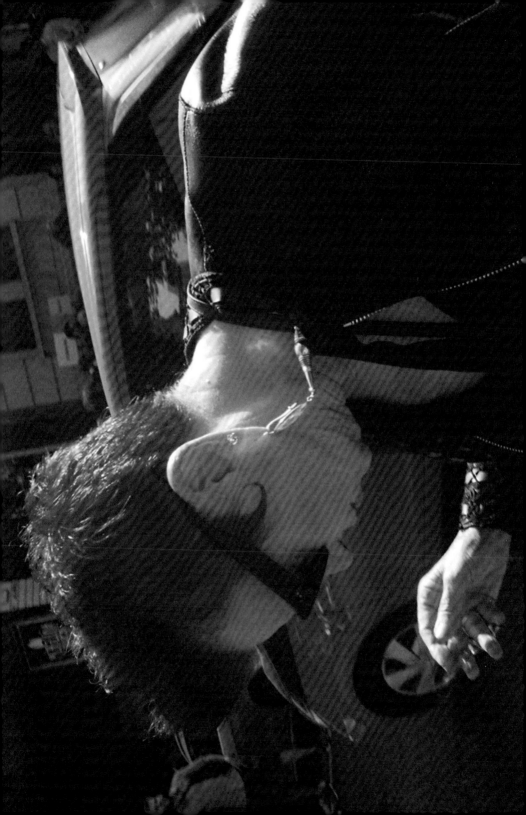

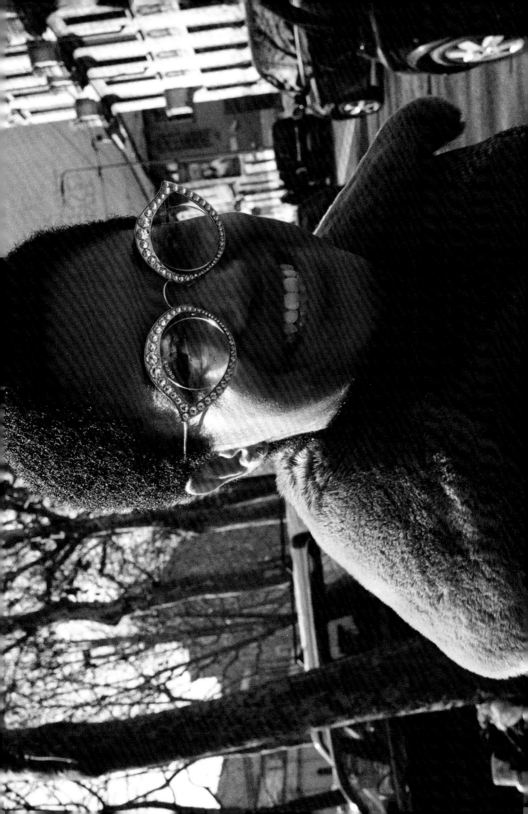

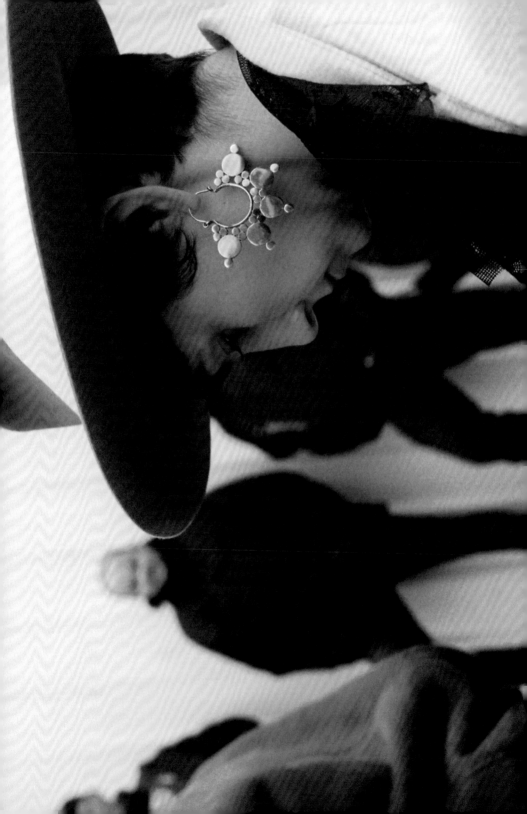

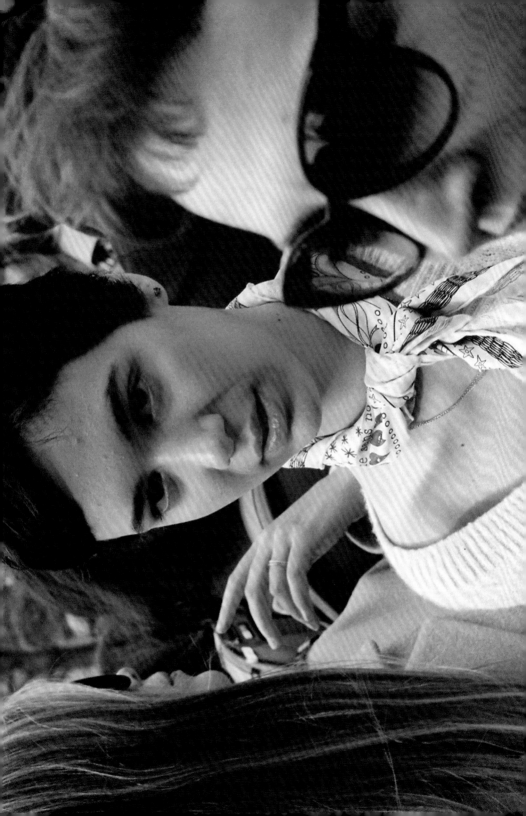

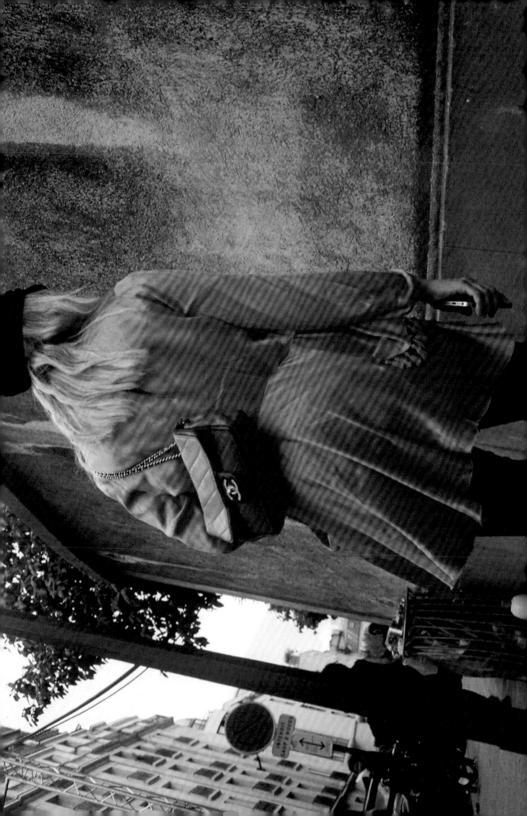

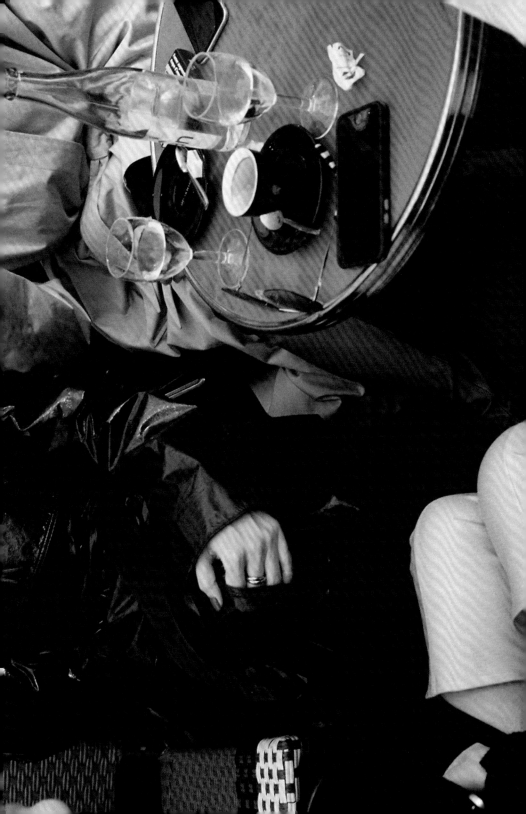

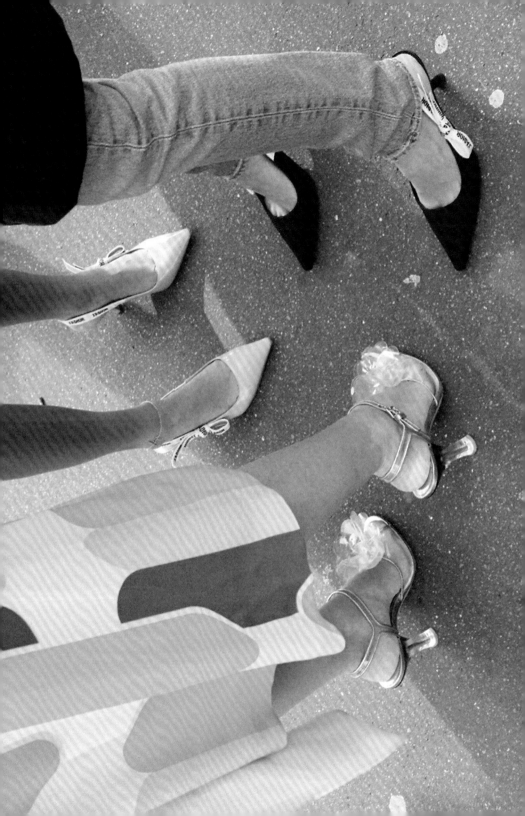

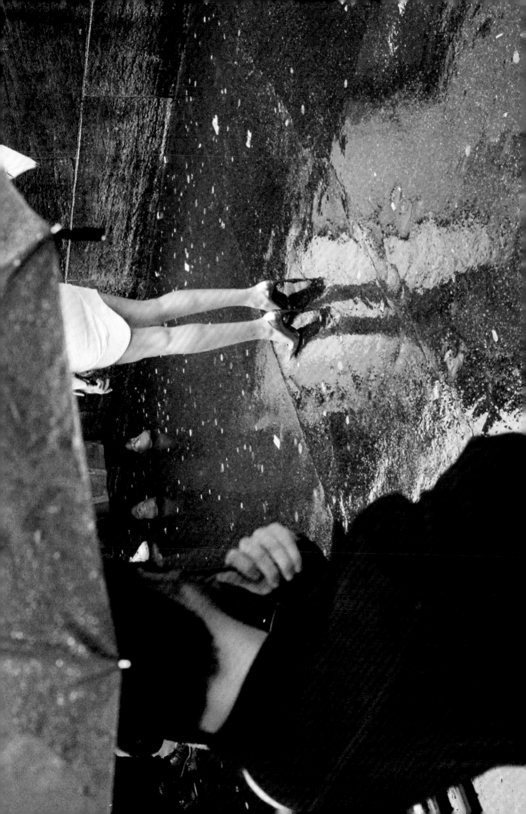

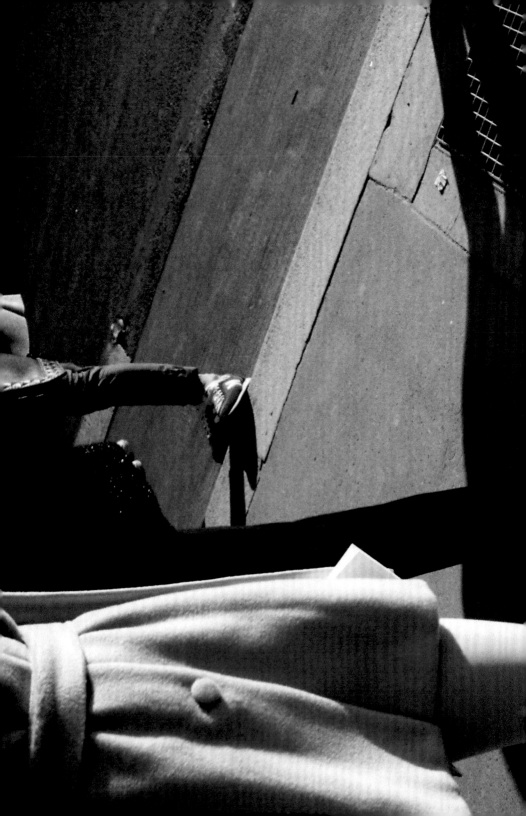

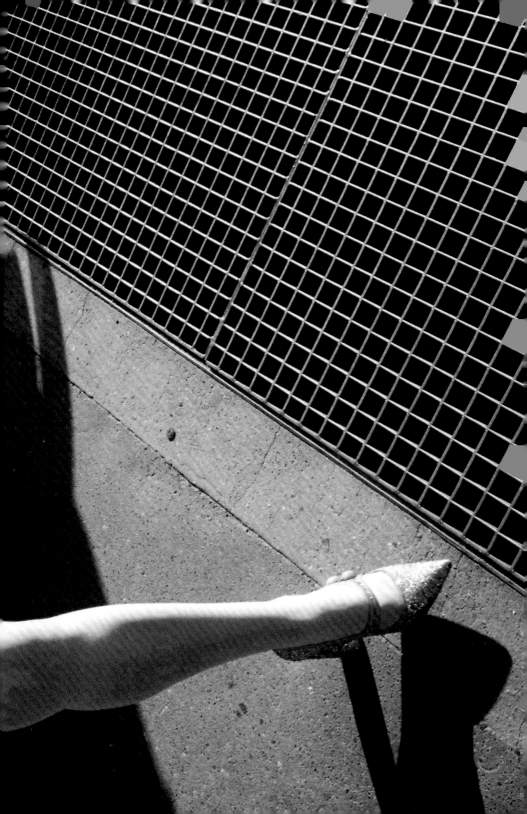

#bryan_boy

#middle_finger

#winter_pose

#photo_shooting

#a_serious_photographer

#quick_lunch

#fedora_woman

#near_j_w_anderson_show

#red_hair
#woman_and_bike
#john_hamon_poster
#milan_street
#kanye
#late_night

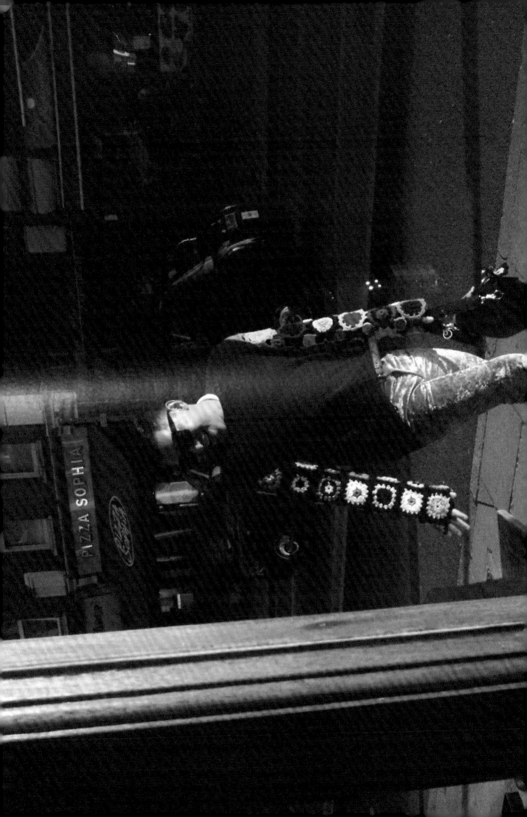

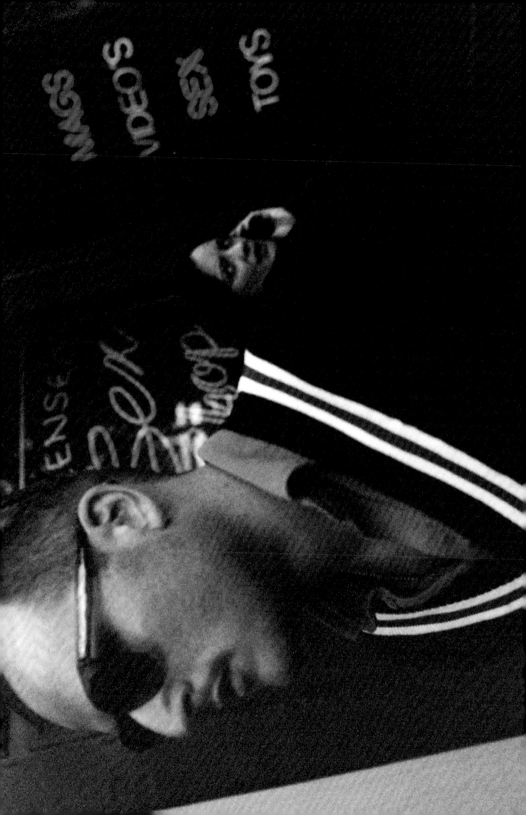

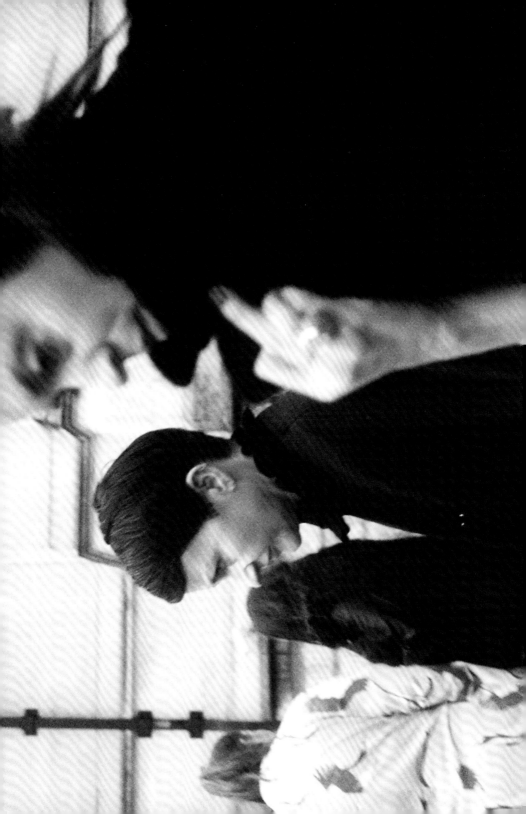

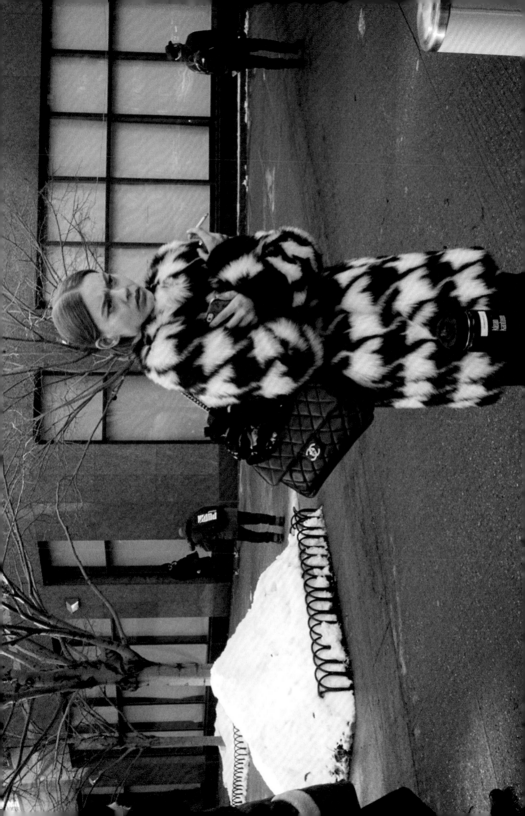

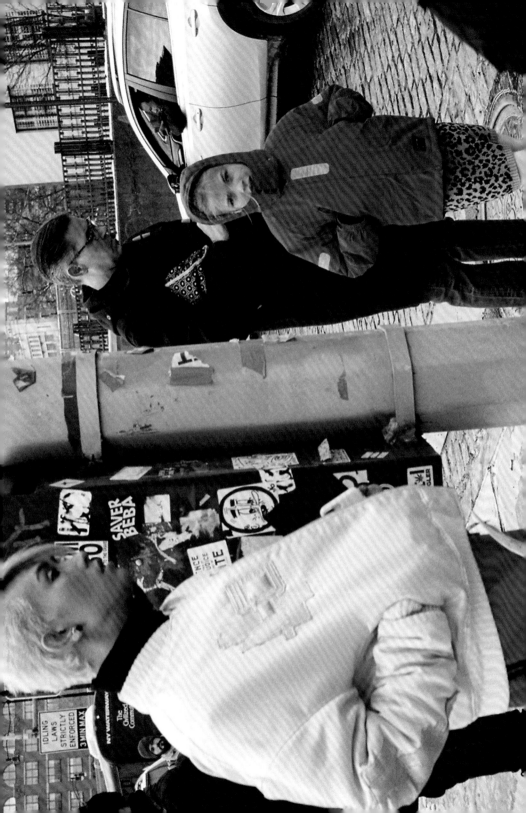

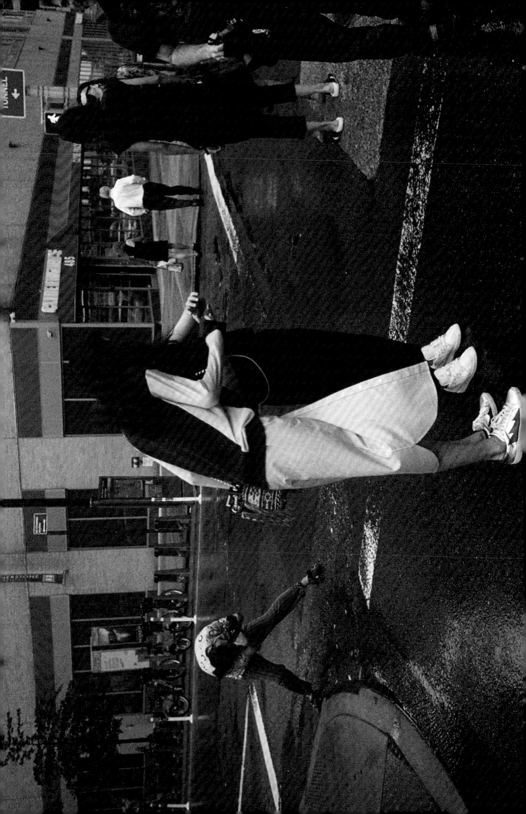

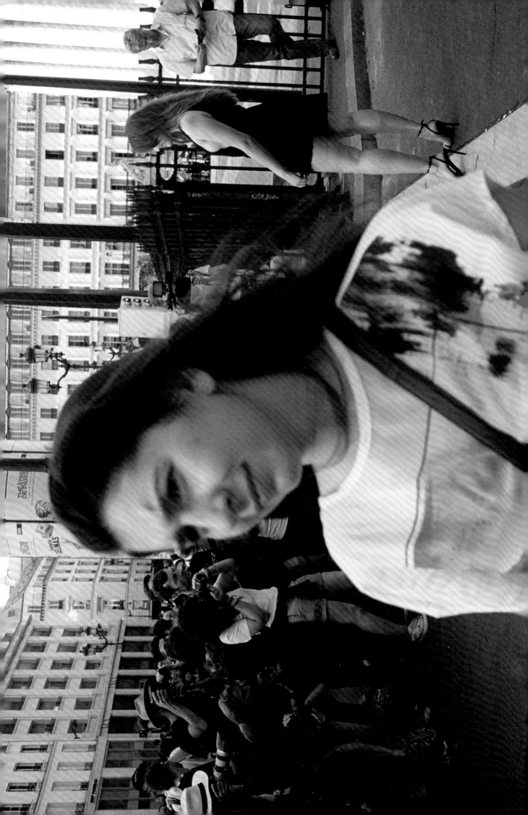

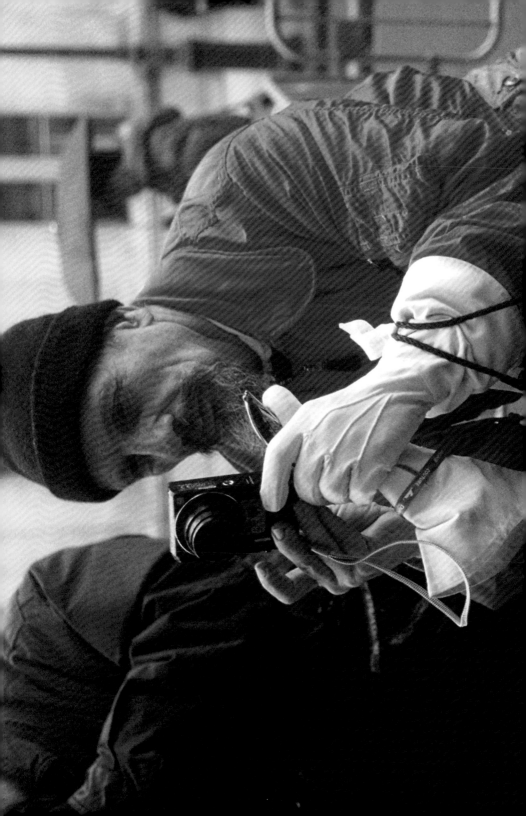

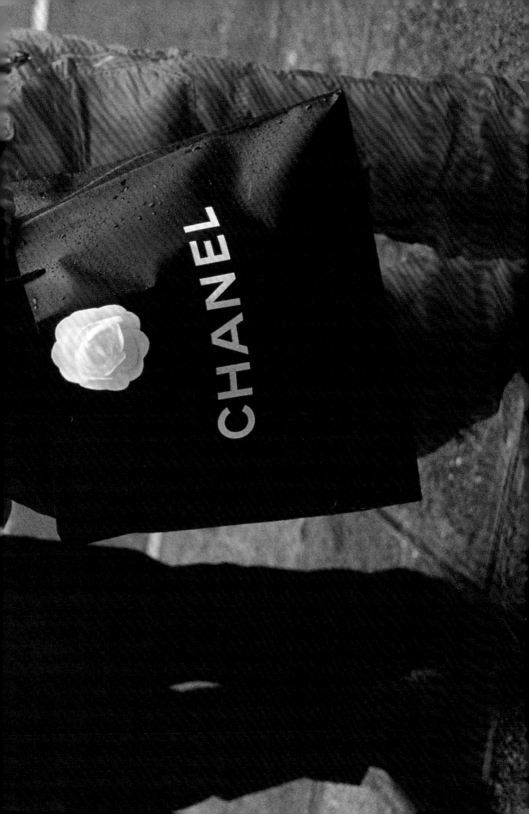

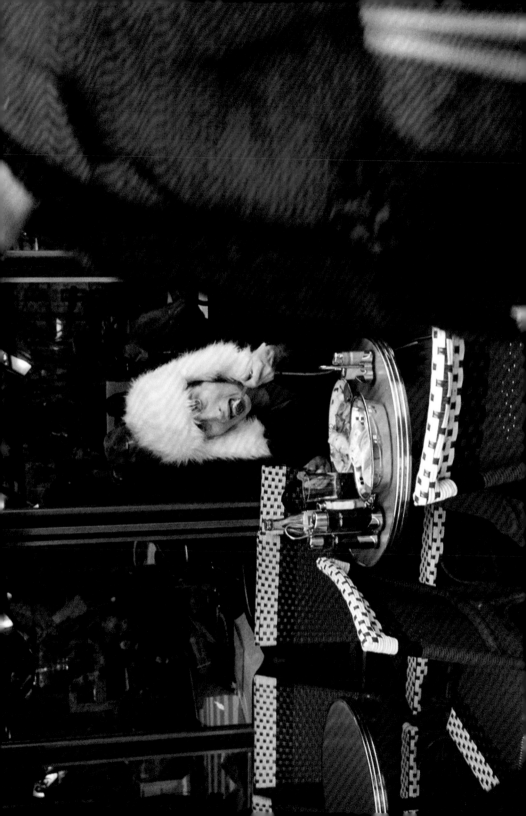

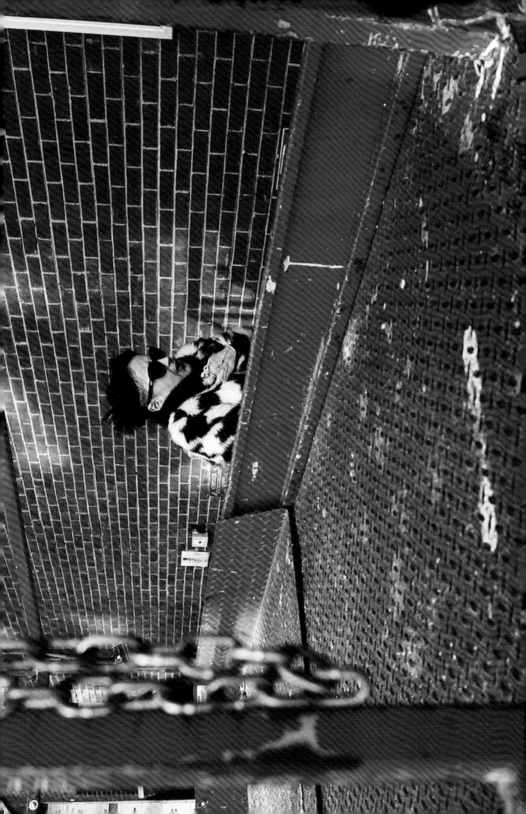

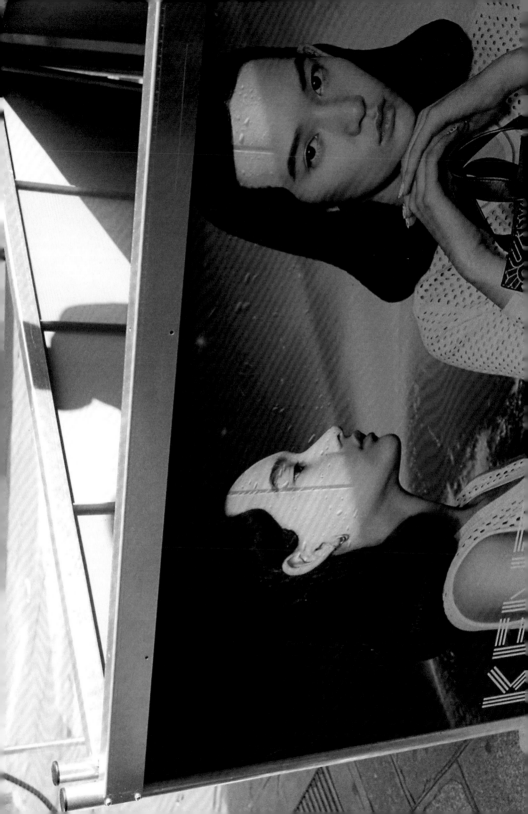

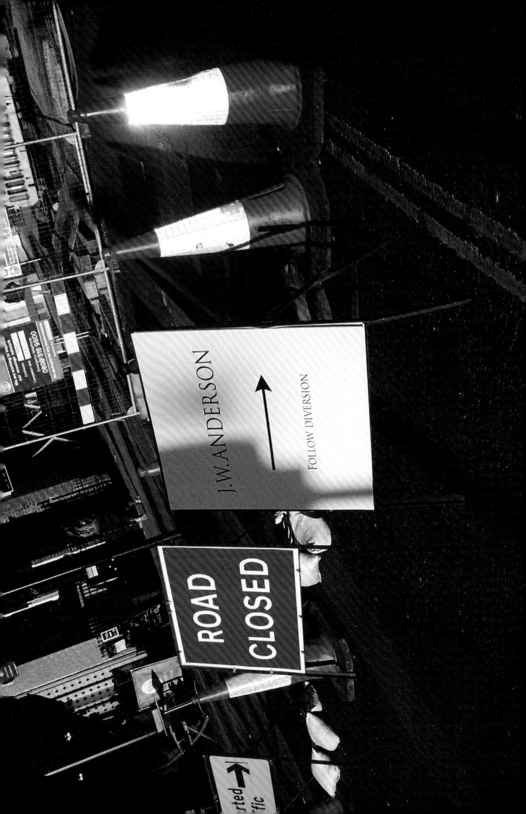

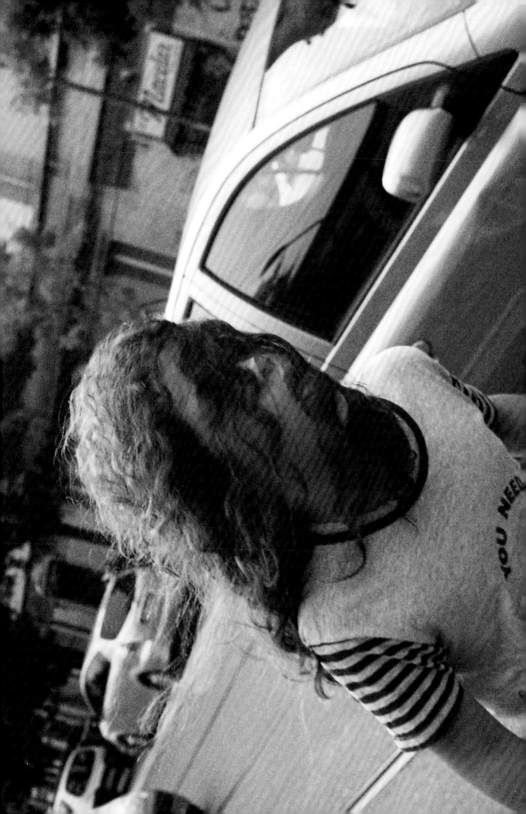

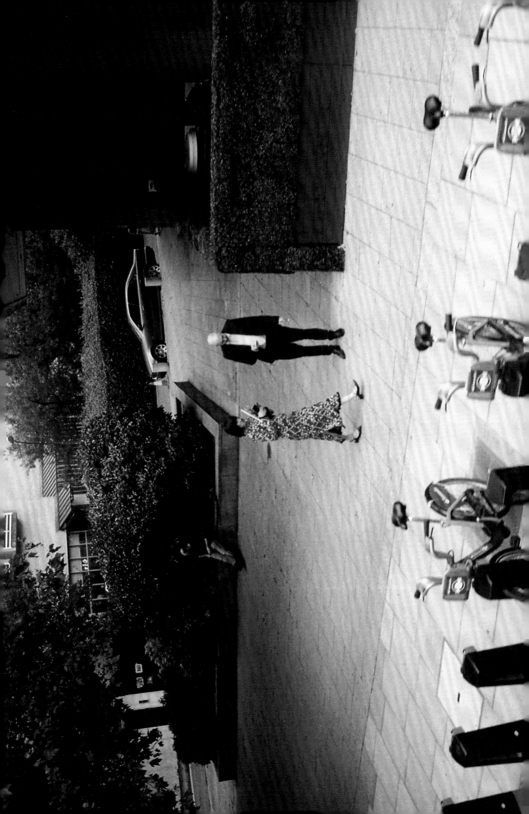

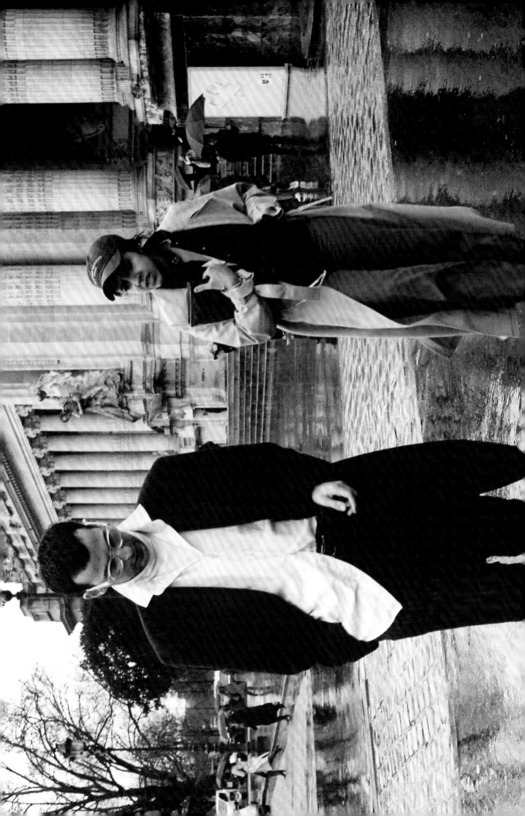

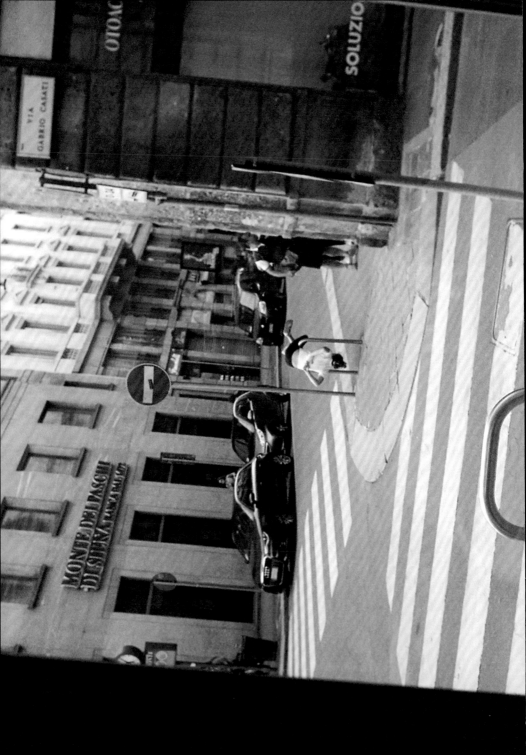

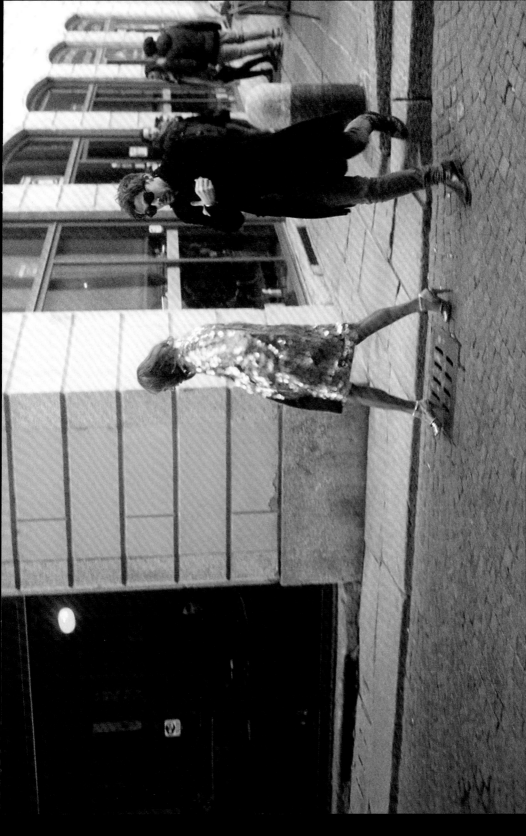